Praise for *My Old Dog*

"This book is a wonderful tribute to our 'sizzlin' seniors'! We all must open our hearts and homes not only to shelter animals, but especially to our golden oldies who *so* deserve wonderful, loving homes in the twilight of their lives."

— Jill Rappaport, award-winning animal advocate,
NBC News correspondent, and bestselling author of
Jack & Jill: The Miracle Dog with a Happy Tail to Tell

"Old dogs have so much to teach us about patience, respect, responsibility, loyalty, and unconditional love. I could not put this book down, and I don't think anyone could read it and not be moved to go out and help an older dog."

— Jennifer Kachnic, president of the Grey Muzzle Organization

"Who knew that old dogs could teach human beings some new tricks: compassion, companionship, healing, random snacking, and the power of second chances. Laura Coffey and Lori Fusaro have given the beasts of the world — human and canine — a map for graceful aging and a full and happy life."

— Roy Peter Clark, author of
Writing Tools: 50 Essential Strategies for Every Writer

"The wonderful, heartwarming stories in *My Old Dog* show that saving the life of a senior dog makes a difference, and it's *real*. It's one of the best decisions a person can make."

— Sherri Franklin, founder and executive director of
Muttville Senior Dog Rescue

"Some people may be afraid that they'll only have a short amount of time with a mature dog. But as the beautiful stories and photographs in *My Old Dog* demonstrate, the quality of that time often exceeds everyone's expectations."

— Lisa Prince Fishler, founder of HeARTs Speak,
a global network of artists who help animal-welfare groups

"*My Old Dog* is a hard book to put down. Each dog's story sucks you in, and the many beautiful photos reveal the dog's true personality. This is a special book for all dog lovers and a compelling celebration of the human-canine bond during a dog's golden years."

— Jeff Theman, director and producer of
the documentary *Guilty 'Til Proven Innocent*

"The information presented here on senior dog rescue is excellent, and the photography brings the dogs alive. If you care about old dogs, you'll love it. And if you don't know what senior dogs can add to your life — read it!"

— Judith and Lee Piper, cofounders of Old Dog Haven

"*My Old Dog* highlights the beautiful compassion of those who choose to love, support, and respect our older animals instead of throwing them away. The book is a look at how we can become better people, as it wonderfully illustrates the joy and fulfillment we can experience by adopting one of these good souls. It's a testament of the transformation that love can bring about in the hearts of those facing the end of life. Thank you, Laura Coffey and Lori Fusaro. You rock!"

— Michael Harney, actor on *Orange Is the New Black*,
Deadwood, and *NYPD Blue*

"If you love dogs, or if you like dogs, or if you've ever heard of dogs, or if you're from planet Earth, you will love this book."

— David Rosenfelt, longtime animal rescuer
and author of *Dogtripping* and *Lessons from Tara*

"This book is a loving celebration of old dogs and of radiant souls that shine through aging eyes. It will touch you and possibly even move you to bring a homeless old dog to share their best years with you."

— Francis Battista, cofounder of Best Friends Animal Society

"Anybody like myself who has had the honor of adopting an old dog knows how incredibly special that bond can be. Lori Fusaro and Laura Coffey have captured the spirit of these animals beautifully in *My Old Dog*. My hope is that it inspires many others to give these dogs one more chance to know what home feels like. Not only is

My Old Dog an idea whose time has come, it is a truly heartwarming celebration."

— Jackson Galaxy, host of Animal Planet's *My Cat from Hell*

"*My Old Dog* is the most heartwarming tribute of unconditional love on both ends of the leash! From Remy to Bretagne to Cullen to Sunny to Duval and so many more, these stories of hope and compassion are timeless. I fell in love with these dogs, and their stories serve to remind us that old dogs are like fine wine — they only get better with age. Four paws up!"

— Dr. Robin Ganzert, president and
CEO of American Humane Association

"Until reading *My Old Dog*, I wouldn't have considered adopting a senior dog because of the heartbreak factor. I've done a 180, thanks to Laura Coffey and Lori Fusaro's shining work. This exquisite, eye-opening book needs a place on every dog lover's shelf."

— Maria Goodavage, *New York Times*–bestselling
author of *Soldier Dogs* and *Top Dog*

"*My Old Dog* is a truly wonderful book. Of course, as a dog behavior expert I am partial to stories about dogs, but this book appeals to me even more because every story reminds me just how resilient dogs are and how strong the human-animal bond can be. Regardless of age, a dog's love is as pure as anything you will experience in your life and pays no heed to fame, money, or social standing, but it's the devotion of a senior dog that is demonstrated so perfectly in this book through written word and beautiful photography. I love energetic puppies, crazy adolescents, and vibrant adult dogs, but the seniors really steal my heart. I suppose I'm biased because I'm lucky to share my life with Sadie, an old rescued chocolate Labrador, but when you read this book, you'll understand why."

— Victoria Stilwell, positive-reinforcement dog trainer
and star of Animal Planet's *It's Me or the Dog*

"The photographs and stories in *My Old Dog* are spectacular and capture senior dogs in their most beautiful stage of life. Old dogs deserve all the recognition! This book makes me want to adopt more old pups!"

— Erin O'Sullivan, founder of Susie's Senior Dogs

MY OLD DOG

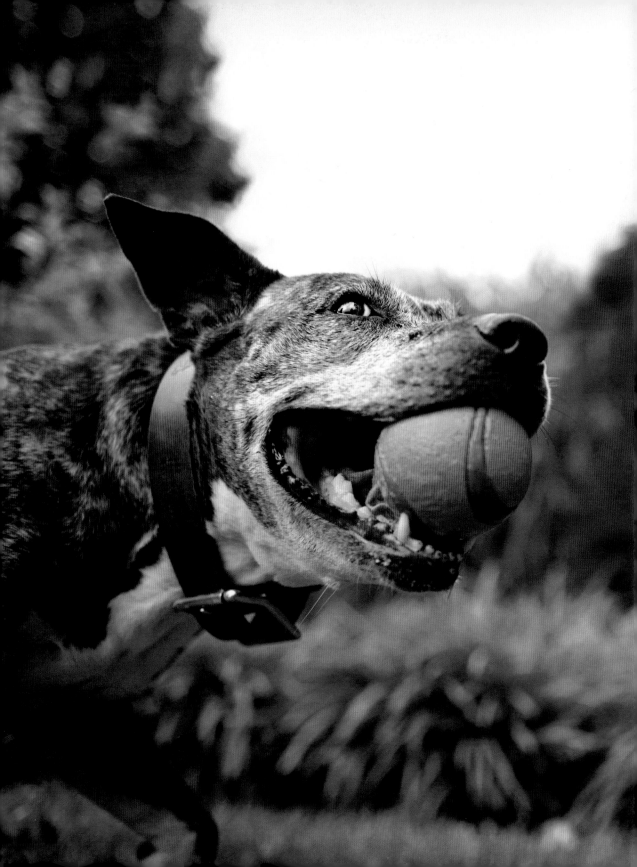

MY OLD DOG

Rescued Pets with Remarkable Second Acts

Written by
Laura T. Coffey

Photographs by
Lori Fusaro

New World Library
Novato, California

 New World Library
14 Pamaron Way
Novato, California 94949

Chapters describing Sunny, Remy, Boomer, Susie, and Bretagne appeared on
TODAY.com in a substantially different form.

Text design by Tracy Cunningham

Library of Congress Cataloging-in-Publication Data is available.

First printing, October 2015
ISBN 978-1-60868-340-6
Printed in China

10 9 8 7 6 5 4 3 2 1

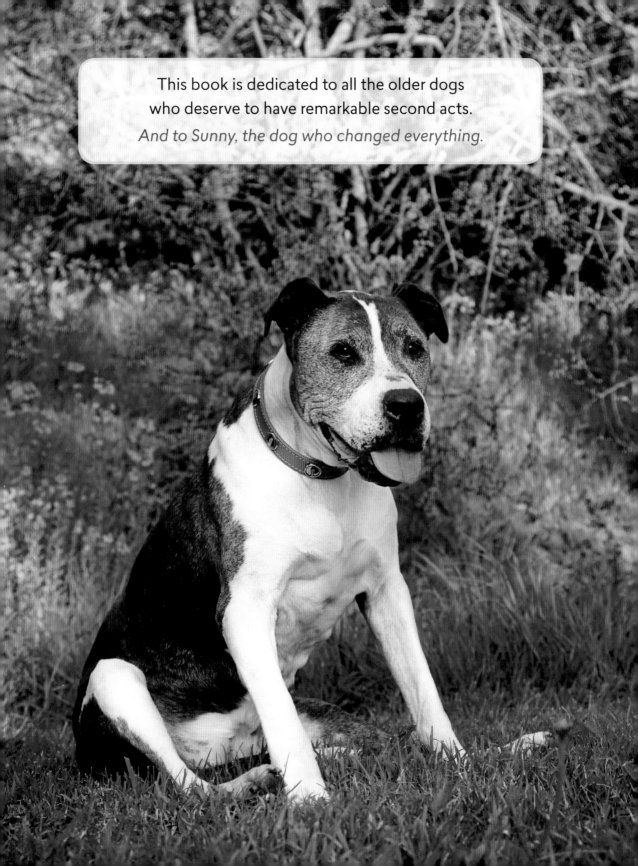

This book is dedicated to all the older dogs
who deserve to have remarkable second acts.

And to Sunny, the dog who changed everything.

CONTENTS

PART 3: HELPING

PART 4: RETIRING WITH PURPOSE

PART 5: HOW YOU CAN HELP

FOREWORD
Please Hold My Paw and Stroke My Ear
Neko Case

FOREWORD
Please Hold My Paw and Stroke My Ear
Neko Case

The first of many dogs to raise me lived to be twenty-one years old. She was a terrier named Buffy, and she was a loving, hilarious badass.

Buffy ran wild and ruled our neighborhood in northwestern Washington State when I was a kid, but she always — *always* — looked out for me. I was an only child, and my parents were gone all the time, so I learned to rely on Buffy as my most dependable friend. She waited for me to come home from school. She stayed close by when I did my homework or read books. She slept with me every night, and one of my hands was always, unconsciously, holding one of her soft tan ears. Buffy was a great dog — and I'm convinced that it wasn't just because she was smart, but also because she knew how great she had it.

Former shelter dogs like Buffy never forget where they've been. They've lived in a shelter, and they know it sucks. Fortunately for them, though, dogs are the ultimate masters of living in the moment. They exist in harmony with this simple formula: if humans take them in and love them, they blossom. The more love they receive, the more happy and silly and generous they become. This formula is as true and trustworthy as the earth's orbit around the sun, and I've witnessed it again and again over the years with more rescue dogs than I can count. I've especially seen it with older dogs who get sprung from shelters, so much so that these seniors belong in their own special category: the Most Grateful Dogs on Earth.

Take Liza, my sixteen-year-old black shepherd mix. The day I met her at a shelter in Tucson, Arizona, I was struck by her gentleness and patience. There she was, an older girl flanked by other dogs in the same crowded kennel. One dog kept barking and barking

right in Liza's ear, but Liza would not get annoyed. She just endured the racket with a Zen-like calm. I remember thinking, "I have to get her out of here — now! That is the most patient dog on earth!" And I did. I brought her home with me, and then I marveled because I have never had to teach her a single thing. Liza came to me fully formed as an ideal family member and friend. No one has ever loved me more than this dog. As years have passed, I've found that all I can do is try mightily to return the favor.

It makes me so happy that older shelter dogs are being celebrated in this beautiful and important book. In its pages, you'll meet a variety of calm, content older dogs like Buffy and Liza, and you'll see how profoundly they help people of every age, walk of life, and income level. They help widows, veterans, teenagers, nuns, movie stars, executives, blue-collar workers, novelists, and retirees. They help toddlers in children's hospitals, first graders who are struggling to read, and twenty-somethings building their careers in New York. These mellow, worldly-wise creatures have the capacity to help anybody — because dogs, as a species, study human behavior. They really do want to learn our language. And it shows! When we feel upset, they get worried. When we feel elated, they rejoice. Dogs delight in giving us a very specific kind of love and empathy. By embracing this gift from them and loving them back, we can be helped to face almost anything.

As a child, I spent more time with animals than I did with people, and animals were the kindest creatures I knew. Now, as an adult, I can't imagine my life without animals. I live on a farm in Vermont with a horse, a turkey, three chickens, a cat named Marty, and four dogs — Liza, Jerome, Bert, and Ernie. All of them are rescued animals who give me so much more than I give them. It's a comfort and a privilege to be part of such unconditionally loving and grateful lives.

My dogs, in particular, have a knack for improving pretty much every aspect of my life. They make me laugh when I'm mad at myself or my day. Their happy, excited faces — so full of love and devoid of meanness — always make me feel like I am part of a legit, loving family. Thanks to my dogs, coming home from a trip to the grocery store is a celebration.

Some people think it might be too sad to adopt an older shelter dog. I get that. As dogs age, they often face health problems — or worse — and who among us doesn't want as much time with our pets as we can get? But always remember that special superpower of dogs: they live in the moment. They live for today. They enjoy what they can enjoy right here and right now. We humans tend to worry and fret about our illnesses and frailties — but dogs absolutely, unabashedly do not. This is just one of the many lessons we have to learn from them.

By not worrying about tomorrow, dogs transform before your eyes into invincible love tanks. The oldies often have great senses of humor and bring some unexpected comedy into the house. And they often keep on trucking much longer than you might expect. Then, when their quality of life begins to erode too much, they will tell you. You will hear them. And you will know in your bones that they are not afraid.

We only get so much time with all of our loved ones — human or four-legged. In the time we have together, we need to take care of each other. We need to help each other out. Ask yourself this question: Where would it be better for an older dog to die? Alone in a loud, scary shelter, or feeling safe and secure alongside a trusted human friend?

A few years back, I had to say good-bye to my greyhound, Lloyd, after he got diagnosed with lymphoma. I won't lie to you: it was terrible, and it was terribly sad. But it also was beautiful and terribly important. I felt so honored to be there at the end, singing softly to my dear friend and comforting him. I hope that when I die, someone is there for me like that — holding my paw, stroking my ear, and helping me feel safe.

NEKO CASE is a Grammy-nominated singer-songwriter known for her clear, strong voice and versatility as a musician. Born in Alexandria, Virginia, to teenage parents, Case moved frequently as a child and spent the largest part of her youth in Washington State. She left home at age fifteen and gravitated toward the Pacific Northwest's punk rock scene. She then built a cult following after launching her solo career as an independent musician. A lifelong animal lover, Case is an ambassador for Best Friends Animal Society, which works toward the goal of ending the killing of animals in shelters across the United States.

Photographs of Neko Case by Jason Creps Photography

INTRODUCTION

Older dogs are wonderful. They tend to be calm and content, loving and loyal — and when they find nice homes and kind treatment in their later years, they give back much more than they get. The people who come to this realization are pretty wonderful, too, and you'll meet plenty of them in *My Old Dog*. In fact, this is a book that will make you want to hug every dog and every human in its pages because you'll be so happy that dogs and humans like these exist.

"Dogs make such good buddies at this age, and in many ways, this is the best time of their lives," said Judith Piper, cofounder of the Seattle-area rescue group Old Dog Haven. "They are relaxed, they are wise, they are loving, they are adaptable — they are such great role models. We should be more like them!"

Senior dogs really do have a lot going for them: they're mellow, they're easy, and they're usually already house-trained. Many people featured in this book never imagined they'd take in a homeless senior pet, but when they did, they watched their own lives improve immeasurably.

"This is such a positive and kind thing for a person to do," said Sherri Franklin, founder and executive director of Muttville Senior Dog Rescue in San Francisco. "It's so rewarding to take in an abandoned senior dog and say, 'We're going to make sure you get a new beginning.'"

My Old Dog celebrates successful senior-dog rescue stories while also highlighting a sad truth: at shelters across the United States, where nearly four million dogs and cats are put down each year, senior animals often represent the highest-risk population.

Animal-welfare workers see the same distressing scenarios all the time: confronted with financial pressures, illness, or another life upheaval — such as a divorce, a home

foreclosure, or even a military deployment — an animal owner is suddenly unable to care for a longtime pet. Another common situation with senior dogs is that their older human owners move into nursing facilities that do not accept pets.

"It's heartbreaking to think about all the senior animals who had been cherished pets and then suddenly found themselves confused and alone in shelter kennels," said Dr. Robin Ganzert, president and CEO of American Humane Association. "This happens to so many older dogs through no fault of their own."

Yes, it's tough to be a discarded senior dog — but a mere decade ago, it was a *lot* tougher. Fortunately for members of the gray-muzzled set, grassroots efforts on their behalf began brewing in far-flung parts of North America in the late 1990s.

In 1997 in Canada, Judith "Jude" Fine created the Senior Canine Rescue Society in Calgary to help senior dogs regardless of their age or health. "We are inspired by the zest for life shown by older dogs thrown away in the twilight of their lives," Jude explained in her group's literature. "It is our mission to do what we can to ensure their safe and happy retirement." The Senior Canine Rescue Society helped secure homes for hundreds of older shelter dogs before Jude's death in 2006. She is remembered in her obituary as "a selfless advocate for the underdog and a champion for the weak, the needy and the voiceless."

Also in 1997, Teri Goodman of San Francisco started the Senior Dogs Project, a website designed to encourage senior-dog adoption. To this day, the site offers one of the most extensive online collections of information about helping and caring for older dogs.

In 1999, Deborah Workman started one of the first rescue groups in the United States devoted specifically to older dogs: the Sanctuary for Senior Dogs in Cleveland, Ohio. "When we started the group, we were openly laughed at," Deborah recalled. "It was *not* a popular thing. Back in the late nineties, no one sought out an old dog. The shelter I volunteered with didn't euthanize their dogs, but the old dogs never went anywhere. Some would slowly go kennel crazy." Despite the initial ridicule, Deborah remained determined to grow the Sanctuary for Senior Dogs; today, her group still finds homes for about thirty seniors a year. "It amazes me that adopters actually seek out old dogs now," she said. "But they do!"

Just as Deborah did in Cleveland, people elsewhere began feeling moved to do something about all the senior dogs being put down in shelters. This led to the creation of dozens of senior-specific rescue groups over the years. For instance, Ellen Ellick and Norma Glodas started the St. Louis Senior Dog Project in Missouri in 2002; Judith and Lee Piper started Old Dog Haven in western Washington State in 2004; Dawn Kemper started Young at Heart Pet Rescue in the Chicago area in 2005; Sherri Franklin started Muttville Senior Dog Rescue in California's Bay Area in 2007; and Zina and Michael Goodin started Old Friends Senior Dog Sanctuary in Tennessee in 2012. (You can find contact information for these and many more groups in the resource guide at the back of this book.)

In 2008, something happened to bring more cohesion to the movement on a national level: Julie Dudley founded the Grey Muzzle Organization, an all-volunteer group that gives grant money to senior-dog programs. "I wanted to do something to help the groups

that are doing this, because they are *so* busy," Julie explained. "Small organizations certainly don't have the time to do national fund-raising." By late 2014, the Grey Muzzle Organization had provided more than $420,000 in grants to shelters and rescue groups across the United States, along with $35,000 worth of orthopedic dog beds to make older dogs' shelter stays more comfortable.

These days, senior-dog programs abound all over North America and overseas. Many rescue groups for dogs of all ages and breeds have special initiatives to help seniors get adopted, and most city and county shelters in the United States promote their older animals in special ways.

"Ten years ago, we probably would have had to beg shelters and rescues to start programs like this, but now so many of them are doing it," said Jennifer Kachnic, the Grey Muzzle Organization's current president. "And they actually have people walking in and saying, 'I want a senior dog, or a dog with health problems, or a dog that's hard to adopt.'"

The senior-dog movement got another boost in January 2014. That's when Erin O'Sullivan started a Facebook page called "Susie's Senior Dogs" to connect people with older pets up for adoption. Almost immediately, the page had a significant impact on the senior-dog rescue scene; in less than a year, it racked up more than 200,000 followers and helped about 300 dogs find permanent homes. Erin knew from the very beginning that she wanted to spotlight the neediest cases. "I try to go for the dogs that are literally sitting in jail cells," she said. "I feel they are valuable. They are creatures on this earth."

These changes are hugely encouraging for all the older canines out there — but senior dogs still struggle with a serious image problem. Even the term *senior* can be fraught with peril if you're a dog. According to American Veterinary Medical Association age labels, a fun-loving golden retriever (a larger breed) can be labeled geriatric at age six, and an affectionate shih tzu (a smaller breed) can be considered geriatric at age seven — even though they might have a decade or more of adventures ahead. Dog rescuers say such labels can reduce an animal's chances of being adopted.

A Whole Month for Senior Pets

Older dogs got a much-needed public relations boost in 2005 when the American Society for the Prevention of Cruelty to Animals (ASPCA) and Petfinder.com designated November as Adopt a Senior Pet Month. The campaign was so successful that the internet now teems with irresistible, white-muzzled faces each November.

It turns out that senior dogs contend with some of the same issues as senior humans: in a culture obsessed with newness and youth, they can get sidelined or, even worse, shunned. Translation? Many people in the market for a new dog want a puppy. Or at least they *think* they want a puppy. Or they may just assume that a puppy is the only logical option.

Therein lies the puppy paradox.

Yes, puppies have puppy breath and squishy bellies and too-big paws and goofy, clumsy gaits. Yes, they are adorable. But, much like childbirth and diets and dental work and endurance races, a great thing about puppyhood is that it ends. It goes by in a blur of chewed shoes and challenging potty-training regimens and destroyed TV remote controls and urine-soaked carpets — and then it's finally, blessedly, over.

Once you power through it, you have a great pal by your side — a four-legged friend who's always thrilled to see you and who even sort of does what you say. But the very best phase of all, an idyllic period of doggy nirvana, doesn't arrive until later. You'll sense it happening when a dog turns about six or seven and starts becoming more relaxed, more affectionate, more grateful to rest serenely at your feet, more insistent about receiving butt scratches. These are all signs that you're entering the best phase of all.

"The good news with an older dog is that you know what you're going to get — you know how big they are, you know they won't eat your shoes, you know they're house-trained," said Jennifer Kachnic. "Puppies are awesome, too, but they're often not the best fit for most people with busy lives."

Those comments transport me back to a time when my husband and I had a ram-bunctious Labrador retriever puppy named Manny. His needle-y teeth tore a swath of destruction across our house, no matter how hard we tried to dog-proof everything. We once came home to discover that he had gnawed his way across an entire side of our wooden coffee table as if it had been a giant corn on the cob. I almost cried as I told my veterinarian about everything Manny had peed on, chewed up, or eaten — including a bumper crop of heirloom tomatoes that had been growing in our garden. The vet looked at me dispassionately for a moment. Then he said, "You're going to have a really great dog in five to seven years."

Mind you, plenty of dedicated, die-hard dog lovers squirm with uneasiness over the notion of taking in an older dog. Lori Fusaro, the photographer for this book, used to feel that way. "I thought it would just be too sad and painful," Lori said. "I didn't think my heart could take it, so I wasn't willing to open myself up." Lori changed her mind in 2012 when she adopted sixteen-year-old Sunny, the dog featured in the first chapter of this book. Sunny altered Lori's view of older dogs so completely that she decided to launch a beautiful photography project to show how much senior shelter pets have to offer.

In 2013, I wrote a feature story about Lori, Sunny, and senior dogs for TODAY.com, the website of NBC's *TODAY* show — and that gratifying experience led to the book you're holding in your hands. Lori and I teamed up to document senior-dog success stories, and

we spent a good chunk of 2014 traveling all over the United States to find them. We've seen firsthand that shelter dogs over the age of six or seven should not be considered damaged goods. Instead, they should be snatched up quickly because they're probably pretty much perfect.

Rescuers say the most grateful canines are older dogs from loud, disorienting shelters who receive get-out-of-jail cards. Often, within fifteen minutes of starting new lives in loving homes with soft beds, they fall asleep in that most vulnerable of dog positions: on their backs, bellies exposed, paws flopped contentedly in the air. The same profound relief is shown by retired working dogs — military dogs, racing dogs, law-enforcement dogs, and others — that you might not expect to end up in kennels or shelters. But they can. For that reason, *My Old Dog* includes compelling stories of working dogs who needed help securing safe, comfortable places to retire.

This book tells the stories of well-known folks who adopted older dogs, such as actor and filmmaker George Clooney; singer and songwriter Neko Case; retail and philanthropic giants Bruce and Jeannie Nordstrom; mystery novelist David Rosenfelt; and Brandon Stanton, author of the popular book *Humans of New York* and of the blog by the same name. (Brandon's blissful little dog Susie is the inspiration for Erin O'Sullivan's Susie's Senior Dogs page on Facebook.) *My Old Dog* also spotlights rescue workers who do what they do on their own time, and often at their own expense, year after year.

As these stories unfold, the joy and ease of living with older dogs (as opposed to untrained puppies!) become evident. At the conclusion of the book, you'll find caregiving tips for older dogs from veterinarian and bestselling author Marty Becker and senior-specific behavior tips from certified dog trainer Mikkel Becker, as well as ideas for helping senior dogs in all sorts of ways — even if you can't take one in yourself. The book's resource guide contains contact information for dog-rescue groups and other senior-pet-loving organizations near you.

Older dogs have so much to teach us about love, trust, forgiveness, and healing. But first, we need to let them in. We hope the stories and photographs collected here will inspire people to do just that.

"Senior dogs might be slower, and they might sleep a little more, but all the old dogs I've photographed like to play with their toys and chew on their bones," Lori said. "They still have that zest, that joy for living. When I look back at my unwillingness to adopt an older dog, it was more about not wanting to feel that pain, not wanting to make hard decisions. But every dog is important. Every dog deserves a home. I finally just boiled it down to love. That's the most important thing."

PART 1

Finding the Good Life

SUNNY, 18

An "Energizer Bunny
Powered on Love"
Imparts a Whole New
View of Senior Dogs

> **"** Every dog is important. Every dog deserves
> a home. I finally just boiled it down to love.
> That's the most important thing. **"**
> — Lori Fusaro

Sunny has a face like Eeyore's and a nose like Yogi Bear's. Her eyes sparkle whenever a friend stops by her orthopedic dog bed to pet her soft, furless chin.

At eighteen, Sunny is one of the oldest dogs around — and she's okay with that. Lori and Darrell Fusaro can tell Sunny knows she's in a good place. When she first brought Sunny home from a crowded Los Angeles County shelter, Lori thought the dog might survive for a couple of weeks, tops. Two and a half years later, Sunny is still kicking — and they're still besotted with her.

"Darrell always tells me, 'She knows you saved her,'" Lori said while relaxing on a Sunday afternoon in the couple's cheery living room in Culver City, California.

"She *does* know you saved her!" Darrell insisted, tucking a pillow under Sunny's dog bed to make sure her head would be elevated just so.

One sunny Saturday morning, Lori was doing what she did most weekends: volunteering her time as a pet photographer to help animals get adopted from overtaxed shelters. She usually approached these photo shoots with hopefulness, but on this day, the Carson Animal Care Center overwhelmed her. The rows of cages, the incessant barking, the astonishing number of dogs and cats bound for the shelter's euthanasia room — all of it made her feel like she was wading through quicksand.

Partly to cheer herself up, Lori stopped at a kennel and tried offering a treat to a dog named Shady. That backfired; Shady wouldn't even lift her head. "I just wanted to run out of there and never look back," Lori wrote in a blog post that night. "Love. Warmth. Understanding. A friendly touch. A place to belong. Feeling like you matter. Isn't that what we all want? Canine, human, feline — our needs are much the same."

Lori still felt unsettled the next day, but she sensed a kernel of an idea growing. Shady's face kept popping into her mind, and it looked so sad and defeated — but why was it making her feel so energized?

"With every thought of her, it became obvious what I had to do," Lori recalled. "But I'm still somewhat sane, so I made a couple calls to some friends." She wanted to ask

them, "Am I *crazy* to pull a sixteen-year-old dog from the shelter?" Her friends weren't available to answer their phones, though.

Her husband, Darrell, wasn't home either. But Darrell — an artist, online radio host, and author of *What If Godzilla Just Wanted a Hug?* — is an upbeat guy who tends to share advice like this: "Spontaneity neutralizes fear, amplifies intuition, and lifts us beyond our limitations." Lori opted to be spontaneous. She hopped into her green Kia Soul, drove back to the Carson shelter, and adopted Shady. Right away, she gave the dog a new name:

Sunny.

At sixteen, Sunny had a host of health problems. Her right eye was badly infected, and she had a bulging, cancerous tumor the size of a tennis ball on her back left leg. Lori didn't care. She was going to make Sunny's last days as comfortable and as joyful as possible. "I was just so touched by her," she said. "She had lived with a family her whole life, and her owners had turned her in because she got cancer."

Lori and Darrell did spend money on veterinary bills for Sunny, but they swear it's not as bad as people might think. Vet visits helped clear up Sunny's eye and led to a sixty-dollar-a-month prescription for pain medication — but Lori, Darrell, and their veterinarian chose to avoid costly, invasive treatment for Sunny's cancer. "When you adopt an older dog, that's part of the package — you're probably going to have to make decisions like that," Lori said. "But for extreme health issues that would arise, I would not prolong her life just to keep her living. I want her quality of life to be good."

Sunny bounced back fast and began relishing her time with Lori, Darrell, and their other pets, a twelve-year-old dog named Gabby and two cats named Enzo and Francis. Gabby took an instant liking to Sunny, squeezing next to her on the same dog bed and letting Sunny use her butt as a pillow. The dogs also loved reclining together in dappled sunlight on the living-room couch, slurping up watermelon, romping on the beach, and taking leisurely strolls under the Japanese elm trees in their neighborhood. (A special thrill for Sunny on those strolls: run-ins with Raisin, a white male poodle who lives on her street.)

Sunny's transformation from a scared, disoriented shelter dog to a happy, playful family member got Lori thinking: maybe she could use

her photography skills to help a whole bunch of senior dogs. In early 2013, she began work on a photography project she initially called "Silver Hearts." With the tagline "Love doesn't keep track of years," the project aimed to change people's perceptions of older shelter animals.

Lori started taking photos of older dogs around the country and posting them online. In July 2013, I spotted the stunning photos on Facebook. I contacted Lori and wrote a feature story for the *TODAY* show's website that ran with the headline "'No Dog Should Die Alone': Photographer Promotes Senior Pet Adoption."

Kaboom. The TODAY.com story blew up and got shared all over the world. Then Jill Rappaport did a segment about Lori's efforts on *NBC Nightly News*, and Sue Manning wrote a story for the Associated Press. Scores of media outlets picked up the story or created versions of their own. The deluge of publicity led to a senior-dog art project, a senior-dog museum exhibit of Lori's photographs, and even "#SeniorDogMitzvah," a project launched by a twelve-year-old Massachusetts boy to help spring an old dog named Bailey from a yearlong shelter stay.

Sunny's contented Eeyore face got splashed across newspapers in faraway places like Malaysia, Germany, Brazil, and the Philippines. As people around the world sighed in relief over her rescue story, messages like these started pouring in:

> **"**You and Sunny were the starting point for me in rescue. You gave me the courage to do what I had always wanted but didn't think I had the strength to do: save animals.**"**

> **"**Because of you and Sunny, I adopted a senior dog two months ago that was scheduled to be put down. Her life and your story have also changed the minds of so many other people, and we are grateful for you and her.**"**

> **"**My wife and I have been thinking about getting a second dog, and reading your article is just the kick in the pants we needed! Gonna look for a senior pooch ASAP!**"**

All of the unabated — and passionate — interest in homeless senior dogs affected Lori and me so much that we ultimately joined forces. The Silver Hearts project evolved into *My Old Dog: Rescued Pets with Remarkable Second Acts* — second acts like the one enjoyed by Sunny, a once-discarded dog who inspired countless people to help senior shelter animals.

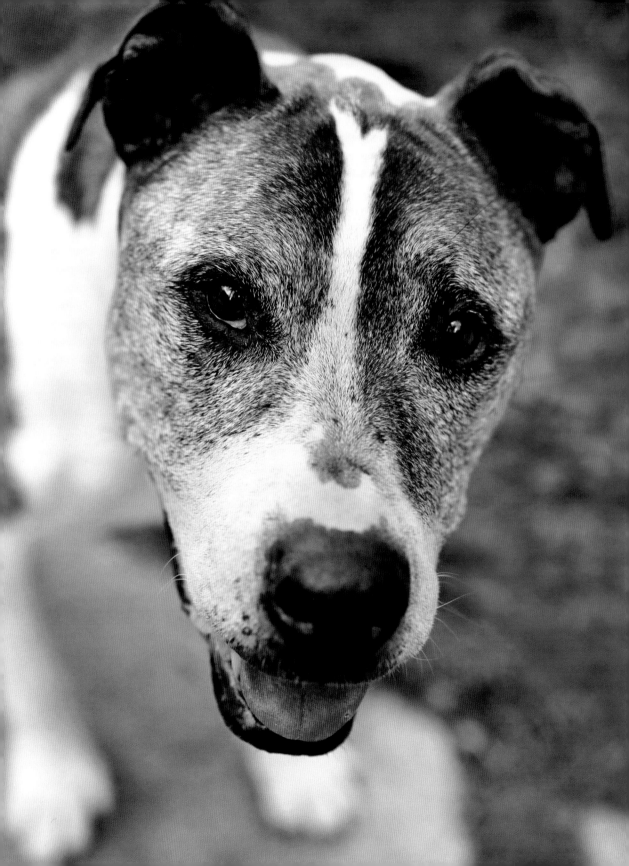

"I still can't believe all of this happened," Lori has said on more than one occasion. "All because I adopted a sixteen-year-old dog!"

Since her adoption two and a half years ago, Sunny's zest for life has never abated — but her mobility has. She's still able to walk — slowly — but most of the time, Darrell and Lori must help her to her feet so she can amble across a series of throw rugs at mealtimes. They serve Sunny's breakfasts and dinners on a specially raised platform so she won't strain her neck. They also carry her outside for bathroom breaks. "See how fit I've gotten?" Darrell said with a big grin as he hoisted Sunny up from her bed and helped her walk to her water bowl. "Sixty-five pounds every morning!"

Sunny has had several health scares in her new home that felt like the end — but weren't. In October 2013, when she was seventeen, Sunny appeared to have a massive stroke right in front of Darrell. The episode left her completely unresponsive. Darrell and Lori asked friends and family members to pray for her; their veterinarian cautioned that if Sunny ever snapped out of it, her head might stay awkwardly cocked to one side for the rest of her life.

Just when Lori and Darrell were preparing to say good-bye, Sunny looked up at them as if nothing had happened. "I swear, this dog is like Lazarus!" Darrell said. "She came back to life, normal and healthy, even running around like she was in better shape than before. It was fascinating! She got no special medicine other than the same pain pills we were giving her before."

Lori calls Sunny "the Energizer bunny powered on love." Darrell is more convinced than ever of the value of people's love, prayers, and good thoughts. "How can it not have an effect?" he said.

After adopting Sunny, Lori took a full-time job as a staff photographer for Best Friends Animal Society in Los Angeles. Darrell's schedule as a cartoonist and cohost of the show *Funniest Thing! with Darrell and Ed* on Unity Online Radio is more flexible, so he's become Sunny's primary caregiver on weekdays — a responsibility he views not as a burden, but as a privilege.

"In the past, I think I wouldn't have wanted the hassle, but now, it's not a hassle at all!" Darrell said. "It just doesn't feel inconvenient. My perspective has really changed.

"I feel like Sunny has always been here with us. I love her so much. It's indescribable."

MARNIE, 12

An Adorable Senior Rescue Dog Attains Wild Fame on the Internet

> *"Trust that little voice in your head that says, 'Wouldn't it be interesting if…' And then do it."*
> — Duane Michals

Marnie the dog is fluffy, friendly, and famous for her tilted head and long, lolling tongue. Onlookers who spot the tiny shih tzu on the streets of New York tend to gawk with disbelief, then smile, then start snapping photos.

Shirley Braha takes this in stride. She knows how unspeakably cute her dog is. Marnie is so irresistible, in fact, that she's become a bona fide celebrity online; with more than one million followers on Instagram, she might just be the most popular senior rescue dog on the internet.

"People love her!" said Shirley, a thirty-one-year-old television and video producer who lives in downtown Manhattan. "She's my dream dog. If I could just create my own dog, she's better than that. She's a dream!"

Most onlookers would never guess key details about Marnie and Shirley's backstory. For starters, Marnie's former shelter nickname was Stinky. When animal-control workers found the little dog wandering the streets of Bridgeport, Connecticut, her fur was matted and soaked with urine, and her mouth was full of decaying teeth. No one wanted the smelly, ten-plus-year-old shih tzu.

Bearing that in mind, get this: Marnie is Shirley's very first dog. On December 20, 2012, Shirley traveled more than two hours by subway, train, and taxi from New York to Connecticut to adopt her. Shirley didn't have much to go on — just two hazy photos in a bare-bones Petfinder.com ad — but she said Marnie looked so "cute and helpless" that the adoption journey felt inevitable. She also confessed that the dog's older age appealed to her.

"I'd never had a dog before, and I didn't want to commit to a dog for fifteen or twenty years, you know?" she said. "As selfless as I could make it out to be, I was thinking, 'I don't know where I'm gonna be when I'm forty-five.' *Now*, of course, I wish she could live forever!"

The initial sight, and smell, of Marnie took Shirley aback. She still went through with the adoption — but on their first frigid December day together, very little happened to lessen Shirley's uncertainty about what she was doing. She said Marnie "stunk up the

whole Metro-North train" on the trek back to New York. Marnie also barked and growled fearfully at the start of the journey. Shirley tried not to panic. "I thought, 'Oh my God, did I really just do this?'" she recalled. "I was shaking. I had gone by myself to get her. It was very scary."

Overwhelmed, Shirley decided to prioritize. First step: help Marnie feel more comfortable and smell nice. She took her straight from the train to PetSmart and had her groomed. "At least then she looked better," Shirley said. "But her mouth was still *so* bad."

A trip to the vet led to much-needed dental surgery. Marnie had fourteen of her forty-two teeth extracted. "Once she made it through that, it was the beginning of when I started letting myself get really close to her," Shirley said. "After about a week, I let myself say, 'I love you.'"

Marnie clearly felt better after getting the care she needed, but it took weeks for her true personality to emerge. She even seemed a little boring at first. Then, in February 2013, Shirley brought Marnie along with her to a Super Bowl party. "That was the first time I saw her be really happy — really smile with a big grin," Shirley remembered. "I thought, 'Hmmm. She likes parties!'"

Ever since that showdown between the Ravens and the 49ers, Marnie has been partying pretty much nonstop. Shirley brings the thirteen-pound dog with her almost everywhere she goes, and Marnie makes everything fun. "She's like my sidekick," said Shirley, who has long, dark hair, glasses, and an easy smile. "We're really a great team."

On jaunts around New York City, Marnie has garnered double takes from — and posed for selfies with — Tina Fey, Jonah Hill, James Franco, Lena Dunham, Miley Cyrus, Demi Lovato, Joe Jonas, and *Broad City* stars Abbi Jacobson and Ilana Glazer. During cross-country trips to Los Angeles, Marnie has hobnobbed with Betty White, Taylor Swift, and Sam Smith. Most of these encounters have been serendipitous, although a few were requested by the celebrities themselves. Instagram set up Marnie's meeting with James Franco, who then tweeted, "I never thought I'd meet Marnie the dog, but today we got some morning coffee."

Marnie's celebrity status keeps skyrocketing because dog lovers can't resist her penchant for costumes, her zany videos, and her playful social-media posts. Here's her profile description on Instagram:

> "Twelve-year-old NYC shih tzu adopted from a shelter as a senior lady. I ♥ walks & parties. H8 being alone. Adopt senior dogs 👍"

And her Facebook page lists these "personal interests":

> "Likes: watermelon, grass, smelling wood, eye contact, parties, fests, broccoli, eggs, walking in left circles, being held like a baby, meeting nice people & animals, and treats, treats, treats!"

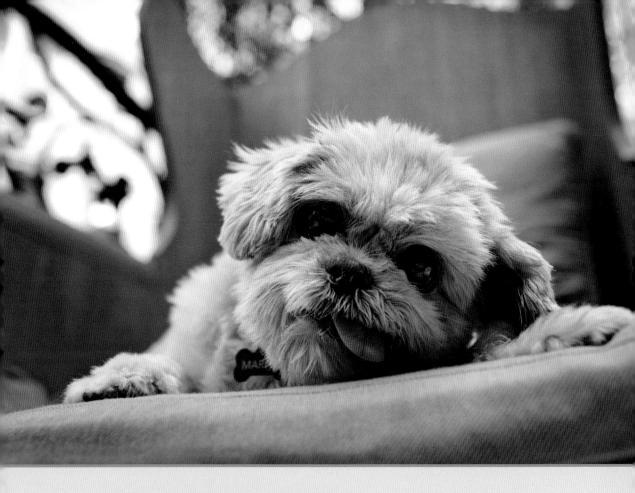

"Dislikes: walking on metal, rain, puddles, baths, blow dryers, dogs that bark at me."

The little dog's extensive digital pawprint reveals an undeniable truth: Marnie appears to have grown younger, not older, since Shirley adopted her. Marnie's left eye used to look cloudy and gray, but it cleared up. Her tan fur is so fluffy and flawlessly groomed that she looks almost unreal, like a toy or a teddy bear.

Marnie's fame on the internet also resulted in something Shirley never anticipated: contact with Marnie's previous owner. Two years after losing her dog, a Connecticut woman happened to stumble upon an image of Marnie hamming it up on Instagram. The woman froze: Could that be her dog? "She noticed that Marnie has a little benign cyst on her eyelid," Shirley said. "She looked through more photos, and then she called me and said, 'This might be strange, but…'"

Shirley received that emotional call in early November 2014. The woman was nothing but gracious and supportive about having Shirley keep the dog. They pieced together this

chronology: One day, when the former owner was eight months pregnant with twins, Marnie had been sunbathing in the backyard without her collar. "The gate was unlocked that day for some reason, and she had drifted away," Shirley said. "Marnie would never *run* away, but she could slowly *drift* away — I can see how that could happen. The woman said she was absolutely devastated and she was crying for a whole month. I can believe that, too — if I lost Marnie, I would cry for the rest of my life."

Circumstances became chaotic right before — and right after — Marnie's former owner gave birth to her twins. Now a mom of three with a busy life, she told Shirley she's thrilled to know what became of Marnie. "She's just really grateful that Marnie is alive and loved," Shirley explained. "This cleared up one of the greatest mysteries of the world: Where did this dog come from? But now I know!"

The phone call unveiled some other facts: Marnie is twelve years old, and as a puppy, she cost $1,700. "What a steal!" Shirley said of her once-stinky shelter dog.

So what's up with Marnie's adorable head tilt? Veterinarians told Shirley that Marnie likely had a brief brush with vestibular syndrome, a condition that can temporarily affect the brain and ear and impede balance. After speaking with the former owner, Shirley surmised that Marnie might have been afflicted with vestibular syndrome while she was out roaming the streets. "She's fine and happy now — but she just still has her head tilt!" Shirley said.

And about Marnie's tongue: She can, and does, keep it in her mouth sometimes — when it's cold outside, for instance. But it's just really, *really* long, and it used to hang out of Marnie's mouth even when she still had all her teeth.

Her tongue dominated the action when Lori and I met her on a crisp, sunny day in Manhattan. The sleepy little dog roused herself from a nap in Shirley's arms, where she had been cradled like a baby. Shirley carefully lowered Marnie to the sidewalk, and the pair began to stroll from bustling Chinatown into swanky SoHo — until Marnie stopped suddenly.

"This might take a while," Shirley cautioned as Marnie ran her tongue over her nose again and again. "She has to lick and lick and lick, and then finally she's all set." Minutes later, when her tongue and nose felt just right, Marnie led the way past SoHo's posh shops. The more she walked, the more she perked up and smiled. Locals and tourists alike gasped and cooed as she approached. Marnie didn't seem to notice much.

"When you adopt an older dog, the risks are a little bit higher because you know the days might be numbered," Shirley said as she ambled down the street behind Marnie. "But if anything, that makes you appreciate every day more.

"It's a really intense love that I have for her. I'm glad that I get to experience that love. Marnie is literally the best thing that's ever come into my life. No person has been as amazing as this dog."

REMY, 9

Elderly Nuns Rescue a Dog
"No One Is Going to Want"

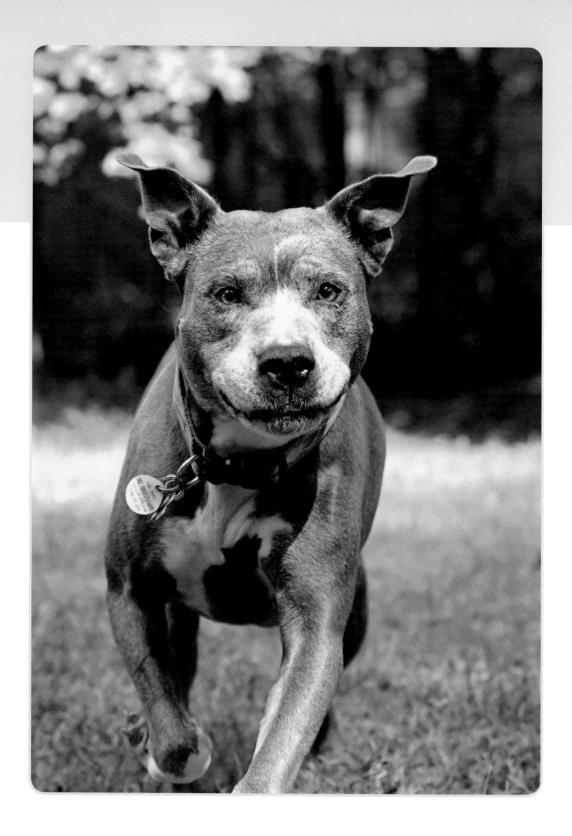

It's not every day that three women in their seventies and eighties walk into an animal shelter and tell the executive director they'd like to see a dog nobody wants.

But to Sisters Veronica Mendez, Virginia Johnson, and Alice Goldsmith, nuns from Sisters of Our Lady of Christian Doctrine in Nyack, New York, their request made perfect sense. Why not adopt one of the animals most in need?

That mind-set led them to Remy, a nine-year-old pit bull that had been overlooked by shelter visitors for more than three months. "As soon as I saw the sign that said Nine Years, I said, 'This is the one. No one is going to want this one,'" recalled Sister Veronica, a vivacious seventy-one-year-old with iron-colored hair and a no-nonsense demeanor.

The nuns' connection with the dog was immediate. Remy was docile. Remy was sweet. And when given a moment to mingle with the sisters at the shelter, Remy leaned her head into Sister Virginia's chest and sighed. "She just got right up there," said Sister Virginia, seventy-nine. "She said, 'This must be my new family.'"

 For the nuns, a four-legged addition to their small, no-frills convent could not come fast enough. They were grieving the loss of their dog Kate, a gregarious seven-year-old mutt who had been a boundless source of energy and comedy in their lives.

Kate had left them too quickly. On a Friday, she went on a four-mile walk with Sister Veronica. On Saturday, Kate's groomer spotted some unusual lumps. On Sunday, Kate was lethargic. A few days later, she was ailing so much from lymphoma that the veterinarian put her down. "She was healthy one day and then, all of a sudden, lymphoma?" Sister Veronica said. "I was furious. I was so angry. I cried! Oh, how we loved that creature."

The sisters rattled around their house crying for one week before they decisively hopped into their car. Their mission: rescue a shelter animal on death row. Minutes later, they explained their goal to West Artope, executive director of the Hi Tor Animal Care Center in Pomona, New York. West liked these women. He learned that Sister Alice was eighty-seven and that Sister Virginia, while statuesque and spunky, often needed

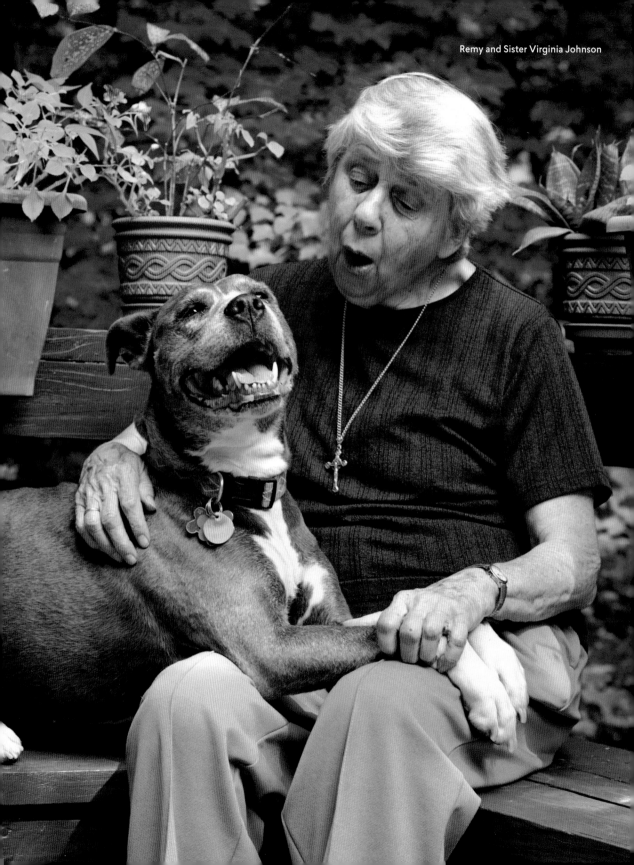

Remy and Sister Virginia Johnson

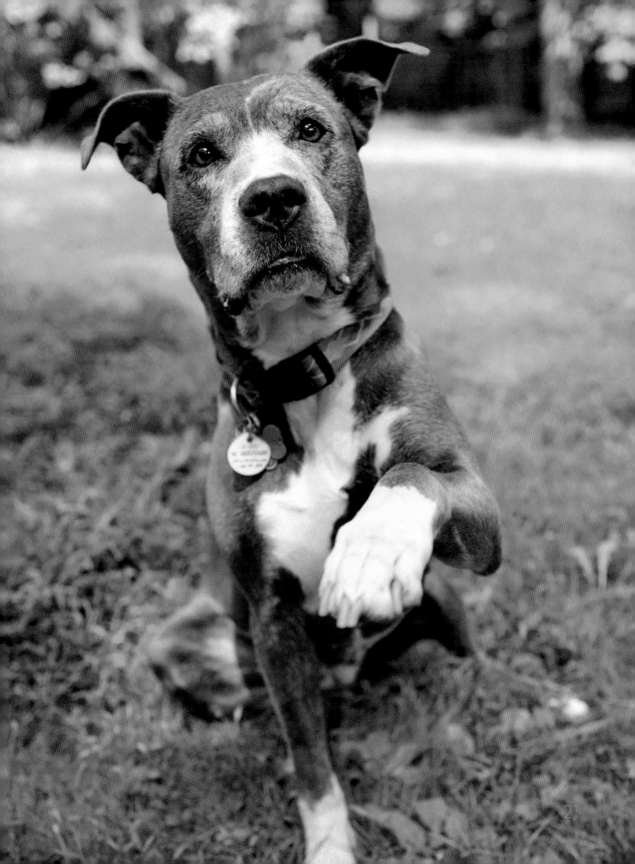

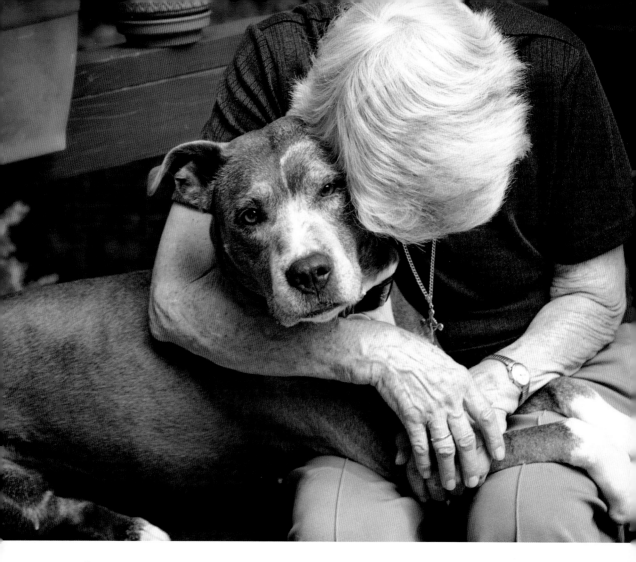

a walker to get around. His mind raced and made a hopeful connection: Remy. Calm, gentle, unadoptable Remy.

Bingo.

"It just worked out so well," West said. "We did a follow-up with them and went to the house, and the dog is so comfortable in that environment you wouldn't believe it. It was like a match made in heaven."

The nuns said they weren't concerned that Remy was a pit bull — they could tell how good-natured she was. And even though they were reeling from Kate's death, they decided not to dwell on Remy's age, either. "Our feeling was that she was in danger of being euthanized, and we wanted to give her the best three or four years she has left," Sister Veronica said. "Here we are, three senior sisters, so we adopted a senior pet!"

Between the three of them, Sisters Veronica, Virginia, and Alice have spent 179 years serving as nuns. Their main mission has been religious education for children and adults up and down the East Coast. "It's a great life," said Sister Virginia, a nun for sixty-two years. "I wouldn't change it."

They love living in Nyack because of Hook Mountain, the Hudson River, and other natural wonders that surround them. "It's the perfect place to pray because you stand here and see all of God's beauty," said Sister Alice, a serene woman of few words. Sister Veronica agreed; she likened looking at the mountain to "praying without realizing it."

Veronica loves having a dog to take along on contemplative walks and hikes. Remy also gets to romp in the tree-filled backyard, play with scads of toys, and luxuriate on soft dog beds in multiple rooms of her new, comfortable home. Remy quickly earned a nick-name — Thumper — because of the happy way her heavy tail goes *thump, thump, thump* whenever one of the nuns approaches her or rubs her stiff left hip.

Sister Virginia said Remy's contentment reminds her of foster kids she helped years ago as a social worker. When those children clicked with their adoptive parents, they showed an unmistakable sense of tranquillity and relief.

"Remy did that with us — she sensed, 'These are going to be my people. I can tell,'" Virginia said. "And we knew this was our dog. We could tell."

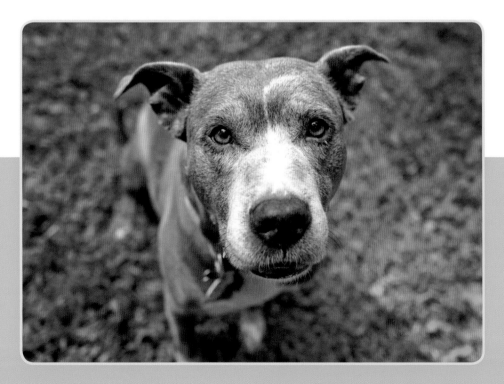

EINSTEIN, 10

When Einstein
Met George Clooney,
It Was Love at First Sniff

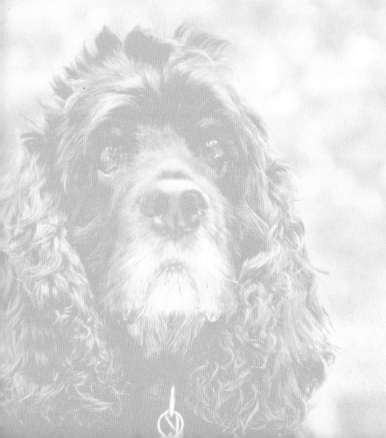

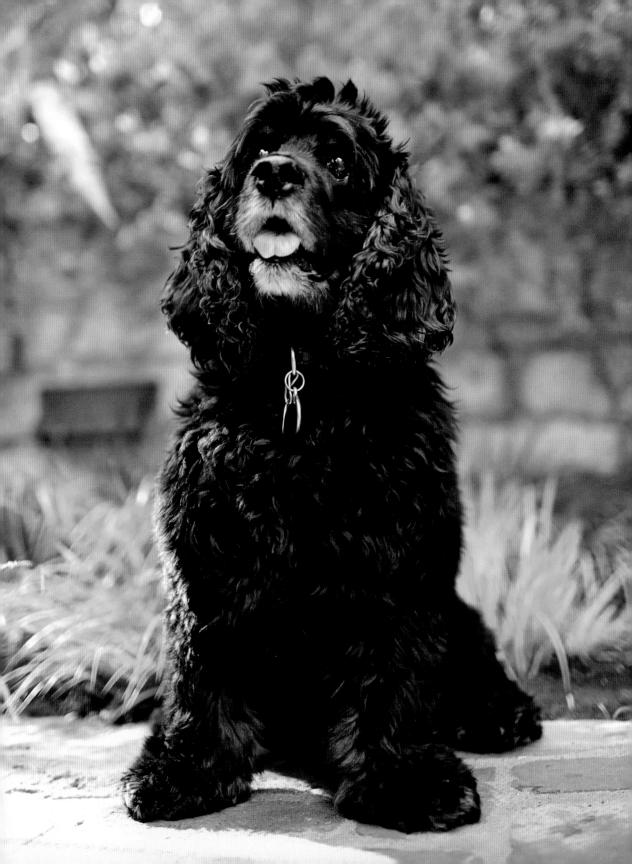

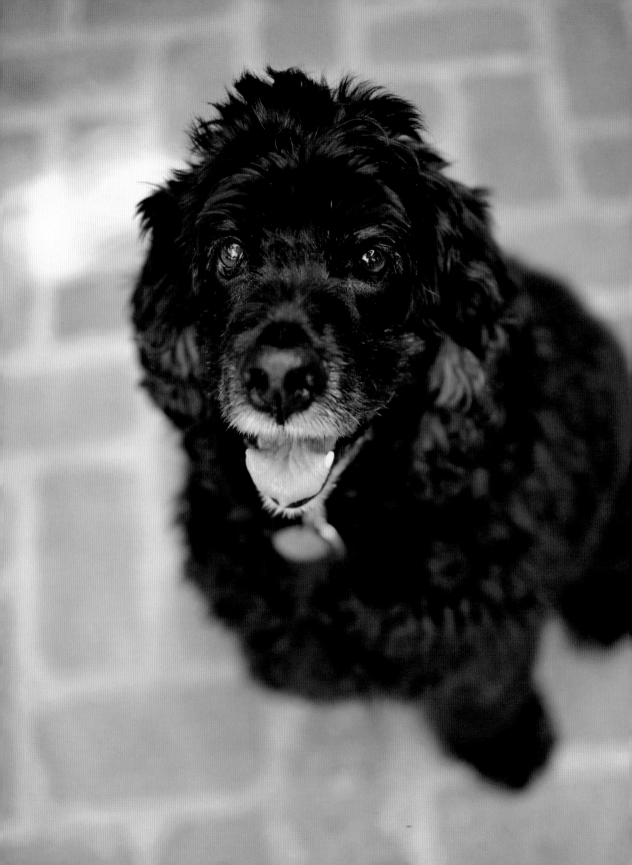

" Age doesn't matter. "
— George Clooney

A few years back, George Clooney decided he wanted a dog. As one of Hollywood's leading men, he could have *any* dog, be it a Westminster contender or an exotic breed from overseas — but that's not what happened at all.

Instead, George stumbled upon an online video of an older, upbeat dog with a sad past, and he swooned. The dog was Einstein, a black cocker spaniel with chronically dry eyes, a thyroid condition, and a fetching, worldly-wise smile.

Einstein's smile didn't always light up his face so effortlessly. When he showed up at a shelter in San Bernardino, California, he was an obese, unneutered stray. At the time, the shelter was so overwhelmed with incoming animals that two-thirds of them got put down within days. Einstein found himself in a crowded kennel, where a big chow mix barked and lunged at him. "His rolls of fat were shaking, and he was terrified, backed into a tight corner in the small kennel space," recalled Cathy Stanley, founder of the group Camp Cocker Rescue. "I knew I had to get him the heck out of there. No way was I leaving him behind."

We humans have much to learn from dogs, including this lesson from Einstein: when life becomes unbearable, maintain an open heart. People can be kind, and things can get better — much, much better.

Cathy and her pal Fran Muzio, the woman who fostered Einstein, spent eight months rehabilitating the dog and helping him lose nearly fifteen pounds — a hefty amount for a small, food-obsessed cocker spaniel. Thyroid medication and walks aided him with his weight loss, as did a strict diet of high-quality pet food topped off with chopped-up vegetables to help fill him up.

Then the women made a triumphant two-minute video showcasing the new Einstein. Set to Ray LaMontagne's soulful rendition of the song *To Love Somebody*, the video captured Einstein smiling and wiggle-wagging his tail nub with glee as people petted him. Shortly after Cathy shared the video online, would-be adopters finally started showing interest in the little black dog. One of them took the time to fill out Camp Cocker's seventy-question adoption application.

The applicant: George Clooney.

"Oh, that made me so nervous," said Cathy, who had spent years working as a personal assistant to a number of high-profile celebrities. In that time, she saw that some celebrities cherish their dogs and treat them like family members, while others get pets on impulse and don't provide the follow-through that dogs need. George Clooney's stellar adoption application did calm Cathy's concerns somewhat. She makes the application process hyperthorough to weed out impulsive adopters. "I got the impression that, on paper, this was going to be a great home for Einstein," Cathy said. "But I was still so worried."

Before long, the day arrived for a home-safety check at Casa Clooney in Los Angeles. Cathy and Fran packed up Einstein's food, veggies, thyroid pills, eye drops, and other gear and made their way to a luxurious, forested piece of real estate in Studio City. Einstein wiggled with anticipation.

When they got there, Cathy felt all her fears melt away. George spent at least ninety minutes with them and wanted to learn every known detail about Einstein. He sat on the floor for much of that time so he could get better acquainted with the squirming ball of friendliness.

Einstein tackled George, then sniffed and investigated all around the room. George had so many questions, and Fran and Cathy had so much information to share, that at one point, it took them a few minutes to realize Einstein had vanished.

"Ummm — where's Einstein?" Cathy asked. They all looked around quizzically.

"Hmmm," George said. "Let's go look."

They made their way through the quiet house toward the kitchen. That's when they heard some soft, determined rustling sounds. Inside the pantry was Einstein, pulling packages off the bottom shelf and trying to open them with his teeth.

Cathy stood there in shock. "Yeah, sooooo, Einstein's a foodie," she said sheepishly.

"Oh, that's okay," George said. "We'll just have to remember to keep the pantry door shut!" At that moment, Cathy knew Einstein would be just fine.

"A lot of people would say, 'Oh, this dog has no manners. I don't know about this.' But he was all, 'No big deal. We'll just have to keep the pantry door closed!'" Cathy said. "He was just so great about it. But still: Oh. My. God. I was *so* embarrassed!"

Cathy and Fran weren't the only nervous humans on the day of the home-safety check. George had jitters of his own. From the start, it was clear that this Camp Cocker outfit meant business. After everything Einstein had been through, this little dog needed to end up in a good home where he'd be valued and loved. Period.

In an interview published in the January 2012 issue of *Esquire*, George recounted his side of the story. He remembered Cathy of Camp Cocker telling him, "We'll bring him to your house, but if he doesn't like you, he can't stay."

"I have this really long driveway, and I open the gate for them, and I start to panic that Einstein is not going to like me," George said at the time. "So I run into the kitchen, where

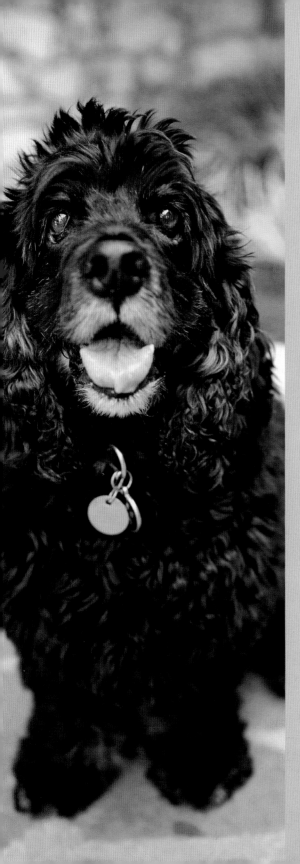

I have these turkey meatballs, and I rub them all over my shoes.

"This woman opens the door, and who knew Einstein was such a food whore on top of everything? He throws himself at my feet. She says, 'I've never seen him react like that, ever!'…

"Forever, now, he just thinks of me as the guy with meatball feet. He loves me. I can do no wrong. He follows me every-where."

So why did George Clooney, a legend-ary actor and filmmaker who's been nomi-nated for Academy Awards in six different categories, want an older dog who'd been sprung from a shelter?

For one thing, it felt like the right thing to do. And on a practical level, another benefit beckoned: unlike a puppy, Einstein already had his bathroom routine all sorted out. "He was house-trained and had a great attitude," George told Lori and me. "Age doesn't matter."

Now ten, Einstein travels on private jets all over the place: to most of George's movie sets; to his oceanfront home in Los Cabos on the southern tip of Mexico's Baja Peninsula; to his newest investment, a nine-bedroom, seventeenth-century man-sion on the river Thames in England; and to his beloved villa on Lake Como in Italy, where lunches last two hours and dinners start at nine and end at midnight or one. ("Einstein has grown to love Italian food," George said wryly.) When George has to stay in hotels, he opts for pet-friendly digs so Einstein can stay by his side.

At home base in Los Angeles, Ein-stein roams with familiar ease around a

7,350-square-foot house once owned by Clark Gable. On the day of our photo shoot at George's house, Einstein was eager to get started. He took the briefest of moments to get his bearings at a spot where the lighting was nice, near the property's dual-purpose tennis and basketball court. Then he began the session by swan-diving — and almost disappearing — inside Lori's camera bag. (Of course he did. There were treats in there!)

It quickly became apparent that Einstein would do almost *anything* for treats. He sat, lay down, trotted toward the camera, and posed on stairs like a good boy. And he drooled.

As George told us, Einstein has "a beautiful life." The dog never fails to appreciate the time he gets to spend with George and his beautiful new wife, human-rights lawyer Amal Clooney. At mealtimes, as the couple discuss the fate of the Elgin Marbles, the use of drones in counterterrorism operations, and turmoil in Sudan and Syria, Einstein stares up at them with adoring optimism.

How could he not? Somebody might drop food.

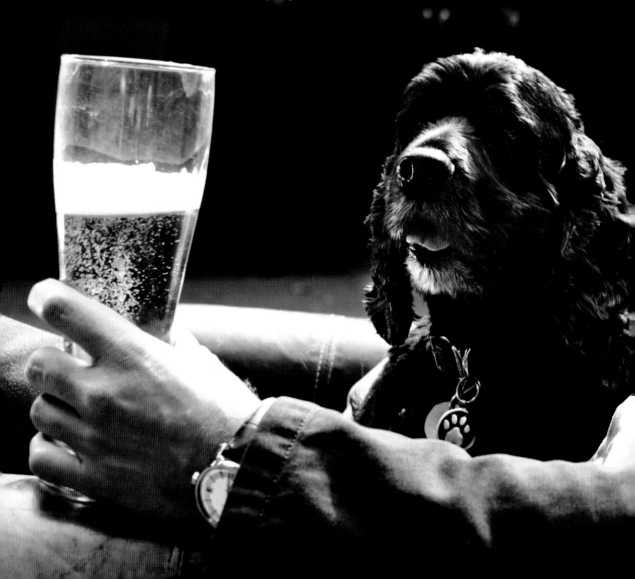

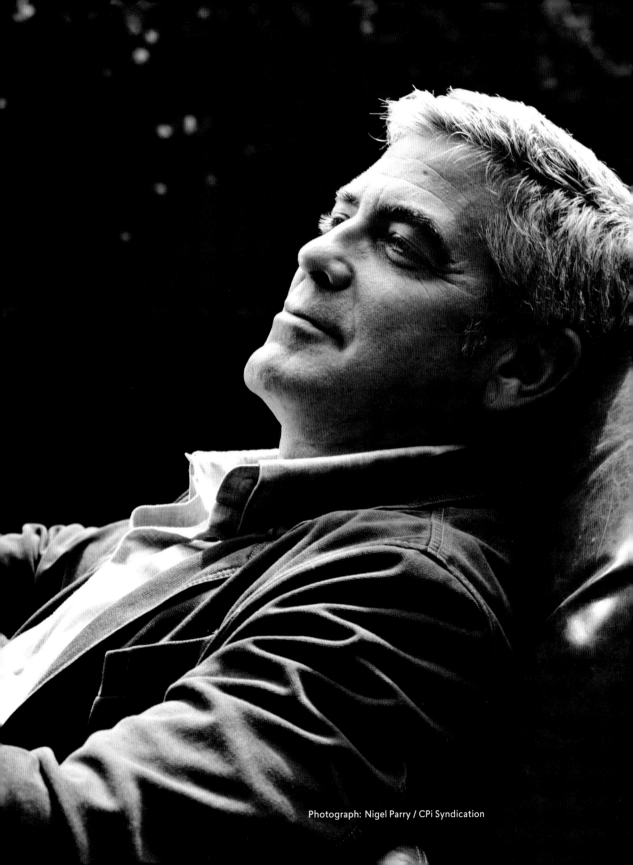

BOOMER, 10

A Big, Beautiful Girl
Belongs to David Rosenfelt's
Happy Pack of
Rescued Seniors

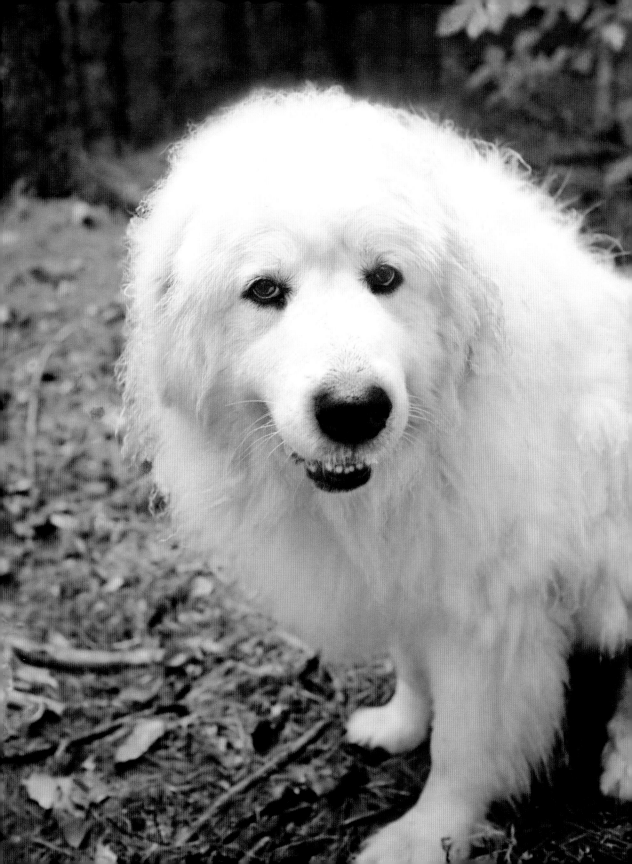

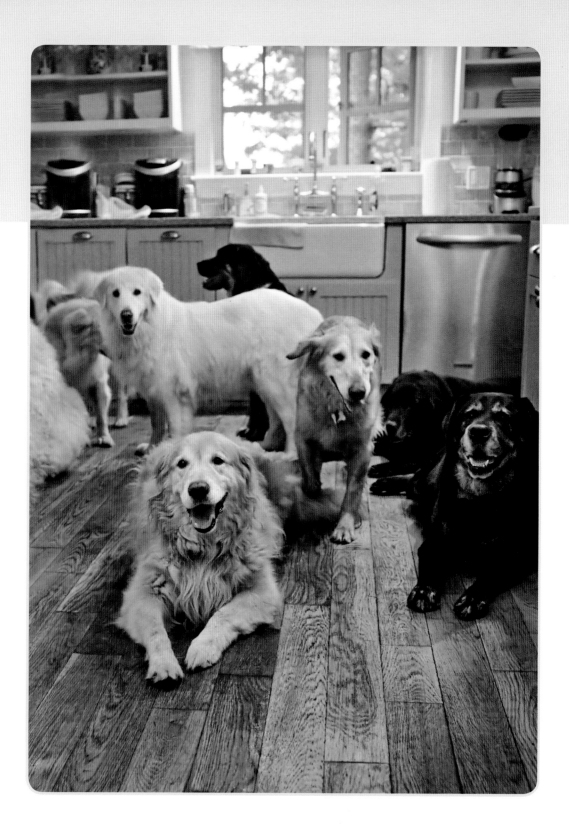

Dog heaven does exist. It's just outside Damariscotta, Maine.

To get there, you drive down a long, winding road past rolling green hills and stands of alder trees, dogwoods, oaks, and pines. Next, you meander down two dirt roads, then follow an unpaved driveway to a spacious log-cabin home with gray beams and blue trim. Note the quiet beauty of the property's ten wooded acres on a lake — then listen for the barking.

You have arrived.

Mystery novelist David Rosenfelt and his wife, retired media executive Debbie Myers, joke that living here is like waking up every morning in a Folgers commercial. Just don't be shocked to find your clothes festooned with fur as you sip your cup of joe: David and Debbie share their home with *lots* of large, old, happy dogs who all got adopted from rescue groups or shelters. The largest number of dogs they've housed at any one time was forty-two; as of this writing, they live with twenty-one.

"When you have two dogs, getting a third is a big deal," explained David. "But when you have twenty-six and you get a call saying that a golden retriever is going to be put down at three o'clock, you take a twenty-seventh."

Debbie and David first became heavily involved in dog rescue in the mid-1990s when they were living in Southern California. Back then, they established the Tara Foundation, a rescue organization named after their first golden retriever, whom they've officially dubbed "The Greatest Dog in the History of the World." (Tara's legacy also lives on in another way: She's an ever-present star in David's Andy Carpenter mysteries. In more than a dozen novels, Andy solves cases with his trusty golden retriever, Tara, by his side.)

Through the Tara Foundation, David and Debbie helped find homes for more than four thousand dogs who had been facing the end at crowded animal shelters. They tended to gravitate toward large dogs because they knew the bigger ones had a tougher time making it out of the shelters. Whenever rescued dogs were too old or too sick to

get adopted by anybody else, they'd end up going home with David and Debbie.

And so it came to pass that the couple had twenty-five mostly geriatric — and mostly large — dogs living with them in Orange County when the time came for them to move to the spot in Maine where they had long planned to retire.

How exactly do you relocate so many older dogs with an array of medical needs from one corner of the United States to the other? Well, a move like that takes planning. *Lots* of planning. So much so that "it made the D-day invasion look like a spur-of-the-moment decision," David wrote in *Dogtripping*, his 2013 book about their epic cross-country trek with eleven volunteers and twenty-five rescue dogs in three RVs.

"If you ask any of the other ten people who were on the trip, they would literally tell you it was the greatest adventure of their lives. They were having *so* much fun — but I just hated it!" David recalled, doing his best impression of a curmudgeon. "I hated it because everything we did was so complicated. You can't just stop and walk the dogs on the highway; we had to bring two hundred feet of plastic fencing and set up a dog park everywhere we went. *Everything* was a hassle."

As curmudgeons go, David is of the crème brûlée variety — crusty on the outside, but sweet and mushy on the inside. Debbie, a no-nonsense, get-things-done business-woman, is a big softy, too: she once rushed out of a theatrical production of *War Horse* in tears because she couldn't handle the mistreatment of a fake metal horse on stage. "I couldn't take it!" said Debbie, laughing as she tried to defend herself from David's ribbing.

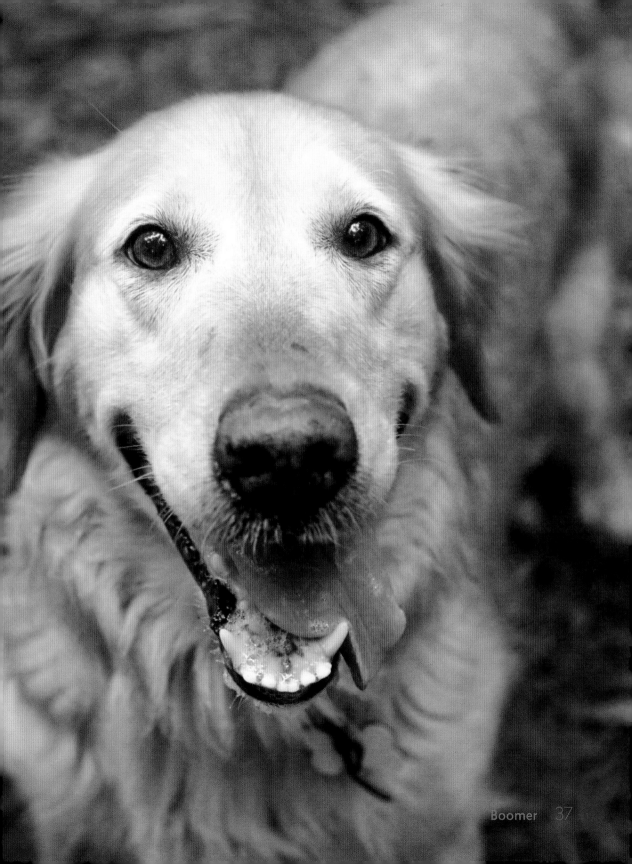

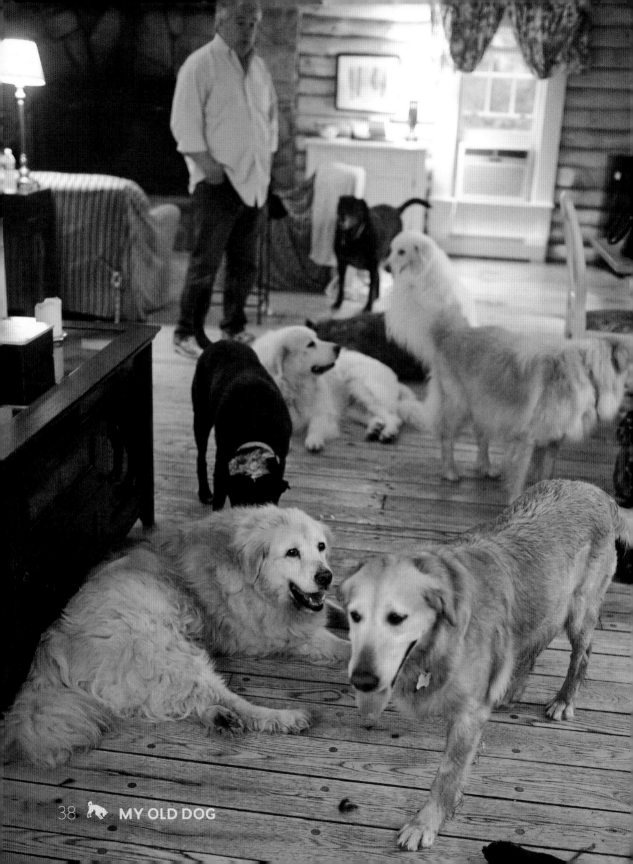

For years now, Debbie and David have spent nearly one thousand dollars a month on dog food and thirty thousand dollars a year on vet bills, and it doesn't faze them to administer about sixty pills a day to dogs with arthritis, epilepsy, and other ailments.

"It takes really special people to adopt elderly dogs, and it takes really, *really* special people to adopt elderly big dogs," said Cindy Spodek Dickey, one of the volunteers who helped on the five-day trip from California to Maine in September 2011.

David and Debbie remain astonished that so many volunteers took vacation time and put their lives on hold to help drive dog-filled RVs more than three thousand miles. What's even more astonishing to them is that the majority of the volunteers were relative strangers to them before the trip. Cindy and Debbie had been friends for many years, but most of the human participants were people from Virginia, Georgia, and other far-flung places, who love David's mystery novels and also love dogs.

"These were readers that I didn't know or that I had met once," David said. "They all flew into California to do this. These people were amazing. This was not an easy trip."

Cindy described the "Woofabago 2011" journey as a "peak life experience" that was made all the more special by the presence of so many happy pooches. "Those dogs! They'd have these huge smiles on their faces," said Cindy, who lives in the Seattle area. "You rarely get to experience love and joy like that."

Now settled and comfortable in Maine, all twenty-one of Debbie and David's dogs have stories to tell. Nine made the "Woofabago" journey. Among them were Wanda, a gentle 180-pound mastiff who was skin and bones when she first came to live with David and Debbie; Bernie, a huggable 120-pound Bernese mountain dog; Mamie, a golden retriever–chow mix lovingly described by David as "the most obnoxious dog in the world"; and Bumper, a fourteen-year-old golden retriever who was given up by his original owners years ago because of his intense epileptic seizures. (Good news, though: Bumper hasn't had a seizure for seven years now.)

The other twelve dogs joined the family after David and Debbie's move to Maine. There's Gabby, a petite golden retriever who loves to run with great bursts of energy now that she's done with her cancer treatments; Dorothy, a chocolate-colored fluff ball who lies contentedly on the floor as other dogs frolic around her; and Boomer, a gorgeous all-white Great Pyrenees with dark, smiling eyes.

Boomer came to live with Debbie and David in the summer of 2013 along with her equally stunning sister, Cheyenne. The couple adopted the fluffy white siblings through Rescue Me–Purebred K9 Rescue in central New York. Geri Spencer, Rescue Me's former foster coordinator, still remembers the call she received from the dogs' original owner. "She lived up north in the Adirondacks, and she had come into hard times," Geri said. "She had an injury — a back problem — and because she was disabled, she just couldn't handle these dogs anymore."

Boomer and Cheyenne needed grooming — their fur was very matted — but they were happy, well-adjusted dogs who clearly had received lots of love. The only problem: How to find a home for two inseparable eighty-five-pound sisters who were closing in on eight years of age?

The moment Debbie and David learned of the dogs, they didn't hesitate. David drove sixteen hours round-trip to Utica, New York, to get them. Then the couple puzzled over how to groom them. "It would have been painful for them to be brushed out," David recalled. "It was summertime, so we shaved them. The groomer left full hair on their heads and faces, so with the rest of their bodies shaved, they looked like twin Q-tips."

Cheyenne died of cancer about a year later, but Boomer is still relishing her time with her big, happy pack. The Maine house is much more calming than you might expect with so many dogs milling about. Still, it's a study in controlled chaos. Wanda the mastiff and Bernie the Bernese mountain dog love to stand, sit, or sprawl on the sturdy wooden coffee table in the living room, while other dogs prefer to drape themselves luxuriously on attractively slipcovered soft furniture. Boomer takes in all the activity with a bemused smile on her face.

Remarkably, the house doesn't smell like dog at all, and every detail about it is geared toward the dogs' comfort. They can come and go as they please through a massive doggy door and explore acres of fully fenced wooded wonderland.

On the rainy afternoon when we visited, though, most of the dogs wanted to stay

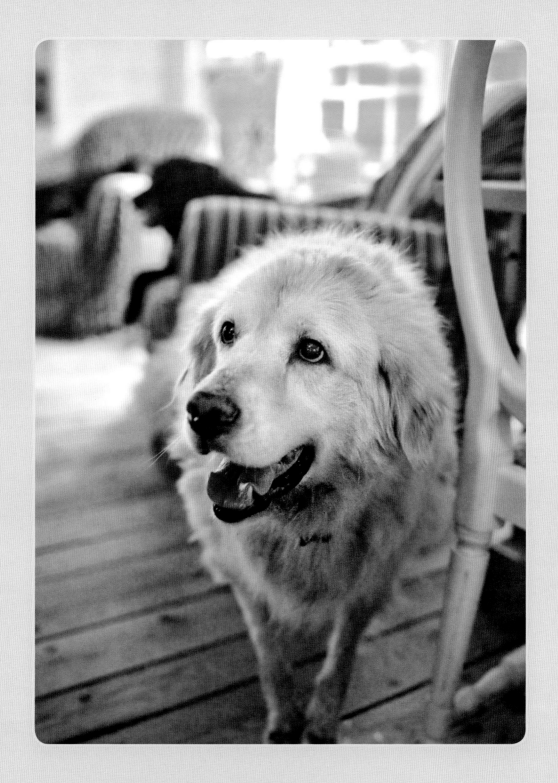

warm and dry inside the house — and some had accidents on the resilient hard-wood floors. While standing fully upright in the kitchen, Mamie got riled up and started barking and pooping simultaneously. "Mamie! You're just doing that be-cause we have company!" Debbie said as she deftly picked up the deposits with a rapid-fire, one-handed, plastic-bag technique before cleaning the floor.

About forty-five minutes later, Bumper — the golden retriever once plagued by epileptic seizures — roused himself from peaceful slumber on the floor. He slowly stood up, locked eyes with David, smiled, and peed. With the speed and tact of a skilled maître d' at an exclusive restaurant, David immediately wet a red towel and sopped up the urine. "We don't get mad at him if he can't make it all the way outside anymore," he said.

David and Debbie take pains to preserve their dogs' dignity. Yes, Bumper is old and has accidents — but he's still eating well, and he's still loving life. That means he'll keep right on receiving top-notch kindness and care.

That's not to say the couple don't know when to let go. Over the years, they've said good-bye to nearly three hundred dogs who were their beloved pets — most frequently in veterinarians' offices.

"[This] means that we have decided on the appropriate time for their lives to end," David wrote in *Dogtripping*. "It is an awful decision to have to make."

They said it never, ever gets easier, but they've cultivated a viewpoint that has given them comfort. "What we needed to focus on was that for whatever time we had [a dog], he or she was safe and happy and loved," David said. "That was all we could do, and it would have to be good enough, or we'd go insane. I say this knowing full well that most people would look at our life with dogs and decide that we've already opted for the 'go insane' route."

Debbie and David's friend Cindy Spodek Dickey summed up the couple's efforts this way: "Every living thing deserves a wonderful life. The world's a better place because of people like David and Debbie."

Charlton Heston Adopted a Homeless Senior

Years ago while running the Tara Foundation in Southern California, David Rosenfelt and Debbie Myers faced the challenge of finding a home for a fourteen-year-old chow mix named Willie. Debbie placed a clever ad in the *Los Angeles Times* with the headline "Tell Them Willie Boy Is Here." The ad prompted a call from a prospective adopter with a powerful voice who identified himself as "Chuck Heston." Yes, *that* Charlton Heston brought Willie Boy home. The legendary actor also donated ten thousand dollars to the Tara Foundation.

AKILA, 15

Call of the Wild: Couple Feel
an Irresistible Pull to Help
a Feral Dog

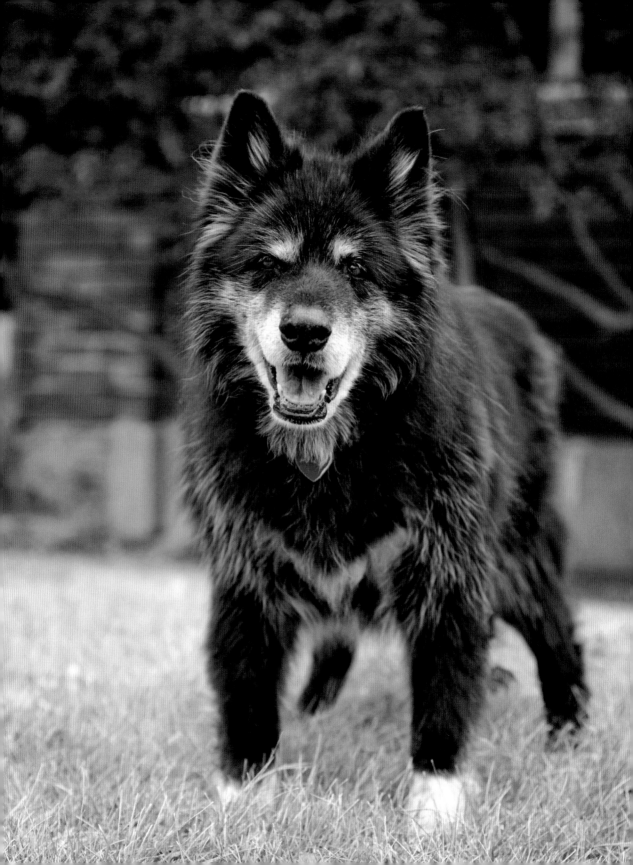

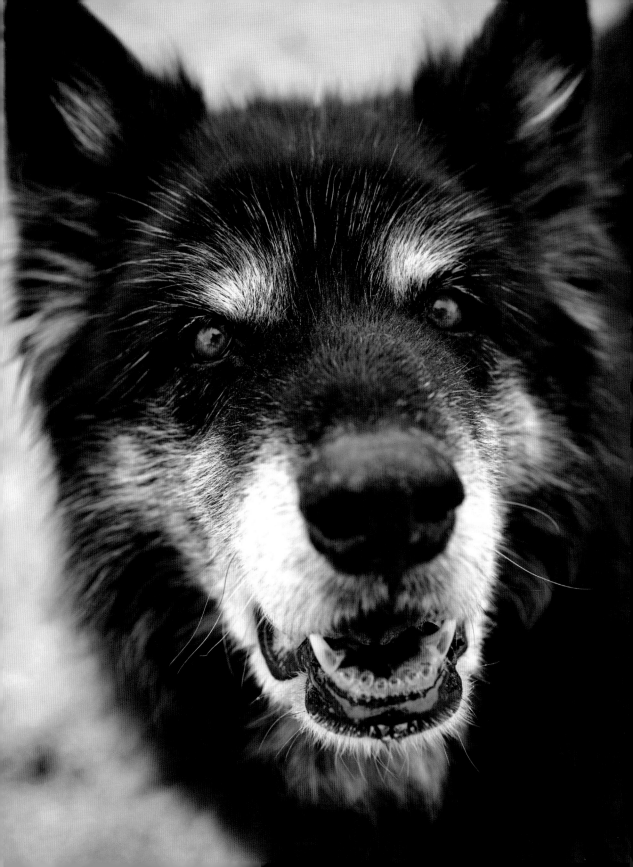

> *"I was walking along looking for somebody, and then suddenly I wasn't anymore."*
> — A. A. Milne

What if you could bring home the most strikingly beautiful dog you've ever seen — but the dog wouldn't let you touch her? Would you do it?

In March 2011, Bret and Stacey Chappell faced that decision. The Salt Lake City couple were both so beguiled by a haunting photo of a feral dog named Akila that they just had to meet her. They piled into their Honda CR-V and drove seven hours to the Best Friends Animal Sanctuary in Kanab, Utah.

Sanctuary workers led Stacey and Bret to a quiet room and outlined some ground rules for their first Akila encounter: No direct eye contact. No sudden movements. No loud voices.

Minutes later, the monstrously fluffy eleven-year-old dog entered the room. Bret gasped. "I'd never seen anything so wolfy in my lifetime," he recalled. "She circled the room and looked at us and looked at us. I loved her from the beginning."

Akila, a special girl with a host of special needs, had the good fortune to look a lot like Jessie, the Chappells' former dog. Jessie — a fluffy, snuggly border collie–husky mix with an outgoing personality — left Bret and Stacey bereft when she died in January 2011.

A couple of months later, Stacey was paging through her copy of *Best Friends* magazine. Akila's glowing, golden-brown eyes stared at her knowingly from the "special adoptables" page.

"Oh, honey," Stacey said. "Look at this dog!"

"Stacey," Bret replied in his most reasonable voice. "We can't get another dog. We just can't."

"I know, I know. But — *wow.* Look at her!"

"No. No way. We are not getting a third dog. Nope."

"Okay, I know."

The next day, they both went to work. Bret, a purchasing manager for the University of Utah's Huntsman Cancer Institute, had a tiny bit of downtime at the office. He hopped

online and visited the Best Friends website. He couldn't help himself; Akila hadn't left his mind all day long.

Bret stunned his wife, a fourth-grade teacher, with this midday email message: "I've emailed them to see what, if any, issues there might be with her health and how to get the adoption process started. She looks awfully sweet. Maybe we'll have to take a little weekend Kanab trip soon."

Four minutes later, Stacey replied, "*Oh my God!!!* Let me know ASAP."

🐕 Situated on 20,700 acres at Angel Canyon in southern Utah's majestic red-rock country, the Best Friends sanctuary is a safe haven for nearly two thousand dogs, cats, horses, burros, birds, rabbits, goats, sheep, pigs, and other critters. Most animals there are well adjusted and adoptable, but some have such serious behavioral or health issues that they must live out their entire lives at the sanctuary. For years, Akila seemed like one of them.

She was a five-month-old puppy in November 1999 when she came to Best Friends from a wolf sanctuary in Colorado. Her caregivers there had determined that she was not a wolf, but a dog — but by that time, she had missed a key window of opportunity for socialization. In essence, she had become a feral, or wild, animal.

Admissions workers at Best Friends Animal Sanctuary decided Akila would be happiest in "the lodges," an area where dogs with special needs get dog runs to themselves and plenty of personal space. Before long, though, they noticed Akila gravitating toward Chow Baby, a large chow chow who could be aggressive with humans. Chow Baby and Akila hit it off. They grew so close that they shared a dog run together for a decade.

"Akila was so shy, and so afraid, that she'd get a lot of her courage from the other dogs," recalled Terry

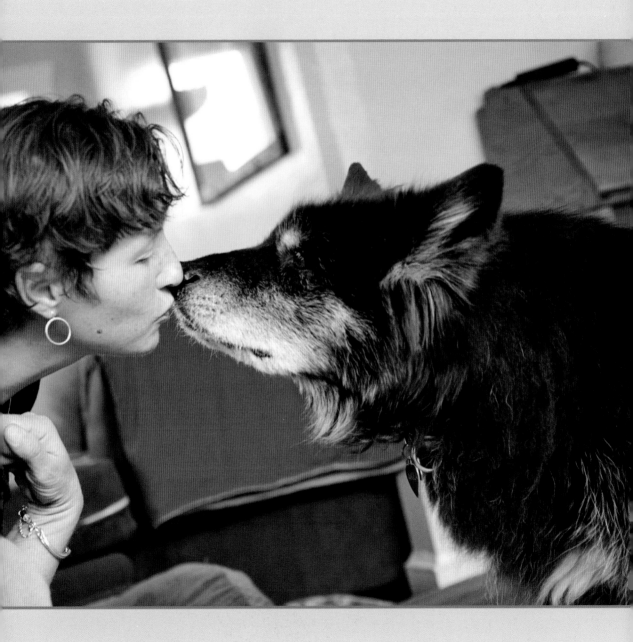

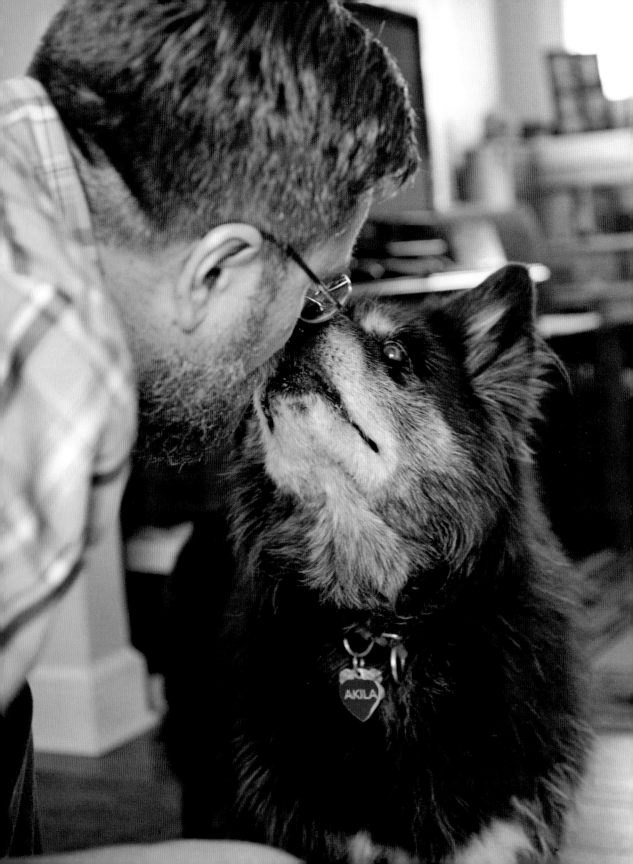

Tate, a longtime dog caregiver at the sanctuary. "She relied on Chow Baby to buffer her, and she gained confidence through him."

Over time, as Akila aged, her human caregivers discerned a conflict brewing within her. "She really wanted to be around people — she was so willing — but she had trust issues," Terry explained. "She was always on guard, always a little apprehensive about what was going on around her — but she wanted more. It was hard for her."

Sanctuary staffers had some success touching Akila when they groomed her or gave her medical care. They started wondering: Could this eleven-year-old dog be helped to live out her final years in the comfort of an actual home? They decided to feature her in *Best Friends* magazine and see whether the right people might come along. Within days, Bret wrote his earnest email message about how much he and Stacey wanted to give Akila a chance.

"We could tell right away that these were people who would accept Akila just as she is," Terry said. "It's all about patience and acceptance — that's what these shy guys need, and that's what we saw in this couple. We all looked at each other and said, 'Mmm-hmm.'"

Today, Akila is a fifteen-year-old indoor dog who loves her soft dog beds, predictable mealtimes, and regular walks. She also adores her doggy siblings, a blue heeler named Blanche and a big brown mutt named Jack. But when Stacey and Bret first brought her home in 2011, they thought they might never attain this state of blissful normalcy.

Their first big challenge: the seven-hour drive back to Salt Lake City with Akila and their two other dogs. Terrified, Akila urinated and vomited more than once inside the Honda CR-V. Stopping at rest stops was a logistical nightmare because of the risk that Akila would run away. When Bret and Stacey did stop, tourists gawked and asked questions about the wild-looking animal on the end of a double leash. "Oh my God, is that a wolf you got there?" one man asked. Bret and Stacey didn't know how to respond.

Then came the challenge of what to do with Akila once they got home. She desperately wanted to be outside in the backyard — but she'd spend much of her time there howling pitifully. "Oh, she was sad — she was scared and sad," Stacey said. "The first two weeks she was here, she howled all night long. So we'd be out there in the snow in bare feet, and my husband in his boxers, trying to leash up this howling dog and get her inside. We had to put up a dog gate so she wouldn't go back outside the dog door."

But the most pervasive challenge was Akila's aversion to being touched. As Stacey put it: "Do you have *any idea* how hard it is to bring a dog home and not be able to touch it?" Stacey gave the matter a lot of thought, and before long, she hatched a plan. The plan involved chicken.

"Akila's very fluffy, so someone had to groom her," Stacey explained. "I'd lay out a special red blanket with a brush and pieces of chicken. Then I'd take her on her leash, take her to the blanket, and brush her. Every time I cleaned out the brush, she knew she'd get chicken.

"Pretty soon, she showed signs that she liked the grooming. She'd usually relax into it, lean into it, lean into my hand. She really liked to have her ears scratched. I could pet her and even kiss her — but just when she was on her leash. The second she was off-leash, there was no more touching or kissing."

Stacey kept up the regular grooming sessions, though, and Akila kept gobbling up the chicken and the positive reinforcement. As months passed, she began to follow Stacey around the house — very, very slowly. She even started to approach Stacey to seek out quick, reassuring scratches on her head or behind her ears.

But Bret was a different story. He made Akila so nervous that she would make high-pitched squealing sounds if he walked too close to her in the house. Sometimes it was mildly humorous — but much of the time, it hurt his feelings.

"At first, it was hard, I'll admit it," Bret said. "I was so used to Jessie [the couple's former dog] — and I could get down on the floor with Jessie and spoon her. I *love* that about dogs — the affection that you get from them. So, yeah, it was hard, and there were moments where it was frustrating, even.

"But then I started to realize that Akila was more giving of herself when I didn't try so hard, if that makes sense. If I didn't try to touch her, she'd approach a little bit more, and her affection would increase — albeit slightly."

Then, on August 28, 2014 — nearly three and a half years after bringing Akila home — Bret had a breakthrough. As Akila relaxed on her dog bed in the living room, he felt inspired. He stood directly in front of her so she wouldn't be startled, and he reached down and scratched the top of her head.

Akila didn't squeal. She didn't resist. Instead, she relished the affectionate scratches — just like any dog would.

"Stacey, come in here!" Bret said urgently. Stacey walked into the room, then froze in place. She almost dropped the toothbrush she had in her hand.

"I was like, '*Oh…my…God…*,'" Stacey recalled. "She was leaning her head into his hand, and she was liking it. After three and a half years? I couldn't believe it!"

🐕 Is Akila part wolf? Stacey and Bret just don't know. They were so curious about it that they even had a DNA test done years ago. The results: one-half malamute; one-quarter borzoi, a dog bred in Russia to hunt wolves; and one-quarter unknown.

At this point, the Chappells no longer care what Akila is. All they know is that they love her fiercely.

"Since we got her as an older dog, it worried me for years that if we had to put her down, we wouldn't be able to touch her and comfort her because touching her would scare her too much," Stacey said. "Now I think we'd be able to comfort her."

Bret said he never imagined how much he and Stacey would learn from Akila. "I know

for a fact that she's made both of us better people," he said. "It was a growing experience for me because really, I'm not the most patient of people. Akila has made me extraordinarily patient with all of our dogs, and with life in general.

"We sometimes pat ourselves on the back about how far Akila has come. But if she could bend her paws that way, she should be patting herself on the back about how much she's helped us and how far we've come!"

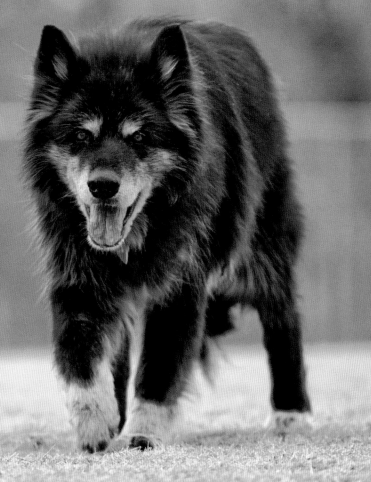

PART 2

Healing

STACIE, 10

Old Dog Haven:
A Network of Safe Houses
for Homeless Senior Dogs

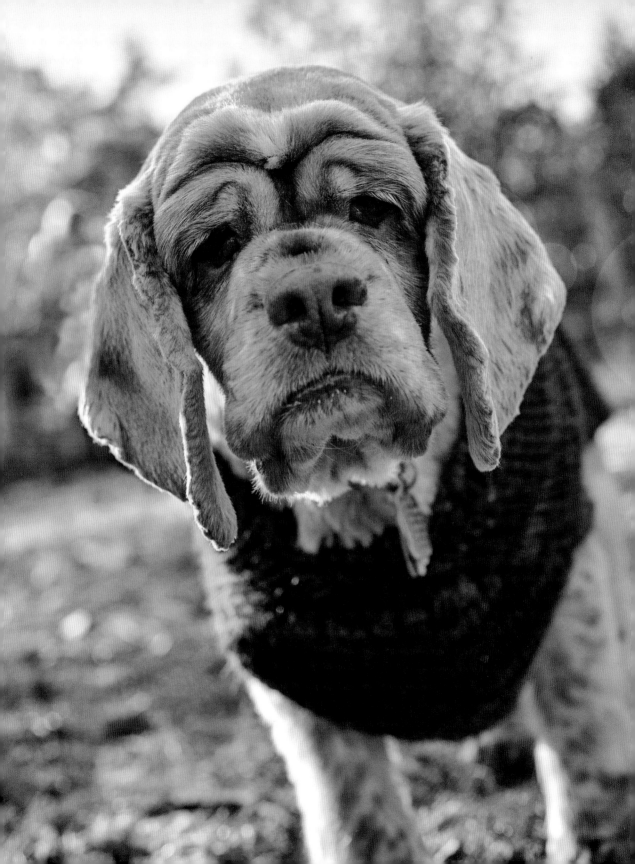

> **"** It amazes me that so many people are willing to do this. It warms my heart.**"**
> — Old Dog Haven cofounder Judith Piper

As you leave Seattle and drive north to Judith and Lee Piper's home, urban madness gives way to bucolic bliss. Tractors and shabby-chic barns dot pristine farmlands; the Cascade Mountains' snowy peaks hover nearby like attentive caretakers.

The Pipers' five acres of open pastures and evergreen trees blend right into their surroundings in Arlington, Washington, but a handmade gift at their front gate might give you pause. It's a concrete sculpture shaped like a dog bone and engraved with the words "You loved us when others would not."

No bone has ever shared a truer statement. For more than a decade, Judith and Lee have been masterminding a system to spare hundreds of older dogs from euthanasia. It's a system that's elegantly simple, but it calls for diplomatic finesse, team-building skills, and the time investment it might take to launch a tech startup.

Judith and Lee run Old Dog Haven, the largest senior-dog rescue group of its kind in the United States. The nonprofit works closely with most of the shelters in western Washington State to help them find adopters for dogs over age eight.

If dogs are too old or frail for adoption, Old Dog Haven places them in permanent foster homes and covers the cost of all their medical care. Thanks to a network of about 140 volunteer households, the group provides these "final refuge" foster homes to about 250 dogs at any time. Foster families get to care for calm, content pets — sometimes for several years — without ever having to worry about a single vet bill, and the dogs get to spend the rest of their days as part of a family.

"It can be very expensive to take care of an old dog — not always, but a lot of the time — so the idea is that we pay for all the vet visits to make this financially possible for people who are willing to do this," Judith explained. "Our vet bills average about forty thousand dollars a month. Fortunately, we're able to afford that — our donors are just fantastic."

Lee and Judith used to describe what they and other Old Dog Haven volunteers did as hospice work. They've since rephrased that for the sake of accuracy. "Now I call it

'assisted living,'" Judith said. "Most dogs stay with us for about a year, but some last six or seven years, and a lot stay for four…. And these dogs are just great at this age. They're *so easy*. It's fun to take them in! They are so happy to be with you, and they ask for so little."

That's not to say that Old Dog Haven doesn't encounter true hospice cases. The group doesn't have a formal facility, but Judith and Lee have a kennel license to care for fifteen dogs at their home — and they often take in the neediest seniors of all. Some dogs last mere days, but many of these assisted-living residents thrive for several years. All the exercise they get helps keep them young. "They need to move," Judith said. "If you keep them moving and you do joint supplements and you do a good diet, it's amazing how well they can do."

On one crisp winter day, dogs poured out of Lee and Judith's house for their midday ritual: "pasture playtime." Energized by the bright blue skies and the ice crusting the grass, schnauzers, Labs, springer mixes, shih tzus, cocker spaniels, and dachshunds wore goofy grins as they tore around the field. "Wow, the cold has brought Lois's personality just completely out," Judith said of a little Lhasa apso–shih tzu mix who ran with abandon. "She's just — gone!"

Tucker, Sue, Logan, Jerome, Gladys, Norma, Lola, and others pranced around the pasture pretty much like dogs of any age. One big old guy — Seymour, a black Lab who has a hard time staying up on his feet for very long — didn't join in the romp session, but he still enjoyed himself. "Oh good, Seymour's found a good spot," Lee observed. "He's lying on the doormat up against the house, right in the sun."

And then there was Stacie. The tan cocker spaniel had a grand old time in the pasture, too; she liked to check in with Judith often, just so she could smile up at her (and model her handmade sweater). Here is Stacie's story in Judith's words:

"Stacie was surrendered to the Everett Animal Shelter by owners who said they'd gotten her 'off Craigslist' and couldn't get her housebroken; it was ruining the carpet in the new house. A few hours later, I was at the shelter picking up another cocker and saw her. I knew instantly that she was very sick. After ten years of working with sick old dogs, I can tell the body posture and facial expression!

"I asked if the shelter vet would look at her immediately; they found nasty diarrhea. I picked her up the next morning. She leaned against me in the van, and my heart melted. We went right to my vet, who recommended an abdominal ultrasound. Amazingly, the radiologist was able to come out the next morning and emerged with instructions to get her to surgery right away. He thought she had an overdistended gallbladder that hadn't yet ruptured but was very invasive. Again amazingly, the emergency hospital called in their best soft-tissue surgeon, who started surgery at 6:00 PM. He removed the gallbladder, but it had adhered

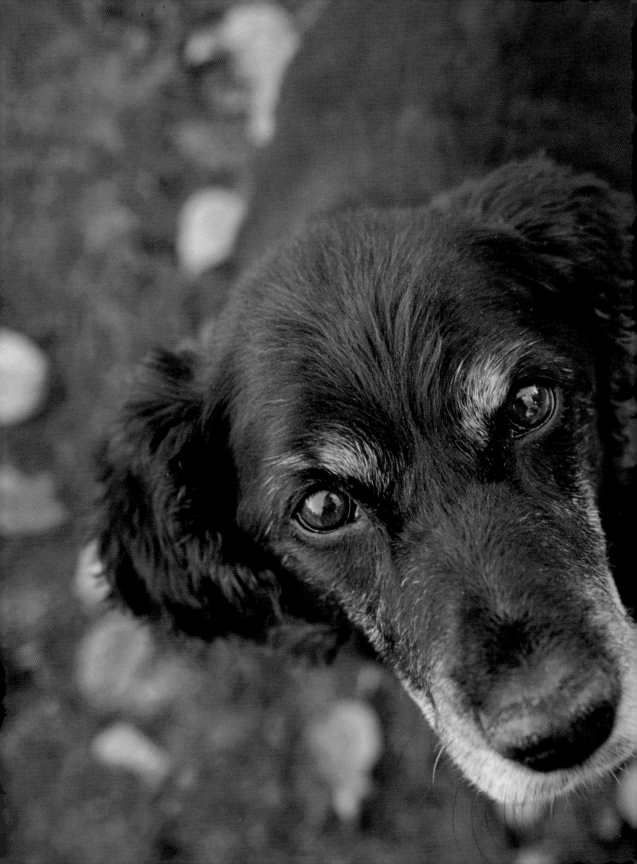

to the liver, omentum [a layer of fatty tissue that surrounds abdominal organs], *and* diaphragm — a very tricky surgery with concerns about how she would be able to breathe until she healed.

"Three days later, she wiggled out into the waiting room to me, sporting a fourteen-inch-long incision but *so* glad to see me. She recovered beautifully and has shown no ill effects. Overall, a series of remarkably lucky things: Stacie would have been dead in three days if I hadn't been there right then, if my vet weren't available, if the radiologist hadn't come out immediately, and if the right surgeon hadn't been willing to come in for an evening procedure.

"She seems to be the result of someone trying to breed parti-color — two-toned tan and white colors that have been in vogue and are expensive — with bad results. She has eyes with strange lenses and bad 'cherry eye' — repaired once and failed — and a *very* deformed pelvis that makes her pretty lame if she trots around for very long. She can't take anti-inflammatories because of her challenged liver, so keeping her comfortable may be a challenge as she gets really old. She'll always need a low-fat diet since she no longer has a gallbladder, but otherwise she's healthy and very happy. And of course she is *perfectly* housebroken now.

"Stacie is a snuggler, and her wiggle-butt is absolutely constant — she walks down the hall in the morning wiggling that tail. She loves her soft toys and her tennis ball and will roll on one of them when she's happy. That spaniel nose is always working, and she is a wild woman on a leash walk. What a light in my life!

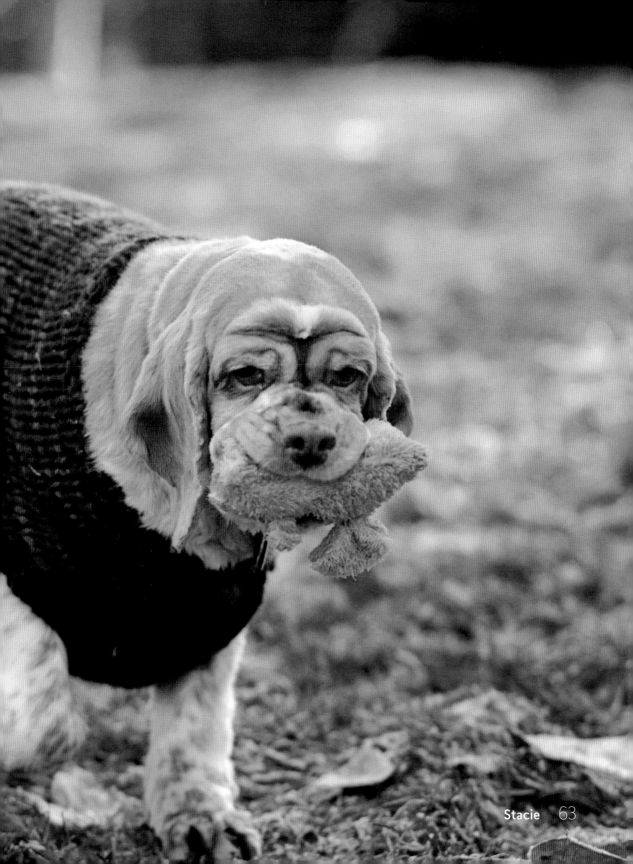

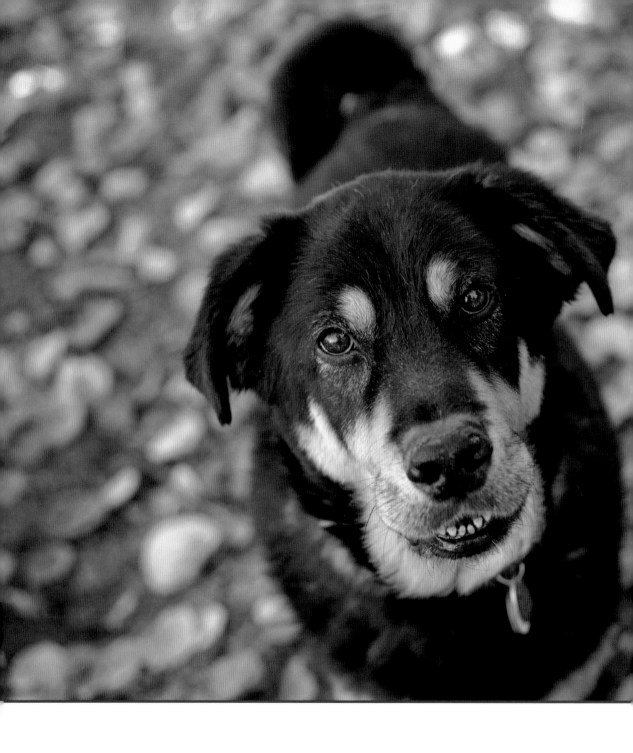

"Her story illustrates how many senior dogs end up in shelters: owner has a problem, doesn't realize it's medical or doesn't want to pay to find out, so the dog is dumped....We see that *so* many times, and we are the winners: we get really nice dogs who love us completely. We just have to do the surgery or fix the infection."

Many people who foster for Old Dog Haven feel drawn to the castoffs of the world. They also tend to be passionate about the work they do. Some get so involved that they launch nonprofits of their own.

One such foster mom was Julie Dudley, a former Microsoft employee and Seattle-area resident who now lives in Raleigh, North Carolina. After providing "final refuge" to fifteen pets through Old Dog Haven, Julie got to thinking: Could she use her entrepreneurial experience and finance background to help senior dogs, not just in western Washington, but all over the country?

In 2008, Julie founded the Grey Muzzle Organization, an all-volunteer group that gathers donations and then uses that money to help fund dozens of programs across the United States that assist homeless senior dogs. To earn a grant, a rescue group or shelter must submit a detailed application, undergo a thorough background check, and follow up to show specifically how the grant money helped older dogs.

"I wanted to help people who are doing senior-dog rescue," Julie said. "I think a lot of people don't realize how much work goes into this kind of thing. Judith and Lee are *amazing*, and look at what they do — it's just constant. The closest thing I can relate it to is maybe farming. It's a twenty-four-hour-a-day job, but in farming, you don't have the constant emergencies and the constant pleas for help."

In the years since Old Dog Haven and the Grey

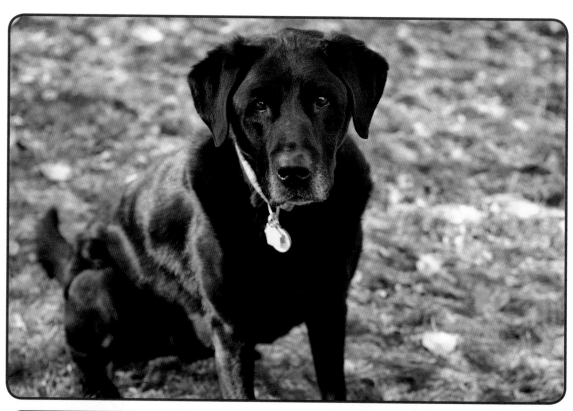

Muzzle Organization got up and running, more senior-focused rescue efforts and nonprofits have sprouted around the country. Most shelters now market their senior animals in special ways. Among rescue groups, some focus on getting older dogs adopted, some focus on placing them in permanent foster homes, and some do both.

One group, Old Friends Senior Dog Sanctuary, got started in 2012 by Zina and Michael Goodin, a semiretired couple who saw a huge need to help senior shelter dogs near them in Mount Juliet, Tennessee. Like Old Dog Haven, Old Friends places senior dogs in permanent foster care and covers their veterinary costs; today, the group helps more than 125 dogs through a network of around seventy foster homes.

"It makes us feel like we're filling a need that no one else is really filling, so that makes us feel really good," Zina said. "If you think someone would give up a dog at twelve or fifteen years old, you kind of wonder what their life was like before that. This might be the very best time of their lives."

Judith and Lee are encouraged by all the efforts afoot these days to help senior dogs. It's so different from when they first got started in 2004. "I remember one vet said to us, 'I guess I can tell people you're doing this, but I don't think there's much of a need,'" Judith recalled.

Since launching Old Dog Haven, they've never seen the need abate, and they've helped nearly four thousand senior dogs who had run out of options. Even today, Old Dog Haven can't accommodate all the senior shelter dogs in western Washington who need a place to go — and in other parts of the country, like southern and central California and most of the southeastern United States, the situation at shelters is much more dire.

Still, a movement is growing, and awareness is spreading. Over the past decade, the Pipers have advised a number of rescue groups as they got started. Because

Old Dog Haven receives inquiries from all over the country, they also do their best to keep a list of active senior-rescue groups at the ready.

"It amazes me that so many people are willing to do this," Judith said. "It warms my heart."

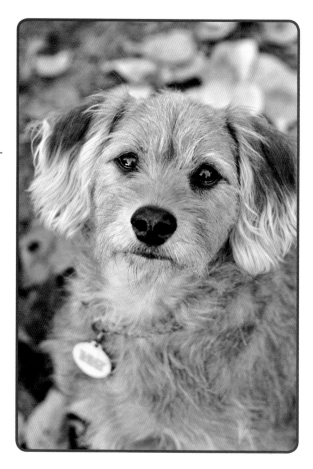 Judith, a former owner of two horseback-riding schools and a riding-equipment store, and Lee, a retired chemical engineer, still chuckle when they think about how their senior-dog adventures began. Judith had just sold her business in 2003 and was thinking about ways to do a little volunteer work.

"Be careful what you wish for!" she said with a laugh. Today, most of the floor space inside their home is dominated by dog beds, their phone rings off the hook, and they frequently juggle multiple trips to the veterinarian each day. The couple's kitchen has become their command center; Lee builds all the databases to track donations and keep the group's voluminous records straight while Judith patiently talks to foster families over the phone and helps them understand when it might be time to say good-bye. She readily acknowledges that a dog's final days are always — *always* — difficult to witness.

"But all creatures die," she said. "The question is: Are they going to die happy with you, or are they going to die alone and scared in a shelter? To me, having them die happily with you is a wonderful thing.…

"It's very different to lose a dog that you've had for a year compared with a dog you've had for fifteen years that's so woven into your life. Then you're losing a whole part of your life — but it's different with a dog you've had for *one* part of its life, where you've been focused on *them*. When it ends, you have wonderful memories. You have all the good that you did through it. And you got to have the company of a really cool dog."

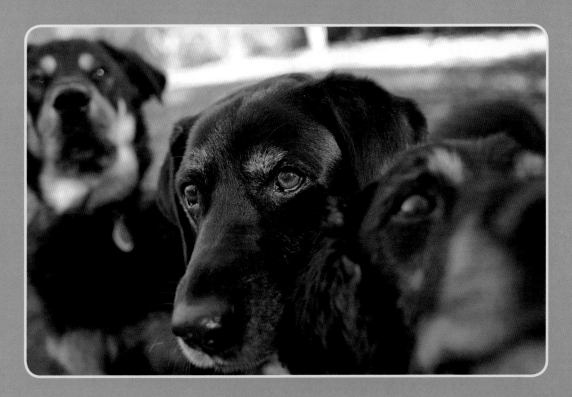

Common, Costly Health Problems

Old Dog Haven cofounders Judith and Lee Piper consistently see senior dogs being left at shelters because of two conditions: bladder stones and bad teeth. Both can be expensive to fix.

Bladder stones can cause a dog to pee all over the house — and promptly get dropped off at the shelter. Sometimes, bladder stones can be dissolved, but in other cases, they must be removed surgically. Often, after treatment, a dog must remain on a pricey prescription diet, take a special supplement, and receive tests on a regular basis. "I really can appreciate people not being able to pay for this," Judith said.

Dental problems tend to plague older dogs, and many need to have multiple teeth extracted. Some oral surgeries can cost between $1,500 and $2,500, depending on the degree of untreated infection.

Old Dog Haven makes sure senior dogs get these and other critical, but nonheroic, treatments. Once they recover, most dogs stop having accidents and relish feeling comfortable again.

FIONA, 17

A So-Called Hospice Dog Ditches Her Little Red Wagon and Starts Dancing

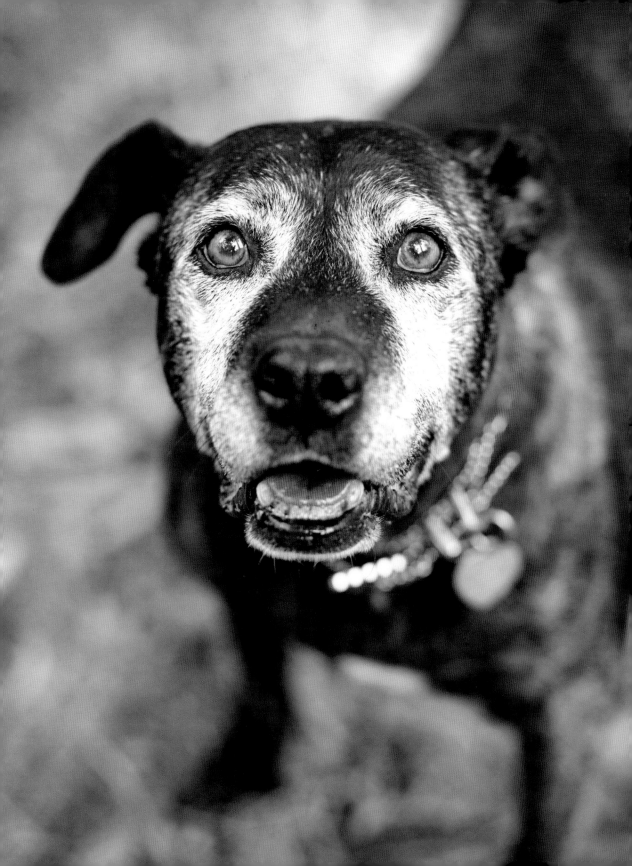

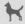

> **"** She makes my heart burst when she looks up at me
> with that gray face, full of love. **"**
> — Rita Earl

Dog rescuers always represent a special breed of human being. But dog-hospice volunteers? They are superhuman.

Hospice volunteers who bring aging, sick shelter dogs into their homes willingly embrace one of the most difficult experiences of human existence: saying good-bye to a dog. They do it because they can't stand the thought of a dog facing the end scared, confused, and surrounded by strangers at a shelter.

Some, like Judith and Lee Piper of Old Dog Haven in Washington State, do this multiple times a year, while others do it on a smaller scale — one dog at a time, year after year. Since 2006, Los Angeles resident Rita Earl has spoiled and pampered ten dogs — sometimes for days, sometimes for months — until they passed away. She thought Fiona would be number eleven.

Fiona had other plans.

By any measure, Fiona's prospects were grim in late December 2012 when Rita first met her at the West Los Angeles Animal Shelter. The then-fifteen-year-old dog had been brought in as a stray one month earlier. She had several breast tumors, and she could barely walk. The shelter staff took a liking to her, and they wheeled her around in a red wagon to prevent her from having to exert herself.

Rita could see that Fiona's chances of being adopted were zero. So she did it herself.

"This poor baby, she was in bad shape," Rita recalled. "I thought, 'Okay, she's gonna go soon.'

"But within a few days at my house, with my other dogs and love and attention and home-cooked meals and a soft bed, this little girl became a dancing fool. It was fascinating to see how fast it happened!"

Some dog-hospice volunteers work through senior-specific organizations, such as Senior Dog Haven & Hospice in Delaware, the Sanctuary for Senior Dogs in Ohio, Muttville Senior Dog Rescue in California, and SAINTS (Senior Animals in Need Today Society)

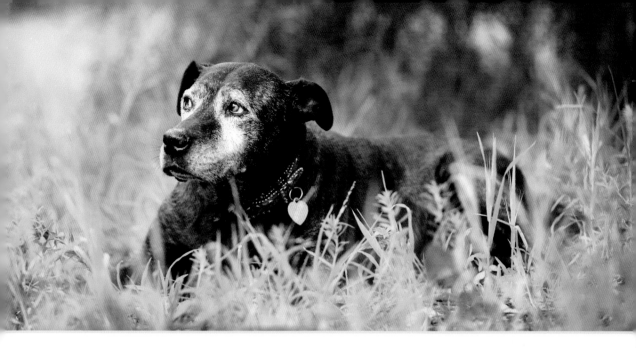

in British Columbia, Canada. In Rita's case, she's become known to a Los Angeles rescue group called Angel City Pit Bulls for her willingness to help any ill or geriatric dog in need.

Rita, who works for a production company in Hollywood, confessed that her volunteer efforts are emotionally taxing.

"It's terribly, terribly hard, and every time I do it, I say, 'That's it, I'm done,'" she said. "Then I say, 'Wait. It's not about me. There's someone waiting for me who needs a mother for a little bit.' And then look what happens: I get to meet dogs like Fiona. How lucky am I?"

As it turns out, Fiona loves to barrel down stairs, plow through doors, and play with Rita and Rita's two other dogs, Julie and Tina. But most surprising of all, Fiona's got rhythm. Her signature trait is marching in place quickly and merrily whenever she feels happy — which is most of the time.

"I like to say she traded in her red wagon for a pair of shiny tap shoes!" Rita said.

In her first days with Rita, Fiona saw the vet and enjoyed a diet of chicken, rice, and noodles. "Fiona was really skinny when I got her," Rita said. "I like 'em a little chubby when they're older." Rita and the veterinarian both decided it would be best not to put Fiona under anesthesia or take invasive steps to remove her tumors.

"I believe in no heroic measures — not at this stage of their lives," Rita explained. "I just want to keep them comfortable and happy for as long as they can be."

She described Fiona as a "pushy ol' broad" who is "absolutely perfect." Fiona's tail is always wagging, and her alert eyes are always locked onto Rita's. Rita said Fiona is welcome to keep living with her for as long as she wants.

"That's always the deal," Rita said. "I always say they can stay as long as they like!"

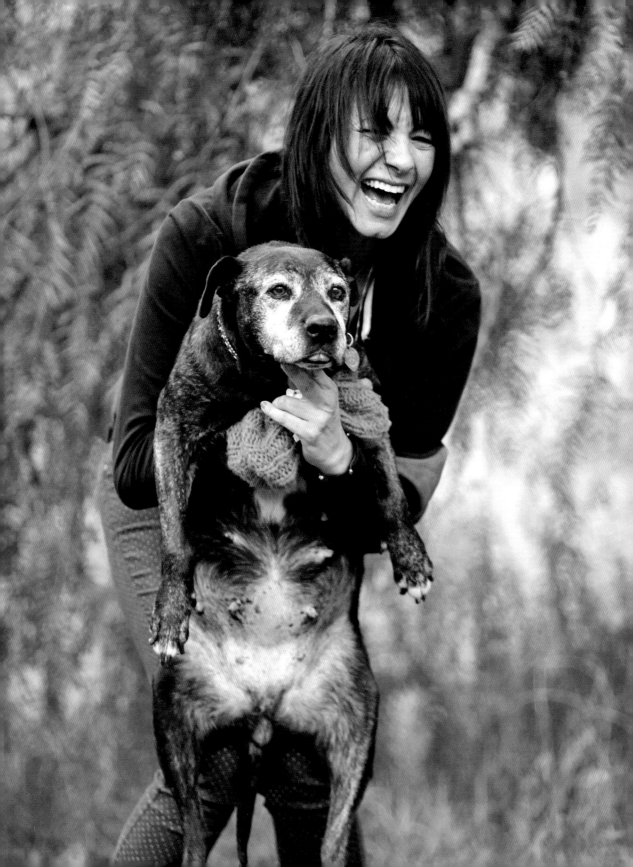

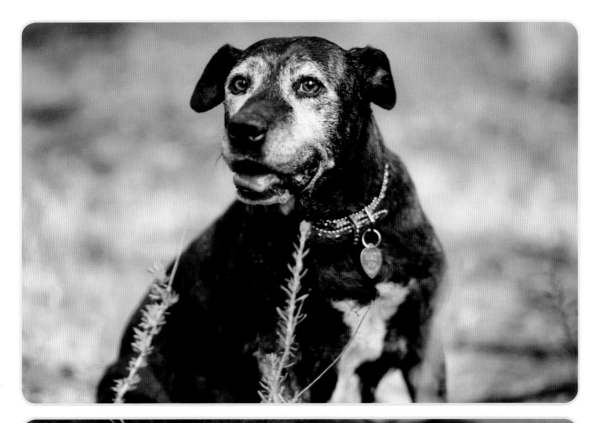

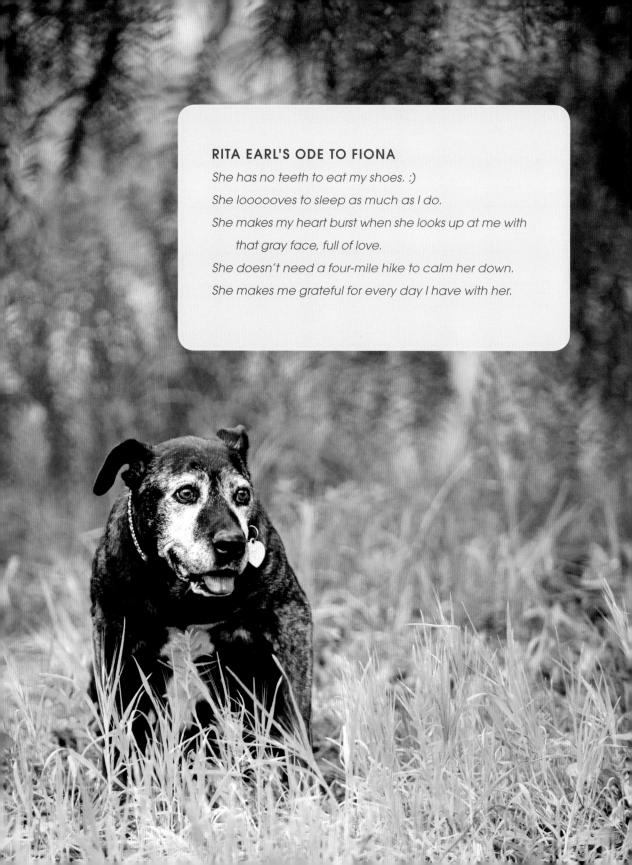

RITA EARL'S ODE TO FIONA

She has no teeth to eat my shoes. :)

She looooooves to sleep as much as I do.

She makes my heart burst when she looks up at me with
that gray face, full of love.

She doesn't need a four-mile hike to calm her down.

She makes me grateful for every day I have with her.

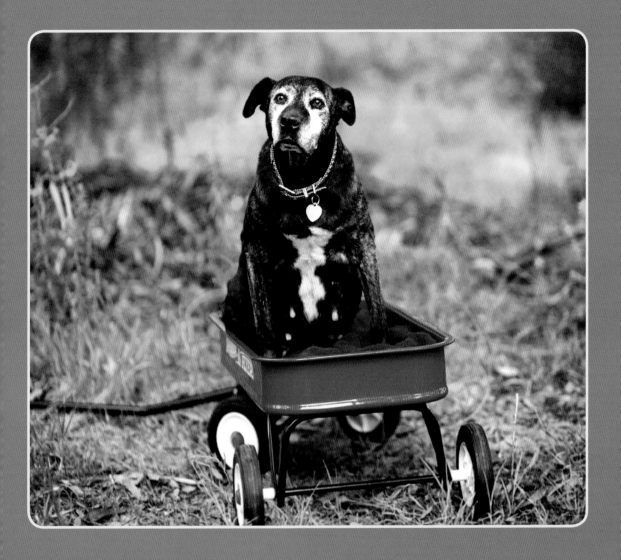

"A Calm, Sweet Senior"

When Lori Fusaro launched her senior-dog photography project in the summer of 2013, Rita Earl was one of the first people who stepped up and wanted to participate. She submitted the following passage about the joys of helping older dogs:

"I wanted an old dog because of their gentle spirit. Because no senior should be dropped off to die alone at the shelter. Because they are so good. :) Because why would you get an obnoxious puppy when you can get a calm, sweet senior?"

MADDIE, 7

Together, a Tiny Dog and
a Seventy-Five-Year-Old
Widow Start Living Again

> **"Dogs are not our whole life,**
> **but they make our lives whole."**
> — Roger Caras

There's something about the way Maddie walks. It's part prance, part trot, part wiggle — and all exuberance.

"It's like she's going for a blue ribbon!" Madelon Weber, seventy-five, said with a laugh as she strolled through her neighborhood with her ten-pound best friend. "Oh, Maddie. You are so beautiful! You are so beautiful! Yes, you are!"

Seven days a week, Maddie and Maddie — "M&M" — can be spotted smiling and greeting neighbors on their brisk walks together in San Mateo, California. They also hang out at Starbucks together, go to the beach together, snuggle up and read together, and watch *Dancing with the Stars* together.

But just a few months ago — before the tiny shih tzu entered the scene — Madelon wasn't walking every day and chatting with her neighbors. In fact, she struggled to find reasons to get dressed and go anywhere. Her husband of forty-three years, Ron Weber, had died from sudden cardiac arrest. Then her beloved Cavalier King Charles spaniel Charlie died. Madelon found herself in her large house all alone.

"My husband had been an airline pilot, so I was familiar with him being gone — it's not like I wasn't used to being alone. But to realize that he'd *never* be coming home?" Madelon said. "Then after I lost Charlie, the house was just *silent* — so, so *silent*. I couldn't handle it."

In San Francisco's Mission District, not far from the spot where Rescue Row merges with Treat Street, you can find some of the happiest old dogs on the planet. On any given day, about two dozen of them lounge contentedly on orthopedic dog beds and cushioned cots in a spacious, sunny room. They relish their refuge on the second floor at Muttville Senior Dog Rescue, a nonprofit that's helped find homes for more than three thousand senior shelter dogs since 2007.

A flagship initiative at Muttville is its Seniors for Seniors program, which matches older dogs with older humans. People over age sixty-two can have Muttville's two-hundred-dollar adoption fee waived and go home with a mellow pet whose veterinary care and grooming

needs have been taken care of. Depending on what's needed, Muttville also will provide dog bowls, leashes, harnesses, collars, food, medication, dog beds, name tags, and even home modifications, such as dog gates and stairs.

"These animals really do transform people's lives," said Andrea Brooks, Muttville's Seniors for Seniors program manager. "That may sound a little bit sappy, but it's true. We've seen people who were not taking very good care of themselves, wasting away in their apartments — and then they get a dog and they start getting out again. They start walking again. The dog gives them a sense of purpose."

Madelon, a retired physical therapist, mom of two, and devout Christian, has lived her whole life with a sense of purpose. But when she found herself so alone in her empty house, she grappled with depression, anxiety, and an identity crisis that blindsided her.

As Madelon struggled, so did a seven-year-old shih tzu on the streets of Fresno, California. After wandering alone for an unknown period of time, the ten-pound stray got picked up on May 7, 2014. "She came in severely matted and wasn't the happiest camper," recalled Kim Yrigollen, rescue coordinator for the Central California SPCA.

Days passed, and no one came forward to claim the little gray-and-white dog. She had no tag and no microchip, and therefore, no name. Kim called her London and started introducing her to prospective adopters. A couple of people showed interest until they learned how badly London needed costly dental work — a common scenario with older dogs.

"We decided that the best outlet for this little girl would be to find a good rescue," Kim said. That rescue group wound up being Muttville. There, London got rechristened "Maddie" and received the extensive dental care she needed. Before long, the comfortable, freshly groomed dog found herself in that glorious room on Muttville's second floor with all the soft dog beds.

Maddie walked around gingerly until she found a spot that felt just right. She settled down. She sighed. And she slept.

The day Ron Weber died, he had plans to go on a walk with some longtime friends. Madelon had errands to run, including a trip to the groomer for her dog, Charlie.

During his early-afternoon walk, Ron collapsed. His friends rushed him to the emergency room, where he began feeling better. A hospital worker called Madelon and conveyed a message from her husband: "I promise I'm fine. No need to hurry here to see me." Everyone was so reassuring that Madelon didn't panic. She made her way to the hospital by about three o'clock and found her husband smiling at her, looking as tan and rested as if he had just returned from Hawaii. "See?" he said. "I'm really fine!"

A nurse promised to bring Ron a tray of dinner and told the couple the cafeteria would be closing soon. Ron encouraged his wife to go get something to eat. She resisted. He insisted. If she had known how little time her husband had left, she wouldn't have gone anywhere. But she found herself in the hospital cafeteria line ordering a burger. She ate it alone in a hard plastic booth.

Ron grinned at her when she returned to his room about twenty minutes later. They started chatting about Corinne, their daughter in Arizona.

"I didn't want Corinne to know I was here because she'd get the militia out!" Ron joked.

"She's been sending texts," Madelon said. "See this one? 'Tell Dad I love him.'"

"Tell her I love her back," he said. Those were Ron's last words.

Madelon was still talking to him, unaware of anything unusual, when she noticed something and flinched. A nurse noticed it at the same time: Ron wasn't breathing. The room erupted in a flurry of activity, but for Madelon, everything stopped.

"I remember standing there thinking, 'Of course he's going to come back and talk to me,'" Madelon recalled. "I was just *sure* he would come back.

"When it was over, I kept holding Ron's hand. It stayed warm for such a long time."

After her father died, Corinne became consumed with worry about her mother. Her worries intensified after Charlie the dog died. "You have *no* idea — it was very unnerving," Corinne said. "I immediately noticed a change in Mom's demeanor and mood, going home to a two-thousand-plus-square-foot house that was so empty and quiet."

Corinne visits her mother every six to eight weeks, and she kept hearing wonderful things about Muttville's Seniors for Seniors program. She knew what she had to do: on her next visit home, she took her mom to San Francisco to find a new friend. During that visit, Madelon fell in love with a friendly little shih tzu named Max. Max was almost completely blind, but that just made Madelon love him more. She took him home, and he was overjoyed to be there; he rolled and rolled in the grass in her backyard.

Six days later, at Muttville's expense, Max had a vet appointment to be neutered. But

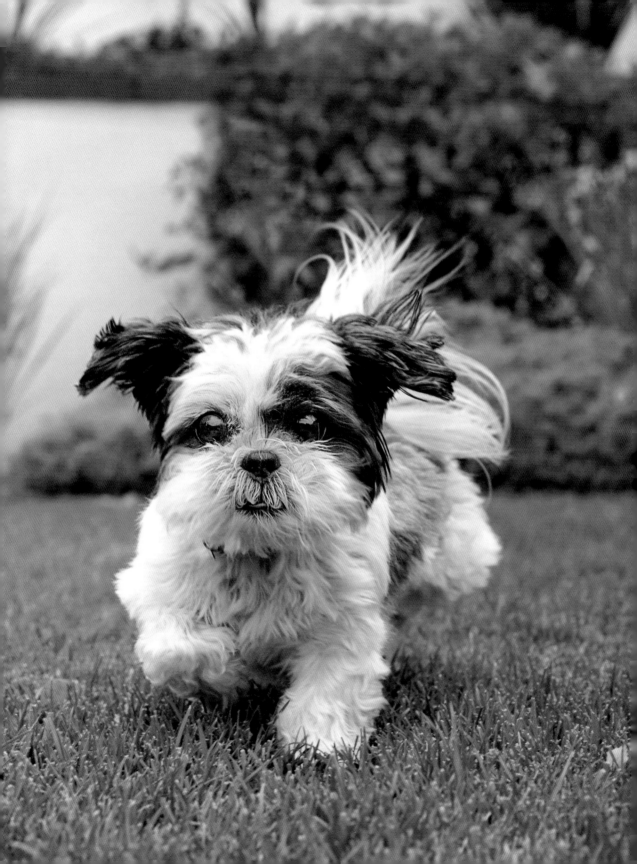

during that appointment, something unthinkable happened. Max died. "I was heartbroken," Madelon said. "I couldn't connect it — another loss? I had been trying to put this new life together, and I thought this was going to be such a special thing."

Madelon felt a wall coming down. Clearly she wasn't meant to have another dog. Then, a few days later, Madelon found a big box on her doorstep. It contained a bouquet of flowers and a sympathy card — from Muttville. "They were so dear," Madelon said. "Then they did a follow-up call and asked me, 'Would you be interested in seeing another shih tzu? We have one here from Fresno.' I still felt kind of burned, but I went. I brought a friend with me and told her not to let me do something stupid and get a dog that would be wrong for me."

Upstairs in that cheery, sunlit room, Madelon sat down on the edge of a low, cushioned cot. Several dogs eyed her with calm curiosity, but Maddie showed initiative. She walked right up to Madelon with dainty elegance and put her head on her lap.

Madelon didn't ask for her friend's opinion.

"I'm taking this dog."

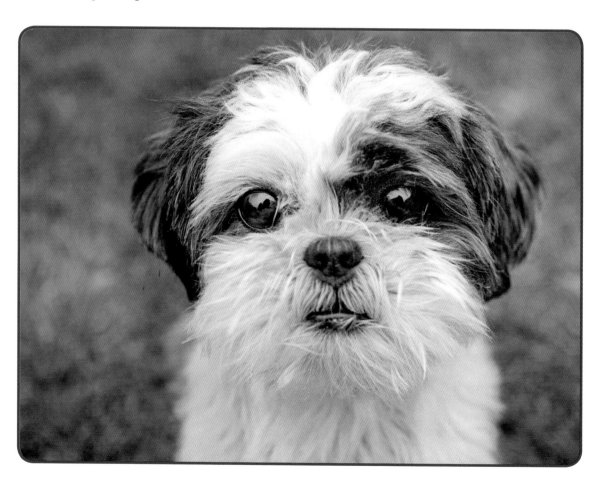

Madelon likes it that Maddie isn't a Velcro dog. She's not overly clingy — unless Madelon needs her to be. Then she'll snuggle up next to her for hours. This helps Madelon on restless nights. "She curls up next to me, and I feel calm and comfortable again, and we both get a restful sleep," Madelon said. "That wonderful touch of another living being is so comforting as life changes from being part of a family to being alone."

Maddie also fills a crucial role during daylight hours: She's a people magnet. Everyone wants to meet her — and, in turn, everyone wants to talk to Madelon. "At Starbucks, I can't even read the newspaper when Maddie's with me — I just spend all my time visiting with people!" Madelon said.

Their twice-daily walks also bring them in contact with their neighbors — even when their neighbors aren't home. On a regular route that Maddie knows well, Madelon has gotten in the habit of delivering people's newspapers up to their doorsteps. When she knows someone is out of town, she hides their papers behind a plant or in another spot that isn't visible from the street.

One neighbor, Louise Chu, was touched to learn what Madelon had been doing to keep her home safe. She wanted to do something to thank Madelon. So she and her husband invited her out on a brunch cruise with about sixty other people on San Francisco Bay.

"We sometimes charter a yacht to show appreciation to people who have been really kind to us," Louise said. "People may think that bringing our paper up is nothing, but I think it's just so kind of her to do that….We weren't really that close with Madelon before — you know how it is in the neighborhood, where you just wave or say a quick hello? But since she started doing the newspaper thing, it's brought us so much closer. All thanks to little Maddie!"

Madelon's social life hasn't stopped there. She's become open to all sorts of new activities. She now takes line-dancing classes and bridge lessons, and she works out with a personal trainer once a week. She also started participating in a jail ministry because she wants to help incarcerated women regain a sense of hope.

"Maddie has helped me learn that you can put together a new life. It's called the new norm," Madelon said. "Having this dog, I have a reason to stay healthy. I have a reason to get my act together. It just transformed me, and now my daughter doesn't have to worry about me so much because I'm so busy.

"A dog cannot replace a person that you lived with, but they do bring joy and meaning into life that would not happen without them….It's a bit scary to think what I could have missed if I hadn't gone to Muttville to find this wonder-filled dog."

JIMMY CHEE, 12

A Quiet Greyhound Is a Perfect Fit for a Man on Kidney Dialysis

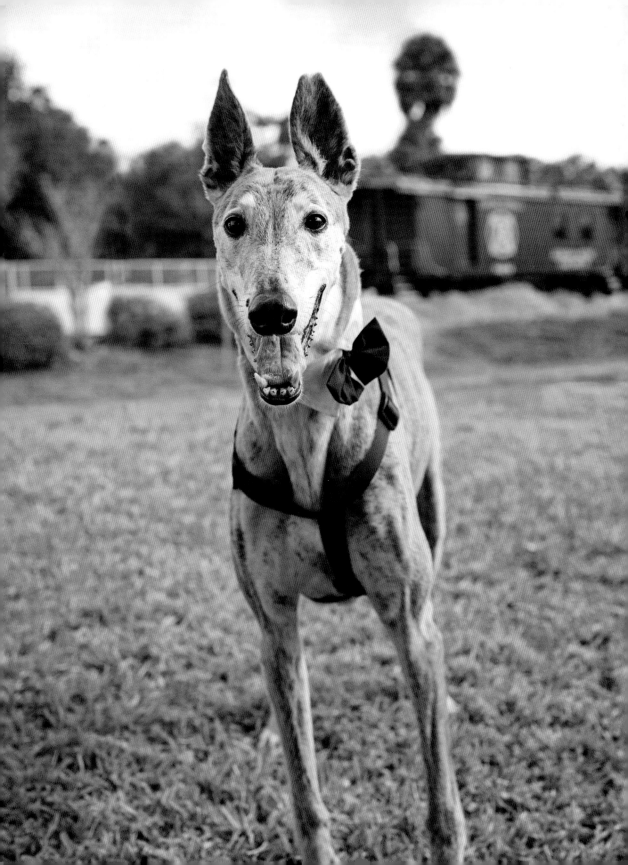

> **"**He needed someone to spend time with him, and I needed someone to spend time with me.**"**
> — Bob Fitzgerald

The ancient pharaohs would have loved Jimmy Chee. Alexander the Great and King Henry VIII would have snapped him up as well. But in the year 2013, despite his noble bearing and genteel manners, the affectionate greyhound had the hardest time finding a permanent home.

For one thing, Jimmy was eleven years old at the time — a detail that kept many potential adopters away. And for another thing, he had not yet encountered Bob Fitzgerald, the person who would understand and appreciate him in every way.

But first, a bit of background: Greyhound rescue groups abound across the United States, particularly in states that allow greyhound racing. For that reason, many greyhounds find loving homes after they finish their racing careers at age two, three, or four. There are also greyhounds who simply refuse to race, and rescue groups tend to have success placing those youngsters as well. But one pocket of the greyhound population is a much tougher sell: the eight-and-older set.

Many of these senior greyhounds have stories that follow a familiar circuit. They used to be lightning fast, and they made money on the track, so they raced for as long as possible — usually until about age five. Then, when they could no longer race, they faced a new demand: the need to breed more winners. "It's simple: they are trained athletes, and then when they're done with that, their new career is to make more athletes," said Peggy Stastny, a board member for Greyhound Pets of America (GPA) Senior Sanctuary of Florida.

Here are a couple of typical adoption listings on GPA Senior Sanctuary's website:

> **"**Gabby joined us yesterday from Champions Farm. She is 10 years old, ran 128 races, and had 27 puppies. She is a happy little girl and the tail is wagging whenever she has a human in sight. Gabby has a slight limp due to a broken right rear hock (which is the injury that likely ended her racing career) but is able to use the leg.**"**

"Donald, aka 'Donnie Boy,' Racing Name: Hallo West Acre, Male, Age 12. Donald participated in the Hollywood World Classic three times and won in 2005, beating everyone who was anyone in the world of greyhound racing. This great racer and sire of 343 pups is now deserving and ready for a soft bed and lots of love."

Granted, not all homeless senior greyhounds are former champion racers with sought-after bloodlines. Many had lived in homes until they experienced the same scenario as other senior dogs: their owners could no longer keep them because of financial problems or other life upheavals. In Florida, a state that's home to twelve of the country's twenty-one active dog tracks, there are so many unwanted greyhounds that it's not unusual to find older greyhounds in shelters.

Jimmy Chee — a former racer whose performance on the track was just mediocre — made his way to GPA Senior Sanctuary when his owner found herself working so much that she couldn't spend enough time with him. Peggy took him in as a foster dog and began trying to help the old guy find a permanent home.

It wasn't easy.

Peggy did find people who wanted to adopt Jimmy Chee. But, through no fault of his own, the dog got returned to Peggy not once, not twice, but three times.

The first people who took Jimmy brought him back two days later. They said their cat was terrified of him, even though he's utterly unfazed by cats and didn't do anything scary.

The second attempt ended after just one day. A sweet couple had been so excited about adopting Jimmy — and then, that evening, the husband fell out of bed and fractured his neck. His injuries called for long-term therapy, and his wife couldn't walk Jimmy during that time because she had severe arthritis.

The third attempt lasted a little longer. It began when a man contacted GPA Senior Sanctuary because he wanted to adopt his very first dog and he had heard that seniors were calm and easy. He seemed great, so Peggy made the arrangements. About two and a half weeks later, the man called Peggy to complain that Jimmy was pooping all over the house. Peggy thought, "Jimmy? *Really?*" She just couldn't believe it — so she did some polite investigating.

"It turned out that he was leaving the dog alone for more than ten hours a day," Peggy said. "He was a single guy who worked a lot, and he'd go out and play baseball after work or go out at night. We all agreed that his lifestyle wasn't conducive to having a dog.

"Here Jimmy was the easiest, the best, just the *most perfect* greyhound, and this kept happening to him. It was stressful for him, and of course all three times ripped my heart out because I had to give him up! I couldn't see doing this to this dog again, so I said I'd just take him."

Peggy thought that settled matters — she'd keep Jimmy Chee with her at her home in Fruitland Park, Florida, and give him plenty of love and attention for the rest of his days. Then, in January 2014, GPA Senior Sanctuary had a meet and greet outside a farmers' market in Eustis, Florida. Events like that are fun because passersby love meeting the greyhounds, and greyhound-adoring volunteers love talking about them.

During the meet and greet, a soft-spoken man with a bushy red beard came by in a golf cart. "He said, 'Can I hang out with you guys? I just lost my greyhound, and I miss her so much,'" Peggy recalled. "I said, 'Sure! Here — you hold Jimmy.'

"You should have seen those two together. *Zzzt! Zzzt! Zzzt!* Static electricity!"

Bob Fitzgerald doesn't complain — about *anything* — but he's been through a lot in recent years. His troubles began brewing when he watched a job he cherished for years turn sour.

Bob used to be the facility district manager for a major retail chain. He had started as an electrician in the maintenance department and worked his way up the ranks until he was responsible for keeping multiple stores clean, flawlessly lit, and impressive looking. Things hummed along swimmingly until the retailer's priorities began to change; it soon became clear that all the work Bob oversaw would be outsourced to save money.

"They were trying to push me out," Bob remembered. "There was a lot of stress, and the problem with stress is that it creeps up on you and keeps getting worse and worse and worse, and you really don't realize it."

Bob blames stress for two debilitating health problems that almost felled him: a leaking mitral valve in his heart, which had to be repaired and required him to get a pacemaker; and end-stage renal disease, which has left him with just 5 percent kidney function. He now spends fifteen hours a week getting dialysis to remove waste and extra water from his body; some sessions take away as much as ten pounds of liquid.

He retired early and qualified for disability insurance — details about his life that still surprise him. It was depressing at first, but over time, Bob's outlook began to change. "I feel more comfortable about everything now. One positive thing is that I don't sweat the small stuff anymore," he said. "And I've kind of gone back to my sixties nonconformist roots — I grew a ponytail and a long beard. Now that I'm not in the corporate world, I heard this little voice telling me: 'Hey! I can do what I want!'"

Bob's days can be long, though, because his wife, Denise, still works full-time. They became even longer, and lonelier, in late 2013 when both of Bob and Denise's dogs died within a five-week span. One of those dogs was Ruby, a gentle, brindled greyhound who developed thyroid cancer at age ten. "She was my best friend," Bob said. "We had to put her to sleep, and then we went up north for Christmas for two weeks. When we got back, I thought, 'Well, maybe I'll just try to manage without having another dog.'"

Those early days in January 2014 were rough. Bob sat around his home on weekdays

and snuggled his lovable black-and-white cat, Simba — but he knew he needed something more. Simba did, too; Bob could tell how much he missed the dogs. It was right around this time that Bob ventured out to the farmers' market where he met Jimmy Chee. He still smiles when he thinks about how quickly they connected that day.

"He just came up and he leaned on me," Bob said. "I spent a long time with him. I didn't want to leave without him. I think it was kind of a thing that was meant to be. He needed someone to spend time with him, and I needed someone to spend time with me."

Greyhounds and humans go way, *way* back. Ancient Egyptians fashioned special collars and leashes for greyhounds and depicted them in precious artwork. In the Bible, the book of Proverbs lauds greyhounds for their comely stride. A reverence for greyhounds persisted among ancient Greeks and Romans, and by the time of the Renaissance, King Henry VIII respected the breed so much that he incorporated a greyhound into his coat of arms.

It's easy to see why these creatures have inspired awe for millennia. Their aerodynamic bodies and huge, efficient hearts allow them to reach speeds of more than forty-six miles per hour, placing them among the fastest mammals on the planet.

Even though their velocity can be intense, their demeanor is docile, quiet, and almost heartbreakingly affectionate. Fans of the breed consistently get mushy when they talk about their dogs. But fans of *senior* greyhounds — they almost explode with enthusiasm. "They are wonderful! They are awesome!" said Paula LaPorte, president and founder of Forever Home Greyhound Adoptions in New York's Albany area. "They're completely house-trained, genteel, loving, grateful, sweet animals."

Shelley Lake, a Kansas veterinarian who rescues older greyhounds and is spearheading a cancer study for the breed, said she's especially fond of "broodies" — female racers used for breeding after they've retired from the track. "I will have a house full of seniors the rest of my life," Dr. Lake said. "They are just phenomenal, phenomenal dogs."

Another bonus with greyhounds, and seniors in particular: despite their capacity for speed in short bursts, they are shockingly easy to walk on-leash. "I'm sixty-something, and I can walk four or five of 'em on a leash, no problem," said Peggy of GPA Senior Sanctuary. "They're so gentle!"

Bob walks Jimmy Chee several times a day, and Jimmy loves it; even trips to the mailbox are a thrill for the regal dog. Every afternoon at about 2:30, Jimmy looks at Bob plaintively and sings a little song — "Ooooo-oooooo-oooooooh!" — to remind him it's time to go get the mail. When Jimmy isn't outside on leash-guided adventures with Bob, he often can be found curled up in a warm, snuggly heap with Simba the cat.

"He's an unbelievably loving soul, and his eyes will melt you," Bob said. "Since the first day he walked in the house, he's owned the couch. He sometimes gives me room. You can't get angry with him — he gives you that look, like, 'Awww. I'm really comfortable here.'

"He's perfect. He's so easy. It's like we've been friends for years."

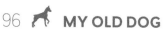

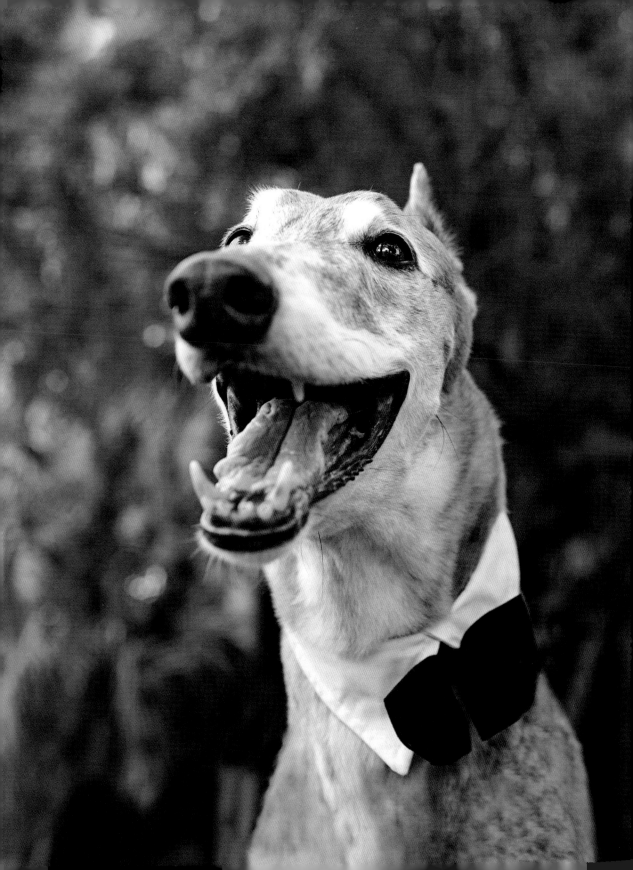

At a recent meet and greet in Mount Dora, a picturesque town on a lake north of Orlando, Jimmy Chee got to visit with about half a dozen of his senior greyhound brethren. The dogs smiled excitedly and high-stepped toward one another with subdued yet gleeful prances; it was as if all of them were simultaneously singing, "*Squeeeeeeeeee!*" without making a sound.

Jimmy was all gussied up in a fancy bow tie for the occasion. Bob wore his GPA Senior Sanctuary T-shirt with the slogan "Taking retirement seriously!" The day felt extra special because Bob's daughter, son-in-law, and two young grandchildren had just flown down from Massachusetts.

"This is the first time I've met Jimmy!" said Bob's daughter, Lynne Sales. "It makes me *extremely* happy that Jimmy's here. I worry about Dad more than he wants me to — a lot more — and his life is so different now. He was always the first person ever awake in the morning — in the world, I think! And he was always the first person at work and a really hard worker. It's hard for him to not be able to do as much as he once did. So Jimmy's *awesome*. He's such a good support for Dad."

Greyhounds have an average life expectancy of twelve — although, like many large breeds, they can live much longer than that. Jimmy turned twelve two months after Bob took him in.

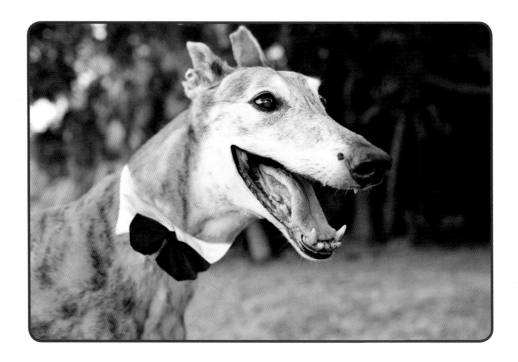

"I thought about that really hard," Bob confessed. "And then I thought: 'You know what? This is a cool dog. He deserves to have enjoyment in life and relaxation and to be treated like a little king. He has a wonderful personality, and his age doesn't make any difference to me.' For whatever time he had left, I wanted to give him a good time. He's definitely given that to me, that's for sure."

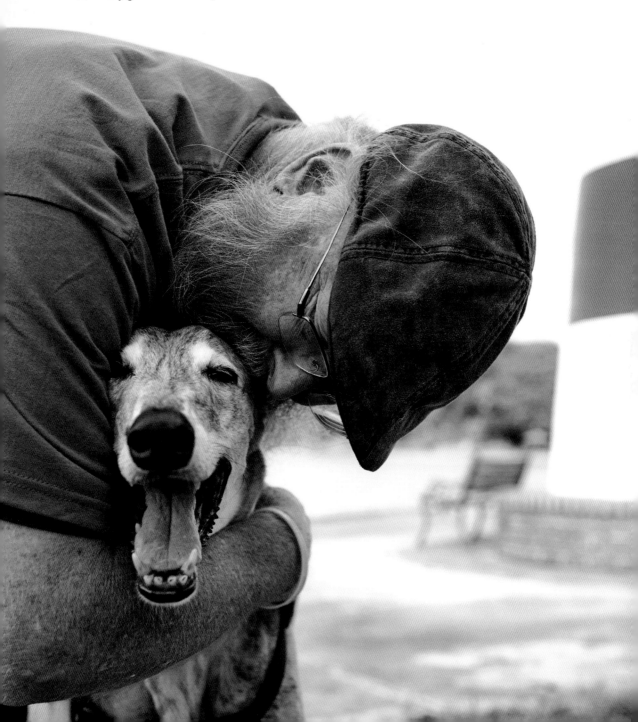

HEALEY, 14

Rescued from Neglect, a Blind Dog Learns How to Love

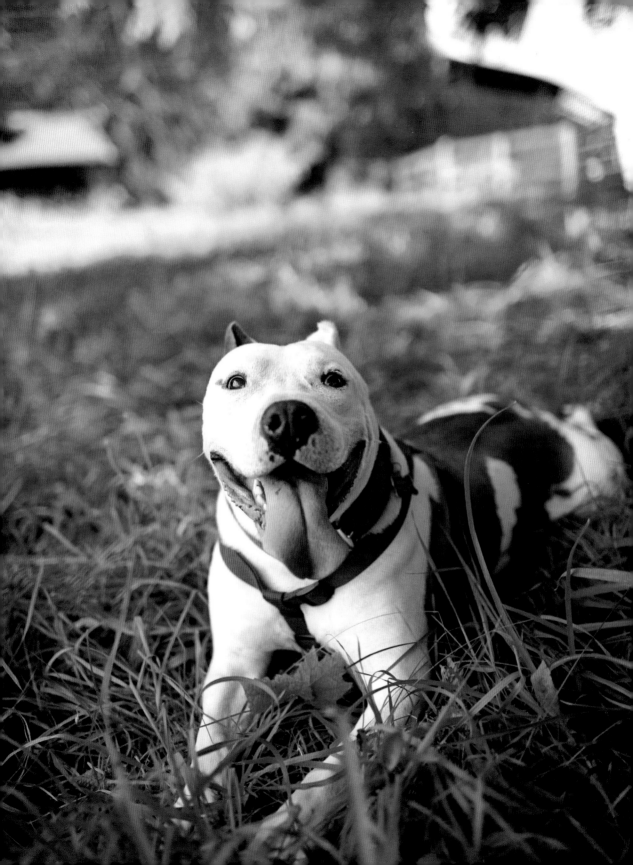

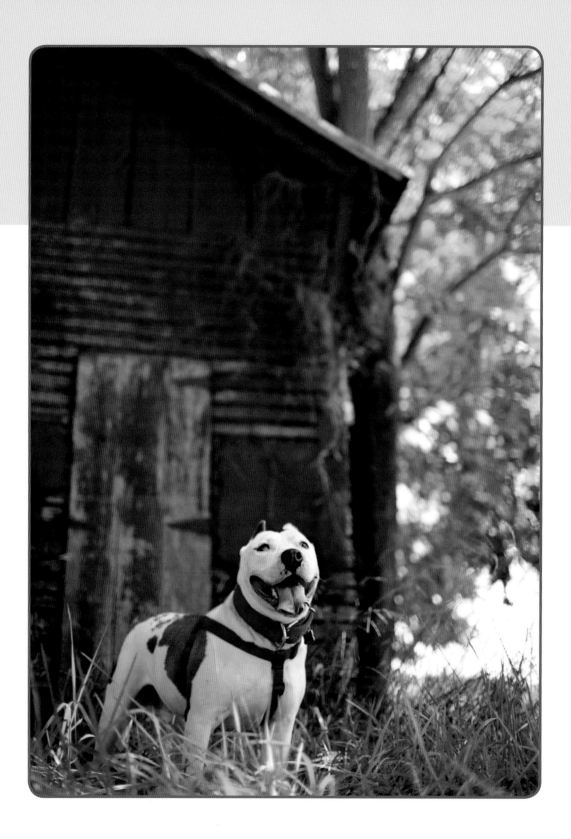

> **"I can't tell you how much forgiveness this dog carries in his heart."**
> — Teresa Powell

Meet Healey, a sixty-pound hunk of wiggly love. Most mornings, you can see him taking long walks near his home in Fincastle, Virginia. He's pretty easy to spot because of his happy, confident gait and his signature move: the "dipsy-doodle."

"He loves to roll in the grass," explained Teresa Powell, the woman who rescued Healey. "Not even three minutes into a walk, he flips over and rubs and scratches his back in the grass. He just has to do it! I always say, 'There he goes! He's doing his dipsy-doodle!'"

Most passersby would never guess this American Staffordshire terrier seemed a hopeless case just a few years back. When Healey was about ten years old, an animal-control worker found him tied to a pole in Roanoke City. He was underweight, covered in sores, and missing two inches of his tail. "And on top of that, he was blind," Teresa recalled.

Her husband, Ray Powell, said Healey had been a pitiful sight. "No one was ever gonna adopt him," he said. "He was a basket case."

Teresa regularly volunteers at two shelters, walking the dogs and taking professional photographs of them to increase their chances of getting adopted. She encounters many dogs with sad stories, and she frets over all of them — but there was something about Healey. She just could not stop thinking about this dog. "He looked so sad," she said. "I couldn't say no to him. I actually wanted him more when I found out he was blind."

After discussing it at length, the Powells decided to bring the terrier home to live with them and their three other dogs, Chance, Merry, and Shyanna. They named him Healey after the late blind jazz musician Jeff Healey, and they were determined to help him get acclimated.

Almost immediately, though, Teresa began worrying that they had made a mistake. Healey was wary of everyone around him, and he had a frightening habit of guarding his food. "Someone had hurt him mentally and physically pretty bad," Teresa said. "He was dog-aggressive, and he didn't trust Ray and me. Especially me. He would growl quite often, and frankly, it scared me."

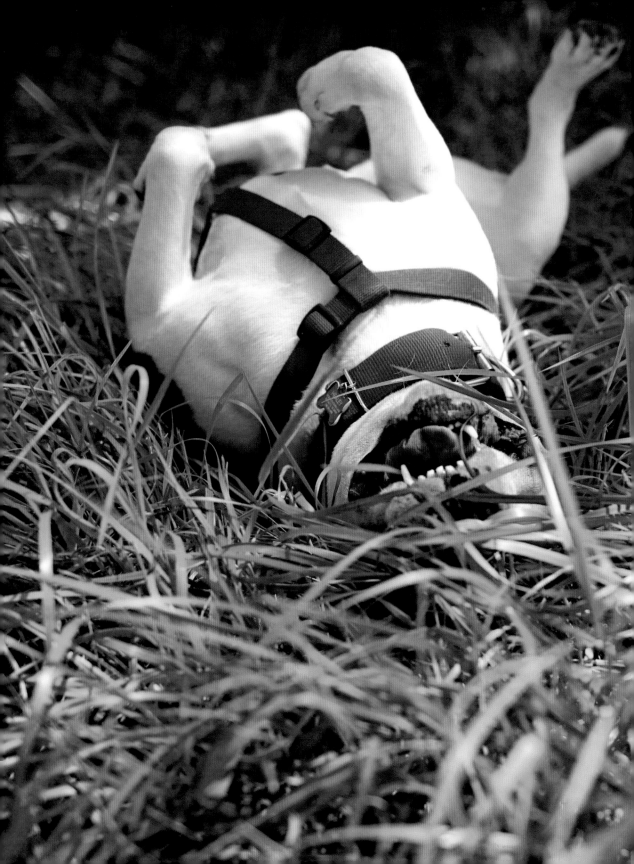

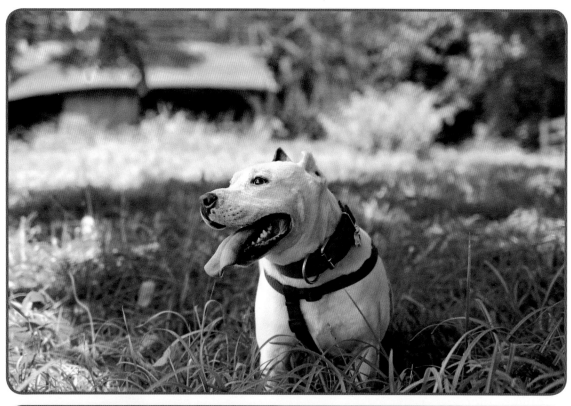
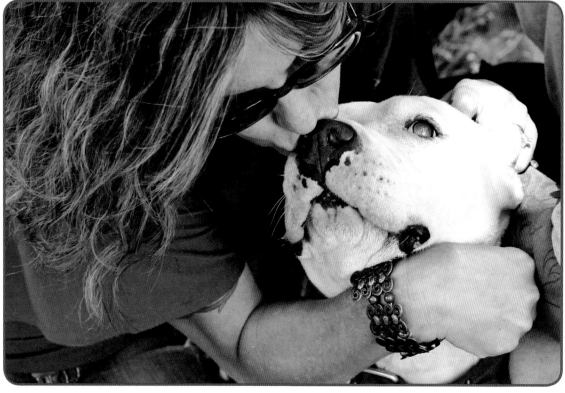

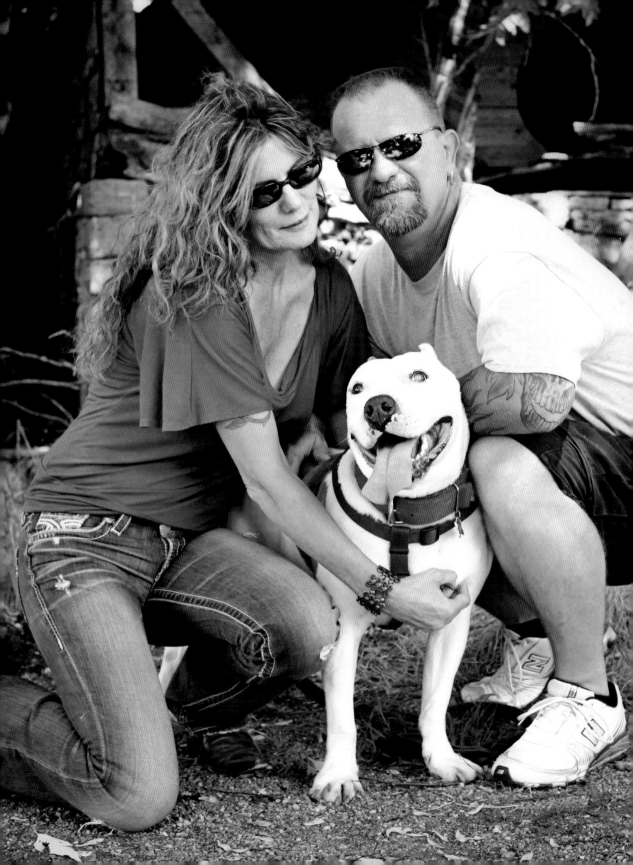

Ray had a hunch: What Healey needed was a walk. A nice, leisurely stroll with no other dogs around. And so Healey's journey toward becoming a happy-go-lucky dipsy-doodler began. Ray, a machinist, started walking Healey religiously before work every morning, regardless of the weather. Their walks increased in length from half a mile, to a full mile, to as many as five miles a day — and in all that walking, something happened.

"He just basically walked it off!" Teresa said.

Her husband agreed. "You wouldn't believe the difference walking made with this dog," Ray said. "At first, he was timid and very leery, but now when he's on his walk, he's got his head held high — he's king dog. Nothing fazes him anymore."

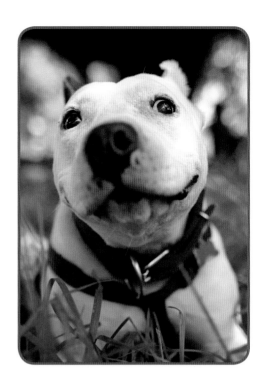

To help break Healey of his food-guarding habit, the Powells sat with him on the floor and hand-fed him his kibble one bite at a time. During those painstakingly slow meals, they'd pet him and talk to him with a soothing voice.

After about seven months of walking, hand-feeding, and giving Healey opportunities to decompress, Teresa and Ray were amazed: they had a well-adjusted, socialized pet that showed no signs of a troubled past.

"I've never seen a dog transform the way Healey did — ever," Teresa said. "He is no longer shy, scared, or broken. He is confident. He is lovable, he is kissable, and he never, ever growls. Feeding time is like with any of our other dogs. He has overcome so much….I can't tell you how much forgiveness this dog carries in his heart."

Ray said he never tires of watching Healey wiggle around happily on his back in the grass with his tongue hanging out.

"We thought he at least deserved a chance to have a nice place to live out the rest of his days," he said. "I think this is one of the best things we've ever done."

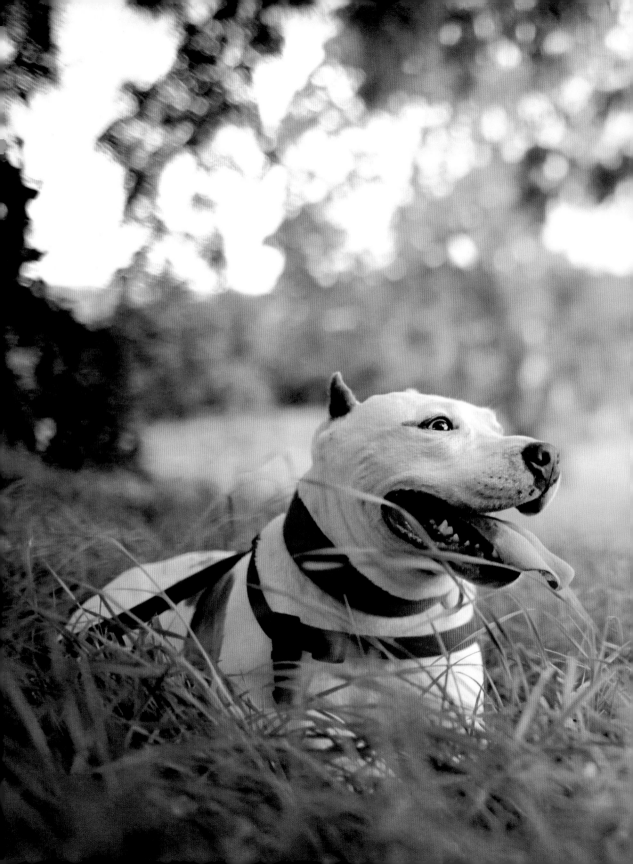

PART 3

Helping

ROCKY, 15

A Furry Nursing Home Resident Buoys Women Living with Dementia

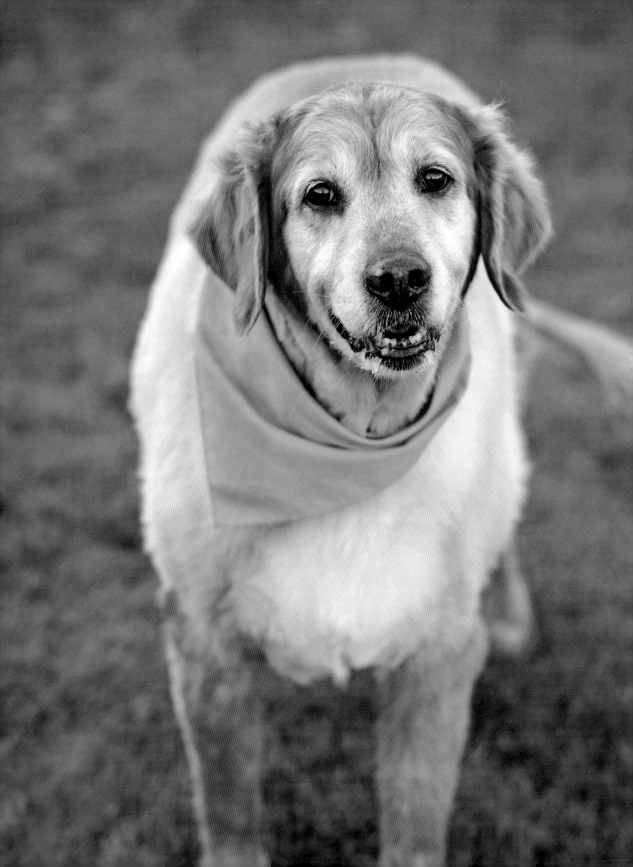

> "A small pet animal is often an excellent companion for the sick, for long chronic cases especially....If he can feed and clean the animal himself, he ought always to be encouraged and assisted to do so."
> — Florence Nightingale, 1859

He may be rotund and relaxed, but Rocky is a quick study in the human condition. He sizes matters up fast because he wants to make sure his ladies are okay.

The fifteen-year-old golden retriever lives full-time at Rosario Assisted Living in Anacortes, Washington, where he serves as an anchor and best friend to a group of older women with Alzheimer's disease and other types of dementia. When visitors enter Mount Baker, a memory-care unit at Rosario, Rocky greets them with a polite tail wag, a pleasant smile, and a direct gaze that seems to say, "What is the purpose of your visit?"

The members of Rocky's entourage fret over him just as much as he watches out for them — and they remember his name more readily than some of their family members' names.

"Rocky is perfect!" gushed Darlene, eighty-one, a woman diagnosed with Alzheimer's disease. "He wags his tail. It puts you in a good mood."

"He's just such a sweetheart," said eighty-four-year-old Doreen. "He doesn't run around very much. He just loves people."

Marjorie, an elegant eighty-three-year-old with jewelry perfectly matched to her red-and-black sweater set, summed up Rocky's role with ease: "He helps all of us."

It was rare twenty years ago, but these days, it's not all that unusual for assisted-living facilities, nursing homes, and other long-term-care communities to have live-in pets like Rocky. And more are allowing residents to bring their own dogs, cats, birds, and other companion pets with them when they move in.

A Place for Mom, the largest senior-living referral service in the United States, was able to direct its callers to more than nine thousand communities that accepted pets in 2014. "About 40 percent of our inquiries about senior-living communities include that question: Can I bring my pets?" said Sue Johansen, a regional manager for A Place for Mom.

Sue noted that people adjust and thrive much more quickly in assisted living when

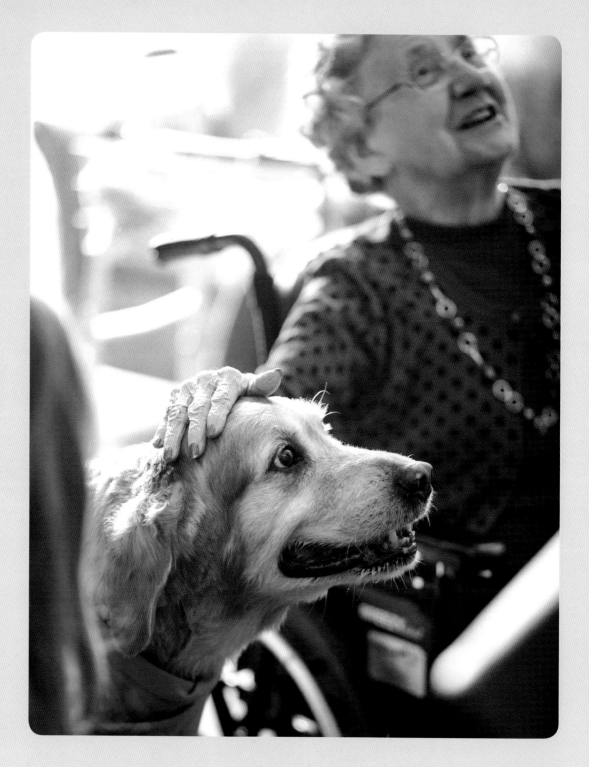

they can keep their familiar furry or feathered friends by their sides. "If they have a pet that they're responsible for caring for, that adds to their purposeful living," she said. "It helps them remain whole."

The modern-day awareness that animals have enormous benefits for many older people in institutionalized settings can largely be traced back to a Harvard-trained physician named William H. Thomas. In the early 1990s, Dr. Thomas began testing a radical philosophy. He called it the "Eden Alternative," and its aim was to transform the culture of nursing homes at their core.

The Eden Alternative set out to eliminate three plagues of nursing homes — loneliness, helplessness, and boredom — with three vibrant ingredients: pets, children, and plants. It sounds simple, but think about it for a moment. What in your life makes you feel the most alive?

The Eden Alternative has attracted enthusiastic supporters over the years, including Jim Roe, who incorporates its principles at the senior-living communities he owns. One of those communities is Rosario Assisted Living, where Rocky lives along with a variety of other companion pets.

"Lots of people who live alone, but who aren't lonely, have pets," said Jim, an avid dog lover. "When you take care of someone else, you feel less helpless, so having a pet is great for that. And there's nothing more spontaneous and less boring than animals."

Jim is quick to point out that this approach is much more than a "fur and feathers program," with animals thrown into the mix haphazardly. It must involve a commitment from a facility's top-level managers to treat elders with dignity and let them be the decision makers in their homes.

For instance, at Rosario, residents aren't made to stick to a strict schedule of breakfast, lunch, and dinner shifts, with predictable bingo sessions at 3:00 PM and mandatory lights out at 9:00. Instead, they can eat whenever and wherever they want and take control over their days in other ways.

"We have four men who stay up really late with coffee, gossiping and reading the paper, every night," said Laura Willingham, Rosario's resident services coordinator. "That is their routine. It's who they are. They sleep until 11:00 the next day, and that's fine. We're not going to change that."

The presence of toddlers and other kids also stands out at Rosario. Rather than stopping by for quick visits, children stay for a good part of the day because their parents bring them to work. On a recent afternoon, Riley, a cheery three-year-old girl with bright-red hair, smiled as she climbed up onto the lap of an older resident named Alice. After about twenty minutes of snuggle time, she wiggled back down to the floor so she could give Rocky a hug and use him as a pillow.

Denise Hyde is a community builder for the Eden Alternative, which, in addition to being a philosophy, is also a nonprofit organization based in Rochester, New York, with

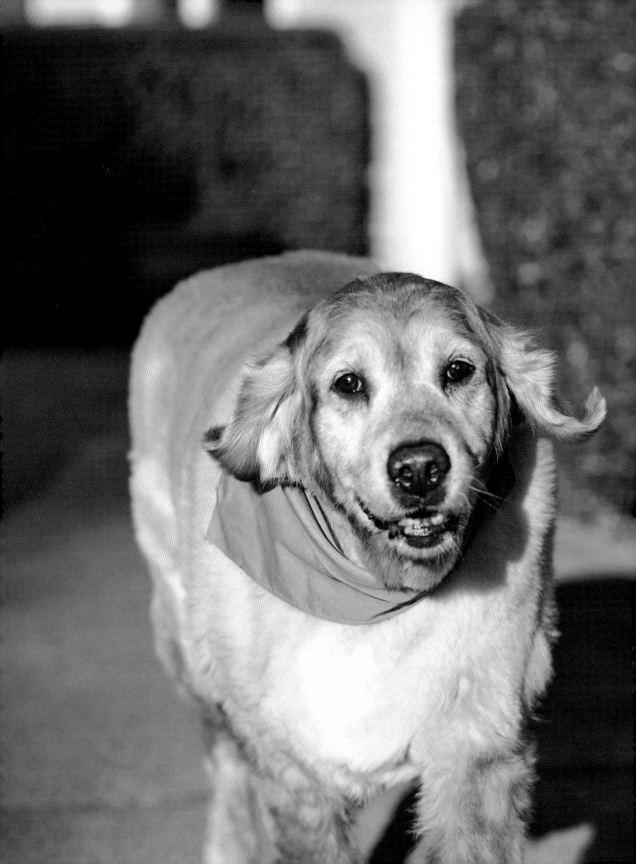

nearly two hundred communities on its registry. Denise stressed the importance of establishing detailed care plans for pets before allowing any animals to join a senior-living community. In addition to nailing down specifics about who will feed the dog or clean the litter box, the plan should spell out who will care for the pet if the elder dies.

"We also advocate something else for shared community pets, and that is this: Do *not* buy a puppy! Do not! Do not! Do not!" Denise said with a laugh. "An older animal is better because you know its temperament and size. It's best to have a mellower dog that can deal with a lot of people."

Jim Roe agreed, noting that he's had the most success bringing in larger dogs between the ages of five and eight. "Wheelchair height is what I say!" he advised.

The evolution of pet-friendly senior communities is encouraging, considering how many senior dogs have landed in shelters after their older human caretakers relocated to nursing facilities that would not accept pets. In an unusual plot twist, that actually happened to Rocky.

Rocky and his brother, Boomer, grew up with an older couple in Stanwood, Washington, on a nice piece of land where they could run free. When the couple needed more care, their children moved them to a senior community and brought Rocky, then seven years old, and Boomer to a shelter.

Shelter workers could see how attached the brothers were, so they insisted on having them adopted together. A family finally took both golden retrievers in — and the fluffy duo promptly resumed their former habit of wandering off together on walkabouts.

Rocky and Boomer proved to be agile escape artists, and animal-control workers picked them up twice. Before long, the dogs found themselves at a shelter once again — and right around that time, Rosario Assisted Living began looking for a "wheelchair-height" dog between the ages of five and eight with a sunny disposition. "We ended up getting both of them," Laura Willingham said. "Everyone was amazed at how well they settled right in, and we've never looked back!"

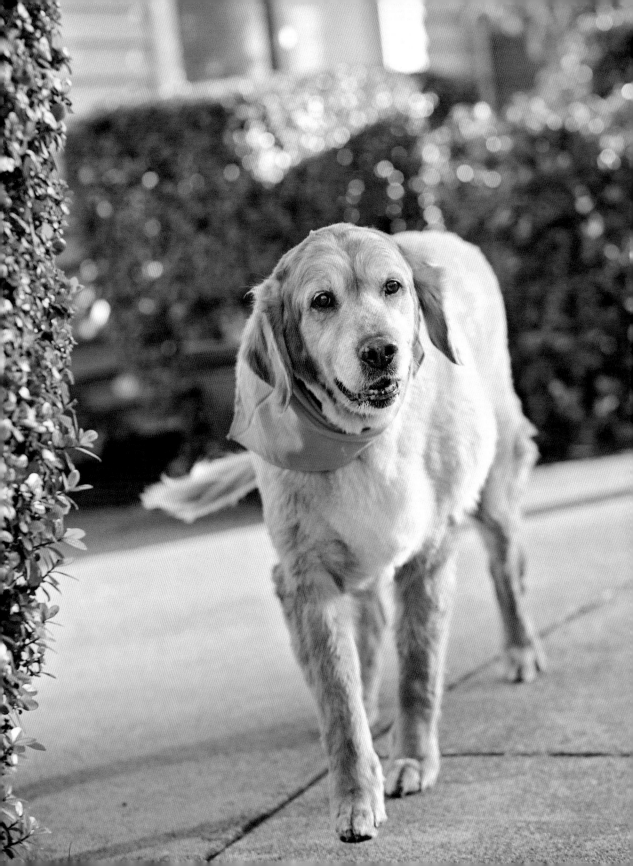

Boomer died about a year after the brothers arrived at the assisted-living facility, but Rocky is still loving life. It's not that he doesn't have health issues. He's survived a stroke. He has cancer. He has arthritis. And he's obese — an occupational hazard of living in a memory-care unit where all the residents want to feed him and can't always remember when they last smuggled him contraband food.

"You would not believe what we've been through trying to get weight off of him," Laura said. "We tried to move him to a different building for a couple of days, and he had a panic attack! He was *miserable*. He wanted to be back with his ladies, and his ladies missed him, too. Their families were furious that we took him — they called us and said, 'What are you doing?! He *has* to be there.' We decided to keep him where he was for his quality of life. He's happier there. Even his vet said, 'Wow. I get it.'"

Rocky's bond with the women of Mount Baker runs deep. Laura said he's connected to each of them in special ways, and he senses when someone is feeling sick or sad.

A few months back, Doreen — one of Rocky's closest pals — received devastating news: her daughter had died during a routine medical procedure. No one on staff realized what had happened yet. "Rocky was right by her side the whole day," Laura recalled. "Later in the day, we got a phone call that her daughter had passed, and then it made sense instantly why Rocky would not leave Doreen's side. He would not leave her for a week, no matter what. He would not eat unless she was right there. When she went to sleep, he was at the foot of her bed. He just had to be with her."

While the ladies of Mount Baker view Rocky as their dog, the staff at Rosario view him as a full-fledged resident. "He is 500 percent one of our residents!" said Babette "Babs" Frazier, an activity coordinator at Rosario and one of Rocky's main caregivers. "He is treated just like them."

This becomes evident when it's time to transport the large, arthritic dog to one of his regular grooming sessions. Babs drives him to his appointments in the assisted-living facility's van so she can use the van's wheelchair lift to get Rocky in and out of the vehicle. "We really want him to be comfortable, and we don't want the stairs to hurt him," Babs explained. "The groomers absolutely lose their minds when we show up — they love it! He gets the VIP treatment on his spa day!

"Then once he gets his teeth brushed, his deep conditioner, his bubble scrub, and his fragrance, he's the happiest little pup — he almost becomes like a puppy again. He loves to show off and he wants to run the campus. We all get so giddy for him. He loves the attention!"

In between Rocky's formal grooming appointments, Babs finds clever ways to keep the ladies of Mount Baker involved in his care. "I'll say, 'Hey, Doreen! I think it's time to give Rocky a bath. Can we use your shower to give him a bath?' And she'll say, 'Absolutely!' So we'll use her shower, and she'll sit in the bathroom with us and say, 'Don't forget to scrub behind his ears!' And then she's right there with her towels to help dry him."

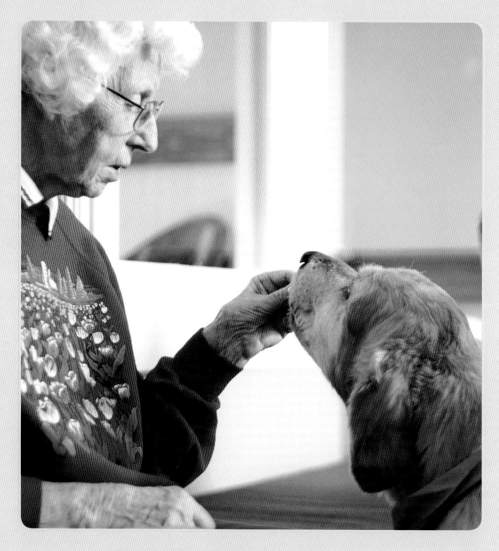

Darlene, the resident who loves to see Rocky's tail wag, is still mobile and quick on her feet, so Babs often invites her to help take Rocky outside for bathroom breaks. "We'll have her call him when he's all done outside," Babs said. "He always comes running to her."

The women's eager involvement in Rocky's care supports Dr. Thomas's theories about the Eden Alternative. The former nursing-home doctor observed that many people in long-term care feel trapped and helpless when they receive more care than they give. For that reason, they need genuine opportunities to give care. In his 2004 book *What Are Old People For?*, Dr. Thomas wrote, "Elders must be able to wake each morning and know, in truth, that their life matters — that they are in some way contributing to the well-being of another."

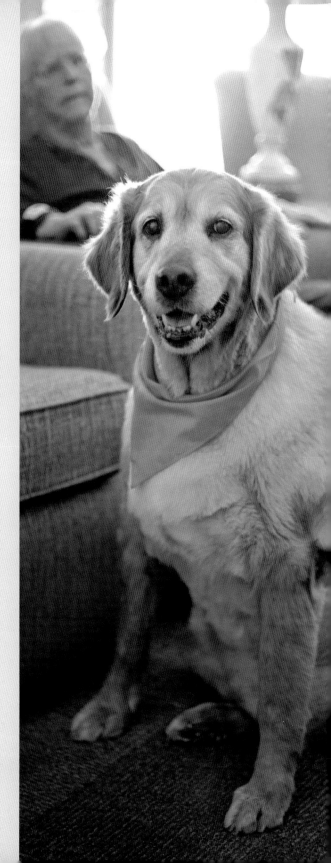

There is no question that Rocky's well-being is bound to the women of Mount Baker. During a sing-along session with a visiting vocalist, Rocky smiled serenely as his ladies stroked his fur, bobbed their heads, and tapped their feet to the old standard *Side by Side*:

*Don't know what's coming
 tomorrow
Maybe it's trouble and sorrow
But we'll travel the road
Sharing our load
Side by side*

*Through all kinds of weather
What if the sky should fall?
Just as long as we're together
It doesn't matter at all*

*When they've all had their
 quarrels and parted
We'll be the same as we started
Just traveling along
Singing our song
Side by side.*

SUSIE, 15

Brandon Stanton's Pooch
Helps Hundreds of Senior
Dogs through Her
Facebook Page

> **❝**When most people think about getting a dog, they think about a new wrinkly puppy. But if you bring up the idea of an older dog and touch their hearts a little bit, they think, 'Oh.' Sometimes it's just a matter of putting that option in front of them.**❞**
> — Erin O'Sullivan

Sometimes you really can find what you didn't know was missing.

It happened to Brandon Stanton, author of the bestselling photography book *Humans of New York* and creator of the popular blog that bears the same name. One summer day in 2011, Brandon was strolling down a Brooklyn street, chatting with people and taking photos, when he spotted the funniest little dog sitting on a stoop.

"I thought to myself, 'That is the coolest dog I've ever seen,'" Brandon recalled, referring to the little Chihuahua mix with the serene demeanor and the wispy-soft Mohawk. "'If I ever get a dog, I want it to look like that.'"

He soon realized the dog was a neighborhood regular, and she captivated him so completely that, even though she was a dog, he photographed her for *Humans of New York*. On June 26, 2011, he posted this online along with her photo:

> **❝**Every time I walk to Prospect Park I pass a dog sitting on a stoop.
> After some consideration, I decided it was the greatest dog in New York.**❞**

A week or so later, a man on that street approached Brandon with an urgent plea. "He said, 'I saw you photographing my dog, and I saw that you really liked her,'" Brandon recounted. "'I have to get rid of her. Would you like her?'"

Brandon never had a dog before, and in that couch-surfing phase of his twenties, he didn't even have a permanent place to stay. But something made him take eleven-year-old Susie along with him — a move he said turned out to be the best decision of his life.

"I realized in those first few days what's so special about the companionship of a dog — it's like nothing else," Brandon said. "It was a very new thing to have this animal with the primary goal in life of being as close to you as possible."

Brandon's girlfriend, Erin O'Sullivan, marveled at the happy, playful bond that formed between Brandon and Susie so quickly. It got Erin thinking: If Susie had *this* much comedy

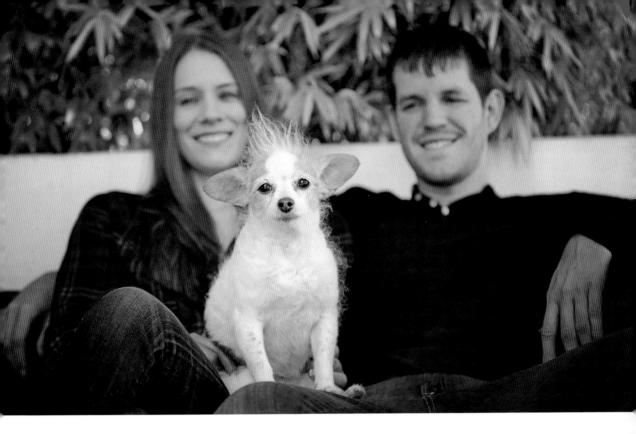

and contentment to offer at this stage of her life, what about other senior dogs? Isn't it kind of crazy that older dogs have such a hard time finding homes?

This line of reasoning led Erin to try something. In January 2014, she launched a Facebook page called "Susie's Senior Dogs" to connect people with older pooches up for adoption. Right away, the page had a noticeable impact on senior-dog rescue efforts across the United States. In less than a year, it garnered more than 200,000 followers and helped about 300 old dogs find loving homes.

Susie's Senior Dogs got a boost early on when Brandon shared a single post about it on his *Humans of New York* Facebook page, a troll-free zone where kindness trumps meanness and decency prevails. (As of this writing, *Humans of New York* has attracted more than twelve million followers on Facebook.)

"Brandon's Facebook fans are very unique — it's a big-hearted and compassionate group of people — and that carried over into Susie's page," Erin said. "When most people think about getting a dog, they think about a new wrinkly puppy. But if you bring up the idea of an older dog and touch their hearts a little bit, they think, 'Oh.' Sometimes it's just a matter of putting that option in front of them."

Erin worked full-time for a jewelry designer in Manhattan when she first started Susie's Senior Dogs at age twenty-nine. In the beginning, she'd spend her evenings scouring

the internet for postings of senior dogs languishing in shelters. "I basically would work, come home, break for an hour, and then write until like one or two in the morning — and have no life!" she said.

As months passed, senior dogs soared in significance for Erin as her job receded. In June 2014, she quit her full-time gig to focus on Susie's Senior Dogs exclusively. At first, she was scared to take that leap — but now she's nothing but grateful to Susie.

"When I was at my old job, I felt like I was in a room with no windows or no doors," Erin said. "Finally, this was presented to me as a window. Yes, I didn't necessarily know how I was going to pay my rent long-term.... But I knew that if I didn't walk through this window with faith — when everything on the inside was telling me, 'Oh, you've got to do this, you've got to do this!' — then that's my own fault.... Even if I can only do this for a year, I knew I had to take advantage of it."

The extra time has allowed Erin to visit overburdened public shelters firsthand to see what workers there are up against. She's also been able to work more closely with reputable, and often cash-strapped, dog-rescue groups. Erin's Facebook posts have become more nuanced — and her efforts are producing results.

"Susie's Senior Dogs is a *huge* deal, especially for a little grassroots rescue like mine," said Jaime Bunny McKnight, founder of Pawlicious Poochie Pet Rescue in St. Petersburg, Florida. Jaime gratefully remembered the time Erin helped her get the word out about Molly, a sweet-natured senior poodle who needed to have fourteen infected teeth removed so she could eat properly again. "I had people from all over the world calling and emailing me about Molly within moments," Jaime said. "Even if I couldn't find a perfect adoption here locally, people were willing to fly here to adopt her."

Success stories like Molly's are popular, and plentiful, on the Susie's Senior Dogs page. A close-knit pair of older female dogs who should be placed in a home together? Adopted. A twelve-year-old American Staffordshire terrier whose owners gave her up because they could no longer afford a dog? Adopted. An eleven-year-old black Lab overlooked at a shelter for more than three months? Adopted.

Susie's reach has extended far beyond the United States. In August and September 2014, Erin traveled with Brandon on part of his *Humans of New York* "world tour" in partnership with the United Nations. (While they were away, Susie relaxed in her regular New York digs and got cared for by Brandon's best friend, who crashed at his apartment.)

The epic journey took Brandon and Erin to Jordan, Israel, Kenya, Uganda, Ethiopia, South Sudan, Ukraine, India, Nepal, Vietnam, and Mexico — and, whenever she could, Erin tried to check out local animal-rescue efforts. At the Sirius animal shelter, a sprawling sanctuary outside Kiev, Ukraine, that houses more than two thousand dogs and two hundred cats, Erin was so moved by the facility's no-kill philosophy and shoestring budget that she put out a fund-raising call on Susie's Senior Dogs. Within days, Susie's followers raised nearly $6,700.

"We are beyond excited that we have not only reached our donation goal for the

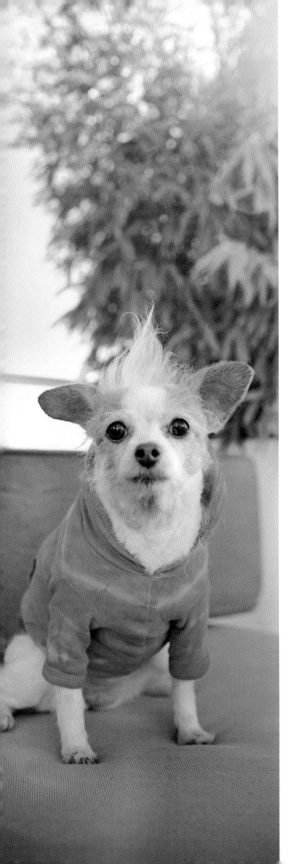

Sirius shelter in Ukraine — but we passed it," Erin posted on Susie's Senior Dogs. "Just WOW. Wow!!"

As dogs go, Susie is about as chill as they come. Very few things faze her — aside from, say, the promise of treats, the smell of chicken, and the sight of the bag Brandon uses to carry her around New York City. ("When she sees it, she starts jumping!" Brandon said.)

Brandon guesses that before he adopted her in 2011, Susie probably hadn't ever journeyed anywhere beyond her block in Brooklyn. Now she jet-sets all over the place with Brandon — not on his huge overseas trip, but to plenty of destinations in the United States and Canada.

"She's dipped her paws in both oceans," Brandon said.

"As long as she's with Brandon, she doesn't even know she's on an airplane," Erin said. "I always joke that if Susie was laying on Brandon's lap, she could be going through a firestorm and she couldn't care less!"

Lori and I met up with Brandon, Erin, and Susie in early November 2014 when the threesome traveled together from New York to Los Angeles. The swanky W Hotel on Hollywood Boulevard was an ideal spot for a Susie photo shoot; as we made our way to the hotel's rooftop deck, Susie was an island of tranquillity in Brandon's arms.

Throughout the photo session, Susie was so…*good*. She sat. She stayed. She agreeably wore shirts. She looked piercingly into the camera when asked to do so. Then, when she sensed that nothing else was required of her, she curled up against the nearest human and snoozed.

After our time together on the rooftop, Brandon had to fine-tune a speech he'd be giving for the digital marketing agency Razorfish, while Erin planned to visit one of the more hard-core

shelters within driving distance. She wanted to check out the Carson Animal Care Center, an "open admission" Los Angeles County shelter where so many cats and dogs come in that nearly 50 percent of them get euthanized.

Carson, coincidentally, is the same shelter where photographer Lori Fusaro adopted Sunny, the senior dog who led to the creation of this book. Lori told Erin what to expect and gave her some driving tips. We joked about how hard it was going to be to leave Carson without a sibling for Susie.

Wanna guess what happened?

Simon could almost be Susie's twin. When they sit next to each other, they look like an unusually adorable set of salt and pepper shakers. On November 5, 2014, this post appeared on Susie's Senior Dogs along with a photo of Simon peering hopefully out of a cage:

> "Big news! I adopted a brother today!!! His name is Simon and he is 15 years old.
>
> I'm in Los Angeles on a doggy trip visiting animal shelters. Today I went to Carson Animal Shelter and could not leave without him. Simon's human passed away recently and he was surrendered shortly after. How could I leave him there? Right? Right.
>
> More to follow soon. Goodnight!
>
> Love,
> Susie "

Simon and Susie get along swimmingly — although Erin and Brandon joke about how seldom Susie seems to notice her newest pack member. Like Susie, Simon cherishes snuggle time and does well on airplanes and road trips. His only issue is that it's a good idea for him to wear a belly band — dubbed a "pee belt" by Erin — pretty much twenty-four hours a day.

"He's fully house-trained — he'll go the whole night and be dry," Erin explained. "It's just that he's not neutered, so he marks a little bit. I think he just kind of will get excited and he'll leak."

Brandon had a different take on Simon's need for a pee belt.

"We've burned through four pillows, three comforters, six blankets, and eight sheets!" Brandon said good-naturedly. "You know how most dogs will pee in the corner? He will get out of the corner and go out of his way to get on my bed and pee on my pillow. Put that in the book!

"I told Erin, 'Simon's got a vendetta against me,' and she said, 'No, I read on the internet it means he loves you.'"

Pee issues aside, Simon fits right in, and Erin and Brandon adore him. He's a case study in something they've learned well in recent years: senior dogs make awesome pets.

"They've kind of flattened out on the energy curve a little bit, and they're very easy," Brandon said. "Susie has always been very easy, very calm — *very* easy to take care of. She's become so entwined in my routines and my life….

"I'm constantly amazed at how much this little creature loves me."

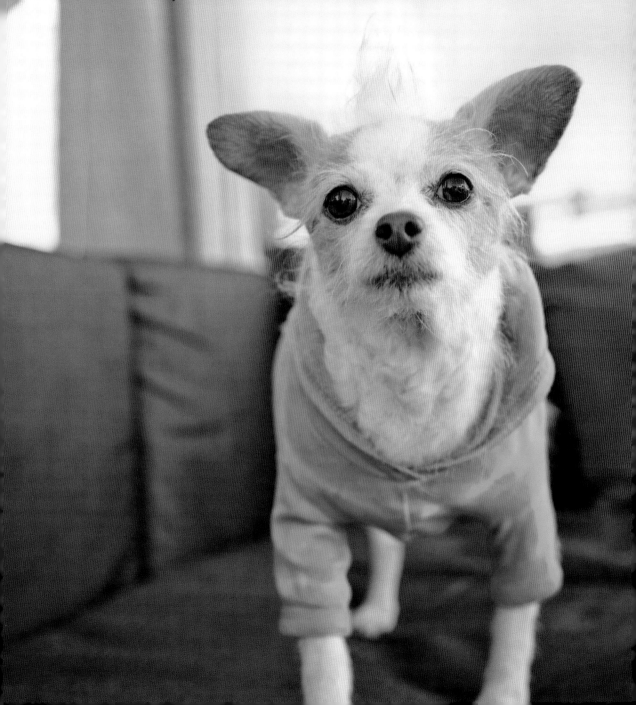

CASEY, 9

Jeannie and Bruce Nordstrom
Love to Nurture Senior
Animals in Need

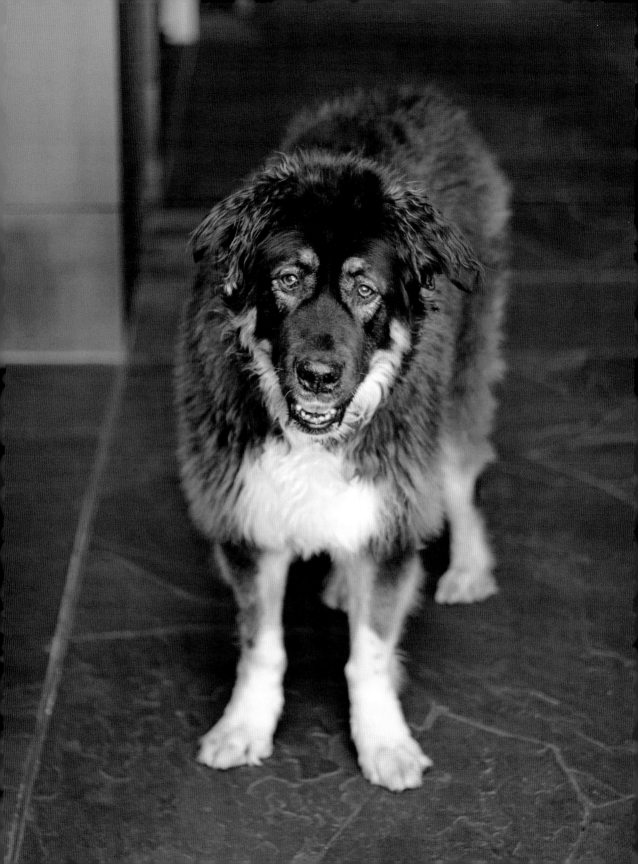

> **"**I always tell people that I think I was
> a homeless dog in another life.**"**
> — Jeannie Nordstrom

The humans behind the upscale retailer Nordstrom love senior dogs. They also love orphaned kittens. They love aging cows and goats. They love needy chickens and roosters. They could simply donate money to help all the animals they love — and they do. But their involvement goes *way* beyond that.

For nearly thirty years, Jeannie Nordstrom and her husband, retired Nordstrom chairman Bruce Nordstrom — the man who helped grow his namesake company from two shoe stores decades ago into the international fashion phenomenon that it is today — have personally provided refuge and care to hundreds and hundreds of animals.

"I've got the animal gene in me, and I can't get rid of it!" Jeannie said with a bright smile. "I always tell people that I think I was a homeless dog in another life."

The Nordstroms have taken in numerous senior shelter dogs over the years and kept them comfortable and mobile for as long as possible. One of them, an enormous Newfoundland mix named Duchess they adopted at age ten, benefited from regular acupuncture treatments and lived to be almost twenty-one.

But that's not all. Years ago, the Nordstroms purchased nine acres on Hood Canal, a glacier-carved fjord in western Washington State, to create an oasis for aging cows, miniature horses, burros, goats, sheep, and chickens in need. And at home in their downtown Seattle condo, they've fostered more than one thousand kittens in a back bedroom.

"They're so generous and hands-on," said Susan Bark, manager of the foster-care program for Purrfect Pals Cat Shelter in Arlington, Washington. "They could just write a check and remove themselves from the reality. But they know there are animals in bad situations that need help, and they *really* want to help them."

The senior dog currently soaking up Jeannie and Bruce's attentive care is Casey, a nine-year-old, one-hundred-pound girl who might be part Leonberger, part Landseer, and part Estrela mountain dog. She has an exotic face, a commanding "*Ar-roo-roo-roooo!*" bark, and the beginnings of a limp in her back legs.

"I think we're going to have to start doing acupuncture on Casey," Jeannie said. "See how she's struggling to get up a little bit? I'd rather head it off at the pass."

When the Nordstroms first encountered Casey, she had something in common with all the animals they help: she was in trouble. Casey had been surrendered to the Seattle Humane Society shelter not once, but twice. "This was a hard-to-adopt animal," recalled Brynn Blanchard, vice president of development for the Seattle Humane Society. "It's funny, though, because when Jeannie first came across Casey's picture, she called and found out Casey had been adopted already."

But that proved to be short-lived; the people who took Casey home decided they did not want to keep her. Fortunately for Casey, Jeannie hadn't forgotten about her one bit. In fact, she kept carrying Casey's picture around and showing it to people.

"About six weeks later, they called me and said, 'Guess what? She's back!'" said Jeannie, sharing her theory about Casey's long journey to their home: "I think she was looking for us!"

Jeannie guessed that Casey's protective nature might have been problematic for other families — but to the Nordstroms, the large, vocal dog is pretty much perfect. Today, Casey lives in tasteful style in a comfortable fifteenth-floor condominium with a large deck that has a sweeping view of Pike Place Market, the Seattle waterfront, the Olympic Mountains, and the Space Needle, as well as pieces of fresh sod for her bathroom breaks. Her furry roommates include another dog named Hula, two cats named Jane and Loretta, and endless litters of foster kittens who get special care from the Nordstroms until they're old enough to be adopted. (Jeannie finds homes for most of them herself through her network of friends and colleagues.)

On most weekends, Bruce and Jeannie take Casey and Hula with them to their cabin on Hood Canal. There, the dogs can romp on the beach and, if they dare, visit the Nordstroms' barn and pasture for rescued farm animals next door to the cabin.

"We have a huge cow and a medium-sized cow, and the big one is well over two thousand pounds," Bruce said. "Sometimes those cows turn on those dogs, and it scares them to death! The cows go thundering along!"

Caretakers live on the property full-time and tend to the needs of Bandit (the huge cow) and Margie (the medium-sized cow); three miniature horses named Ollie, Chelsea, and Nicki; two goats named Jimmy and Linda; three sheep named Peter, Paul, and Mary; and nine chickens.

Jeannie said it makes her happy to see such a variety of creatures thriving in their later years. "I'm a huge believer in this idea for all animals," she said. "Just knowing that, at the end of their lives, they feel safe and loved."

Bruce and Jeannie have done a lot for animals, but to the Nordstroms, it's always gone both ways. They said they'll never forget the animals who helped them through some of the most challenging chapters in their lives.

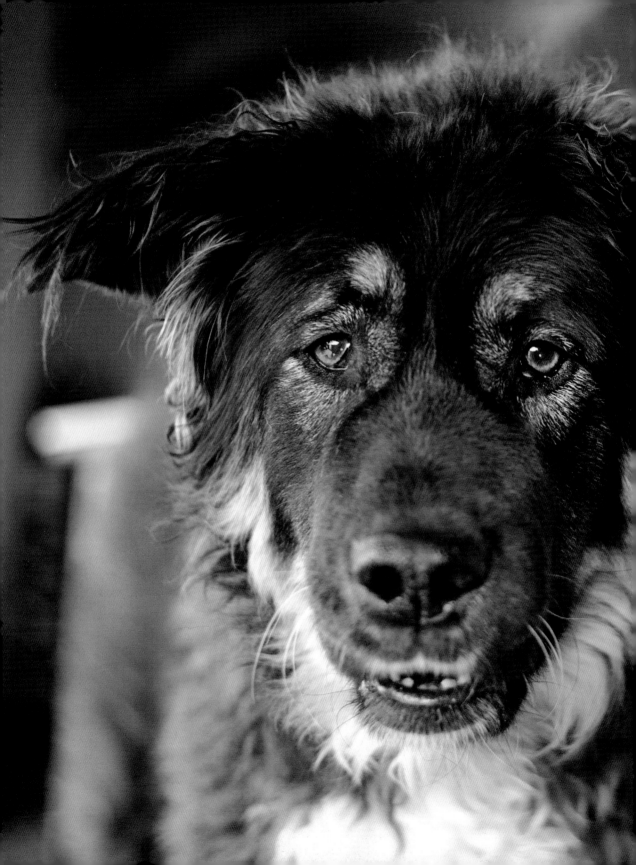

To this day, Jeannie cherishes a small photo of Stuffy, the little dog who accompanied her on her cross-country move to the Seattle area more than thirty years ago in the wake of a divorce. "She is still near and dear to my heart," Jeannie said.

Bruce said the happy spontaneity of animals helped him greatly after he lost his first wife, Fran, to cancer in 1984. "My wife was only forty-six years old, and I was fifty — so, you know, you're right in the middle of your life, right?" Bruce said. "She was such a good mother to our three boys, and she came down with breast cancer when she was thirty-five. She fought it for eleven years."

In his 2007 memoir *Leave It Better Than You Found It*, Bruce wrote, "Losing Fran was the most catastrophic thing that ever happened to me. I can't think of anything worse." He candidly chronicled his struggle with depression after she died: "I just couldn't pull myself out of it."

"We had this nice home on Mercer Island, but the boys were all gone by this time. I was just rattling around the house, which was a dark and lonely place to come home to at night," Bruce wrote. "I learned that I'm one of these guys who needs a wife; I'm horrible by myself. The only thing I could cook was bacon and eggs, which I'd have for dinner all the time. I couldn't get the bacon to come out with the eggs, so I'd eat out of the pan."

A year and a half after Fran died, Bruce decided to ask someone out on a date: Jeannie O'Roark, a woman he had met a few years earlier while running a United Way fund-raising campaign. Jeannie, a former schoolteacher, was fun, effervescent, and passionate about helping the vulnerable — particularly low-income and homeless women and children and unwanted animals.

"I came to deeply love this most thoughtful of persons," Bruce wrote in his book, adding that he "became whole again" on the day in 1988 when he married Jeannie.

"She has taught me so much about humanity, truly caring about others, and compassion for all living things," he explained.

Jeannie has loved animals since she was a little girl in West Virginia. As a young woman in Rochester, Minnesota, she helped investigate animal cruelty for a local humane society. She always knew she wanted to do as much as she could to help homeless and neglected animals.

"Jeannie still had Stuffy when we first got married, but Stuffy didn't last real long after that," Bruce remembered. "Then we looked at each other and said, 'What are we going to do?' So we started adopting dogs, and she started bringing in all these cats, and before long we're up on the fifteenth floor in our condominium and we've got dogs and cats and everything else running around!

"It helped me a lot in my bereavement. It was just great. And for Jeannie, she finally had a chance to really expand her basic love for animals because we could afford to do it. And we did it!"

Together, Jeannie and Bruce became major supporters of the Seattle Humane Society, Purrfect Pals, PAWS–People Helping Animals, and other groups — all while pursuing

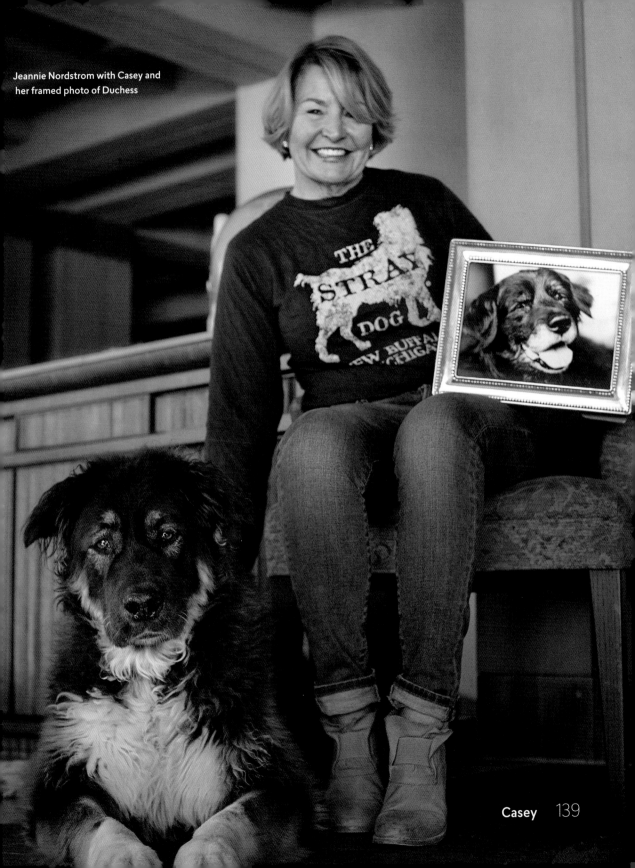

Jeannie Nordstrom with Casey and her framed photo of Duchess

extensive animal-rescue efforts of their own. They've taken in farm animals from Pasado's Safe Haven, Center Valley Animal Rescue, and Hope for Horses, and they've bottle-fed kittens in the middle of the night.

"When we first started in 1993, Jeannie was literally doing litter after litter after litter of kittens," said Kathy Centala, founder of Purrfect Pals. "She'd always be ready for another one, and then she placed 99 percent of them herself!…It always amazes me how absolutely down-to-earth she is. It's never about her at all — it's *all* about the animals. We would not be where we are today without her."

So many different critters have animated Jeannie's and Bruce's lives over the years, but ask them both, and they'll tell you: there's something about senior dogs.

"It just breaks my heart that older dogs end up in shelters," Jeannie said. "It must be so confusing to them to be in a home for a long period of time and then end up in a shelter at a later age."

Bruce agreed, noting, "You have more sympathy for them as they get older — because they're older. We, who are supposedly smarter, should help them."

Every few years, the Nordstroms can't resist rescuing a senior pooch who's run out of options. Rosie, Sweetie, Biscuit, and Stella were all lucky dogs in that category, as was Duchess, whose framed eight-by-ten portrait holds a place of honor in Bruce and Jeannie's condo. In the late 1990s when they first met Duchess, the ten-year-old Newfoundland mix had been languishing at the Seattle Humane Society for six weeks. No one wanted to take a chance on such an old, large dog. Jeannie fell in love immediately, but Bruce cautioned her about potential heartbreak. "You need to know that big dogs like this don't go past ten very much," he told her.

"I don't care," Jeannie said. "If we can help her have a good life, however long that is, I would like to do that. I don't want her to be alone in a cage."

"All right," Bruce replied. "You got it."

Duchess wound up astonishing veterinarians with her longevity; she flourished in the Nordstroms' care for more than a decade. At the condo, she'd relax on soft dog beds; at the cabin, she'd frolic on the beach and go "fishing."

"She'd go in until the water was just touching her on the stomach, and then she'd wade around until she'd spot a little fish or something, and she'd try to get it!" Bruce said. "She'd do that for the longest time — she just loved it."

When Duchess turned eighteen or so and began to have a harder time getting around, Jeannie and Bruce couldn't bear to deprive her of her fishing expeditions. So Bruce donned his waders and devised a plan. "I'd take her in the water and put a strap underneath her to hold her hind end up, and she'd swim with her front paws," Bruce said. "Oh, she enjoyed it! And I enjoyed it!"

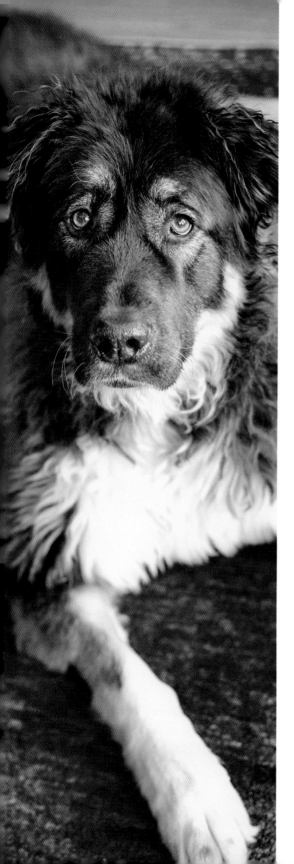

In his memoir, Bruce wrote that marrying Jeannie reconfirmed for him "how wonderful life is."

"She just has this unwavering love for animals," he said. "I think it helps our marriage. Caring for them takes us out of ourselves a little bit."

Bruce was nine years old when he started sweeping the stockroom floor of the company his grandfather, John W. Nordstrom, and Carl F. Wallin founded as a shoe store in 1901. He became president of Nordstrom in 1963, and he retired as chairman of the board in 2006 — but he still goes to work every day. ("I don't do too much anymore, and I shouldn't," he quipped. "An eighty-one-year-old man shouldn't run a successful fashion business.")

His spacious office at Nordstrom's corporate headquarters in downtown Seattle is filled with photos: of him and Jeannie beaming on vacation in Hawaii; of his three tall sons, Blake, Pete, and Erik, the fourth generation of Nordstroms to lead the company; and of — you guessed it — animals.

One photo collage labeled "Our Family" includes happy portraits of the Nordstroms' dog Casey and their late senior rescue dog Stella, along with cats, goats, chickens, and miniature horses. Bruce gave a rundown: "This dog is still alive; she's passed; she's passed; she's passed; he has not passed, and he's *old*; she's passed; she's still alive; she's still alive; she's passed….We sure have had a lot of them."

Jeannie said her husband should be sainted for embracing animal rescue as much as he has. Bruce declared that his wife deserves a medal.

"Oh, I love animals — I really do," Bruce said with a wide grin. "But she loves them more!"

DUVAL, 14

This Reading-Assistance
Dog Is the Best Listener Ever

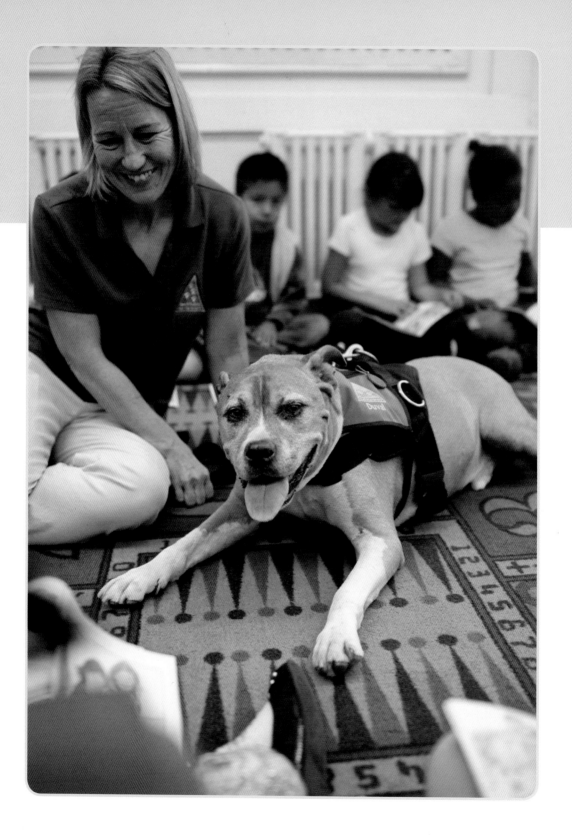

"I wish Duval was my dog!"
— An adoring first grader

Sometimes, the best teacher can be a dog.

Seriously. Just ask a teacher.

"One of my first graders told me, 'I like reading to Duval because he doesn't judge me when I read' — and oh my gosh, that is so true!" said Ryoko Matsui, an elementary school teacher in Los Angeles. "Especially with insecure kids, I've watched him build their confidence."

Duval is a certified therapy dog and reading-assistance dog with an impressive attention span. At age fourteen, Duval still boasts a commanding presence — people sometimes call him the sheriff, or the mayor — but that belies some fundamental truths about him: he's a goofball who loves everyone he meets, and he has a knack for bringing out the best in children.

Again and again in Ms. Matsui's classes, Duval has soothed struggling students and given them the quiet courage they need to read out loud. He's helped so many kids over the years that the grown-ups who know him sometimes wonder: What if his gifts never got discovered?

Back in 2006, Duval's future was uncertain. The man who nurtured Duval for the first six years of his life adored him, but his own life was in such a state of transition that he could no longer keep him. Duval also suffered from such severe skin allergies that he appeared to have mange.

"And on top of that, he was a pit bull," said Peggy Kennedy, the Los Angeles woman who adopted him along with her husband, William. "We knew that a six-year-old pit bull with horrible skin allergies was going to have a tough time finding a home, no matter how awesome he was."

Peg and Will first met Duval for business reasons. Peg owns a pet-sitting and dog-walking service in Hollywood Hills called Fetch! Pet Care, and Duval entered her life as a four-legged client. "My husband was so nervous about having this unknown pit bull

come stay with us," Peg recalled. "But that all flew out the window when he met Duval. I left to walk another dog and returned to find Duval lying on my husband's chest. My husband fell in love. When it was time for Duval to go, my husband looked sad and said, 'Can't we just keep him?' I said, 'No, he has to go back to his owner!'"

As it turns out, Ken Jaffe, Duval's original owner, was trying to tamp down a sense of dread. Ken was going through a divorce, and he had just driven across the country from northwestern Vermont with his two dogs, Duval and a miniature dachshund named Max. (Actually, here's a quick point of clarification: Max's full name is Maximilien Menachem Tiananmen Smooth.)

The dogs were ideal travelers on the long road trip, and Ken viewed them as family — but their new life in Los Angeles was vastly different from their rural existence near the Canadian border. Duval's skin erupted in the sun and heat, and Ken's new job had him working long, unwieldy hours. What's more, landlords rebuffed Ken because he had a pit bull. "It was right around then that I began to think the unthinkable," Ken recalled. "It just hit me: I can't give my dogs the care they need."

Ken noticed how smitten Peg and Will were with Duval, so he acted fast without giving himself time to overthink anything. He surprised the couple with a question: Would they consider keeping Duval?

"We loved him so much that we said we would," Peg recalled. "It broke our hearts because we really wanted to take both dogs, and we didn't want to break Duval and Max up. But we already had another dog, and we just couldn't have three. We were moving, and it was going to make it that much harder for us to find an apartment."

Max was so friendly and cute that he got adopted almost immediately, landing in a nice house tailor-made for miniature dachshunds, with special ramps leading up to the couches and beds. Duval went to live with Peg and Will.

"It all came together in twenty-four hours," said Ken, now an aspiring composer in Culver City, California. "I was stepping very, very carefully because these were my kids, but sometimes in life things just come together beautifully."

Peg and Will have never stopped being smitten with Duval — but they were blind-sided by how much veterinary care he would need over the years. They've tried prednisone, antibiotics, and Atopica for his chronically inflamed skin, and topical creams and special booties to prevent his paw pads from cracking open and bleeding — a problem that plagued Duval for years.

Still, despite obvious discomfort, Duval always rallied, eager to have a good time. When Peg would take him to the Zoom Room, an indoor dog park in LA, he'd get so animated he'd almost explode. "He gets so vocal when he's excited: 'Row-row-row!'" Peg said, laughing as she did her best Duval impression. "'Row-row-row, I'm a happy, friendly dog, and I'm so happy to be here!'"

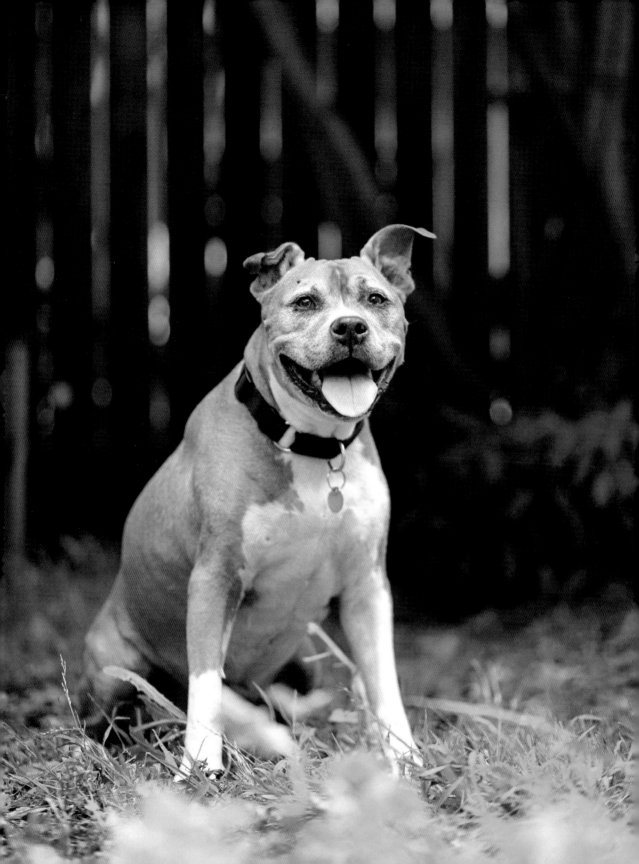

Shortly before Duval turned eleven, Peg got to thinking: he sure would make a great therapy dog. First, she had Duval take the American Kennel Club's Canine Good Citizen Test, which he passed with ease. Next, she and Duval got certified as a therapy dog–handler team through Pet Partners and its local chapter, Paws 4 Healing. After that, they went a step further and became certified as a reading education assistance dog (READ) team.

LA public school teacher Ms. Matsui — who also happens to be an avid dog rescuer — pounced on the opportunity to have Duval help her students with their reading. "All animals are amazing, but Duval — he's just so special," said Ms. Matsui. "I had this one really, *really* shy boy, and Duval singled him out and put his head right on his lap. That little boy started laughing out loud. It was so heartwarming to me!"

Duval and Peg volunteered in Ms. Matsui's first- and third-grade classes for three years. The veteran teacher noticed that her students' behavior and focus would improve in the days leading up to a Duval visit because every child in the room longed for the chance to read to him. Ms. Matsui also gave her students writing assignments about Duval, then smiled as everyone rushed to complete them. Excerpts from her first graders' papers reveal the love-fest that would ensue whenever "Duval the Thera-pit" entered the room:

> "I wish Duval was my dog so he could listen to me read, and so Duval could meet my dog, Buddy."

> "I like Duval because he is sleepy."

> "I wish I could play ball with Duval."

> "I want Duval to be my pet."

> "I wish Duval was my dog, so he could listen to me read again because he is my favorite dog."

> "I wish I could read a book for Duval at my house."

> "I wish Duval was my dog!"

"It made me laugh so hard that so many of them would practice *so* much for Duval, but not for me or their parents!" Ms. Matsui said. "I mean: *oh my gosh!*

"Peggy and Duval have done so much for the kids, and I know it's something that the kids will never forget. They're not going to come back and visit me and say, 'Remember how you taught me multiplication?' They're gonna say, 'Remember Duval?!'"

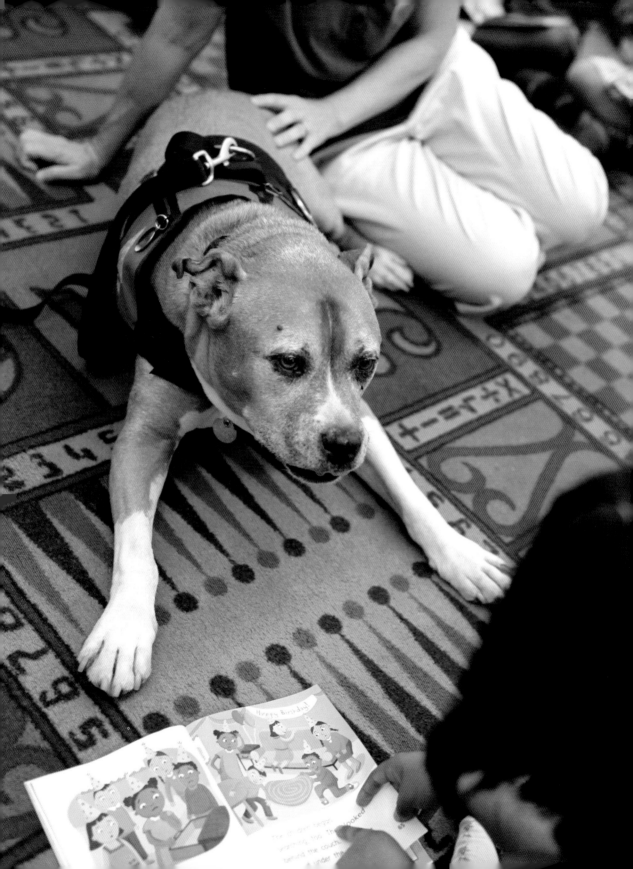

Peg brought Duval to elementary school classes for as long as she could, then retired him two days before his fourteenth birthday. He was having too much difficulty moving around, and he started to have occasional bathroom accidents.

These days, Duval is outfitted with a supply of doggy diapers and an assortment of cushy dog beds. Peg and Will have employed a system of kid gates around their cozy LA apartment to prevent Duval from hobbling his way into narrow rooms, like the kitchen or bathroom, and getting stuck there. Instead, he has full access to the living room and dining room, where he likes to shuffle between his dog beds, slowly and carefully, for a change of scenery.

"I'm constantly reinventing what I can do with him," Peg explained. "Sure, he can't go running or hiking with me anymore. But I got him a wagon, and I take him to the park in that. He doesn't *love* to go in the wagon, but he still looks so happy in it anyway. I'll still see that smile.…

"It feels almost a little bit selfish, but there's something so wonderful about having a senior dog to take care of — to be able to make their final months or years, whatever they have left, as enjoyable as possible for them. I wish that I could take in more. I see these seniors at the shelter all the time. I want to take them in and show them some love and feed them some meatballs."

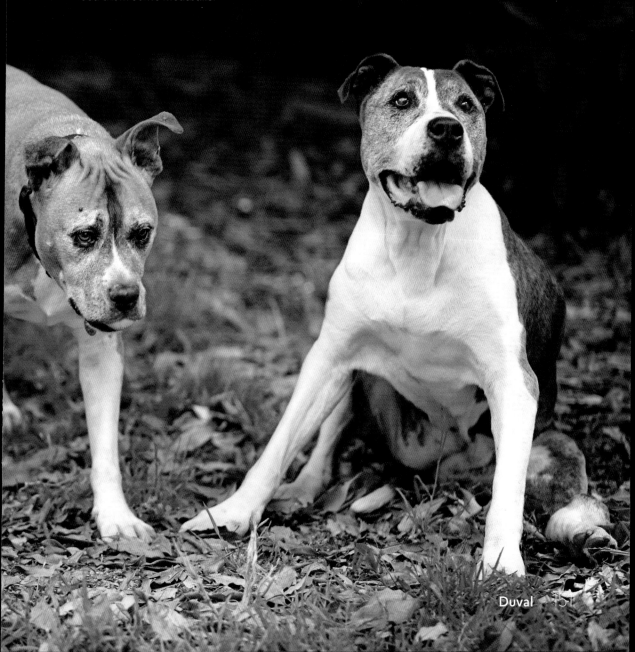

PART 4

Retiring with Purpose

CULLEN, 9

A Retired Service Dog
Finds Joy and Meaning
in a New Line
of Therapy Work

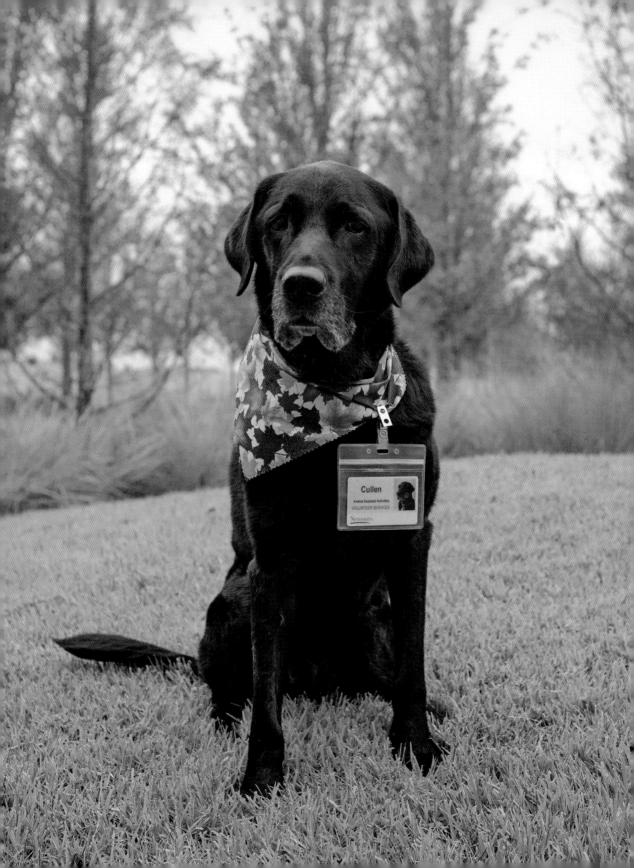

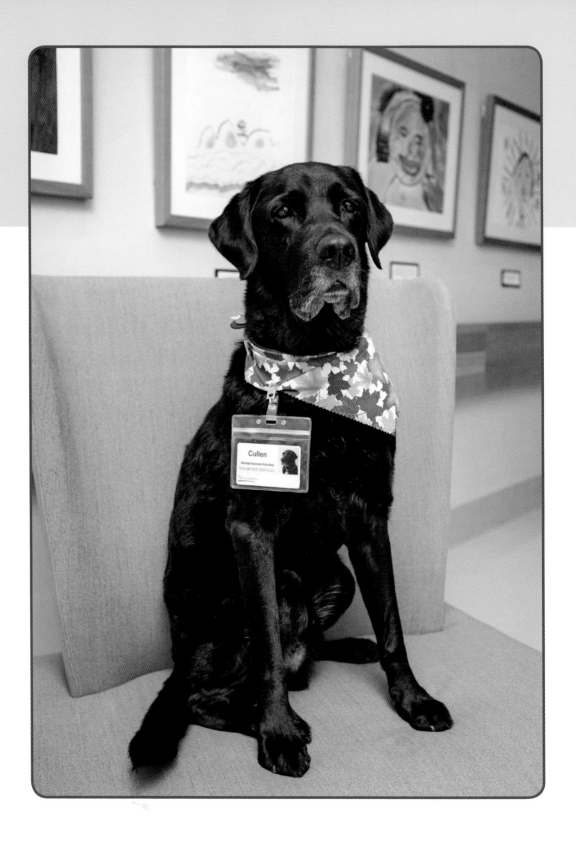

> **"** I think that God put animals in our lives
> to make this journey easier. **"**
> — Kristie Baker

Cullen walks the halls of Nemours Children's Hospital in Orlando with a certain swagger. He knows where he's going, and he knows what he's there to do.

The black Labrador retriever is earnest and all business — someone who understands the rigors of great responsibility. But in his role as a therapy dog for ailing children and teens, he's figured out just when to cut loose to make a kid smile.

"He used to be a service dog," Cullen's handler, Jeanne Curtin, explained to Kristoffer, a hospitalized fifteen-year-old with stitches on his scalp. "He knows how to do all kinds of different things, like push doors closed or open drawers.

"Here," Jeanne said, handing Kristoffer a bottle of hand sanitizer. "Drop that on the floor."

Thunk! went the hand sanitizer.

"Cullen, get!" Jeanne commanded. The dog picked the bottle up with his mouth and brought it back to Kristoffer. A happy grin crept across the teen's face.

The smiles kept coming as Cullen followed commands to "visit" (up-close affection and tail wags for Kristoffer) and "spin" (a move that's just plain fun).

"Dogs just seem to know," Kristoffer said. "My dogs at my house, they can sense if anything's wrong. They come up to you. They put their head on your lap. I miss them."

"I hope our visit helped a little," Jeanne said.

"It did."

At least once a week, Cullen makes his rounds with purpose and professionalism at the children's hospital, but therapy work is relatively new for him. He spent almost six years devoted to just one person: Kristie Baker, a sixty-four-year-old Florida woman who contracted polio when she was four.

Cullen was the third of four service dogs assigned to Kristie by Canine Companions for Independence, an organization that trains service dogs and has paired them with more than four thousand disabled children and adults. Kristie lives alone, and Cullen

did so much for her: picked up keys that fell to the ground; carried grocery bags from her van to her kitchen; deposited her used plastic dishes in the sink; put her dirty clothes into the laundry basket, then dragged the basket to the utility room.

"It's amazing to see how these dogs can change someone's life," said Jeanine Konopelski, national marketing director for Canine Companions for Independence. "They allow people to do a lot of things that many of us might take for granted."

One of Cullen's biggest responsibilities was also the most physically taxing: pulling Kristie around in her wheelchair when she couldn't maneuver it herself. Over time, Cullen began to have intermittent attacks of ataxia, losing control of his muscles. "That could have been a safety issue for us if we were crossing a busy roadway or something," Kristie said. "That never happened, but if it did, it could have been very bad for both of us."

By 2013, Kristie knew Cullen needed to retire. She also knew she could only manage one dog at a time. She said the prospect of losing contact with her most understanding pal was crushing, but the idea of Cullen feeling like a "second-class citizen" in the presence of a new service dog was even worse.

"The working dog has to be primary, and that wouldn't be fair," Kristie said. "Cullen had been the one and only dog in my life. I would still have loved him, but I couldn't have taken him with me anyplace. After everything that he's already done, he doesn't deserve that.

"It's hard. Oh, it's hard to give them up," she added, starting to get choked up. "But you have to make the best decision for the dog."

Jeanne Curtin first met Kristie twenty years ago when Jeanne embarked on a special kind of volunteer work: training a puppy to become a future service

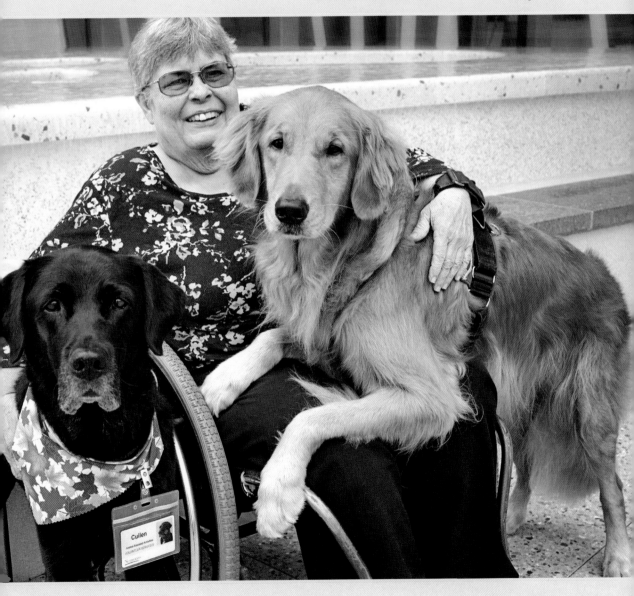

Kristie Baker with Cullen and her current service dog, Hobbes

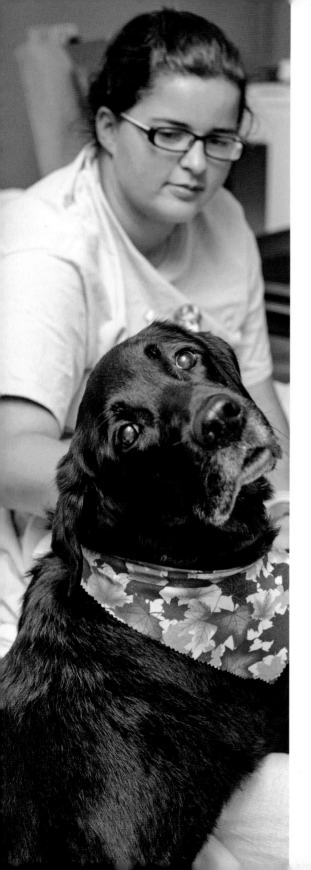

dog for Canine Companions for Independence. "I didn't know what I was doing!" Jeanne recalled. "I would make my puppy mimic the behavior of whatever Kris's dog was doing at the time."

Their friendship grew closer over the years, and when Jeanne heard about Kristie's dilemma with Cullen, she didn't hesitate: "I offered to take Cullen so they could still get to see each other all the time. It's been great!" Kristie's home in Orlando is about twenty miles away from Jeanne's property in Chuluota — five fenced-in acres dubbed "dog paradise" by Kristie.

"It's tremendous," Kristie said of the ongoing relationship she gets to have with Cullen. "If I could not be close to him, that would just rip my heart out. I don't know what I would do."

Cullen now enjoys a cushy retirement with Jeanne and her husband, Kevin, and five other dogs — most of whom are black rescue dogs. ("That's kind of our thing," Jeanne explained.) One of the six dogs in the couple's care, an enormous Labrador retriever puppy, is Jeanne's fifteenth service-dog-in-training.

The dogs get to swim in Jeanne and Kevin's pool, roam the property in safety, and relax on soft dog beds in front of a fireplace. It's the ideal retirement community for a dog like Cullen — but Jeanne sensed something after he came to live with her in April 2013. Could Cullen be...bored?

Jeanne knew that retired service dogs could make fabulous therapy dogs, so she got Cullen registered with Therapy Dogs Inc. in July 2013. The pair began visiting Nemours Children's Hospital once a week and an assisted-living facility twice a month. When Cullen sees Jeanne getting her red volunteer vest out and readying his special work bandanna — look out.

"He comes alive!" Jeanne said. "He really enjoys having something like this to do."

One overcast Saturday morning at the children's hospital, Cullen cheered up Kristoffer, the

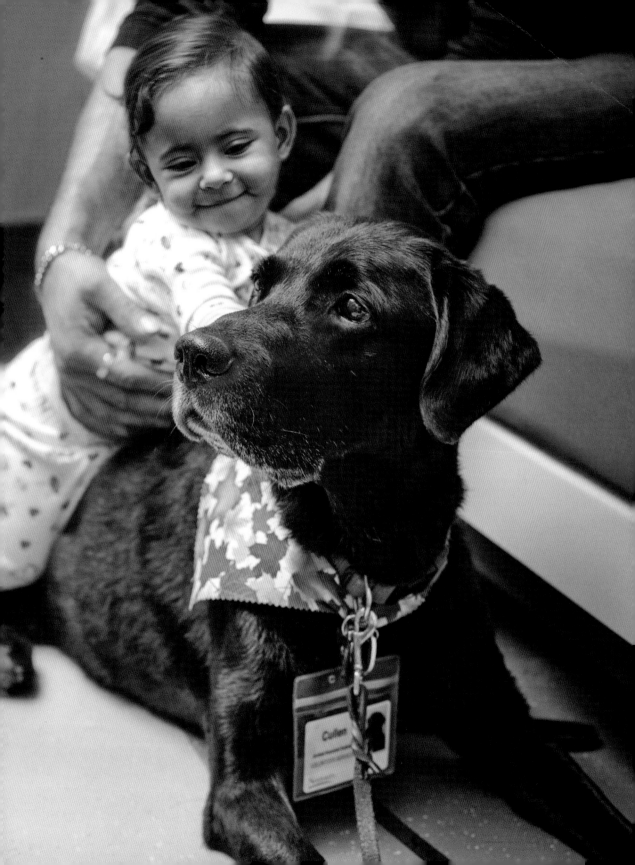

teen who had been missing his dogs during his lengthy hospitalization after undergoing brain surgery. Cullen also visited Jorge, a twelve-year-old boy with appendicitis; Heather, a teenager experiencing mysterious abdominal pain; and Azulianys, a ten-month-old girl with hemangiomas, or abnormal collections of blood vessels, on her lip, arm, and back.

Azulianys *loved* Cullen, and Cullen knew what he needed to do for her. He parked himself on the floor so she could lean into him, coo at him, and pull off one of her pink socks and offer it to him.

"He often does this — lets kids climb on him," Jeanne said. "They'll lie on the floor and hug him and whisper in his ears and tell him secrets."

On weekdays, Cullen is a regular in a room at the hospital where children receive chemotherapy. He forms relationships with kids who are consistently there over a period of weeks. "One little girl had less and less hair every time we saw her," Jeanne recalled. "She was petting Cullen one day, and she said, '*Oh no*, you're shedding! Oh, don't you worry, Cullen — my hair's falling out, too. It will be fine.'"

The role of therapy dogs at children's hospitals like Nemours is huge — and growing. More than fifteen thousand children are diagnosed with cancer each year in the United States, and more than forty thousand receive treatment. To measure the potential power of dogs, a study called "Canines and Childhood Cancer" is under way by American Humane Association and Zoetis, a company that makes medicines and vaccines for animals. Its aim is to demonstrate scientifically whether young cancer patients and their parents experience less stress throughout the course of treatment when they receive 15-minute visits from therapy dogs once a week.

"It seems like so little, just going in and saying hi and a few pets on the head," Jeanne said. "But it's amazing what a difference it can make."

When they reach retirement age, many of the dogs placed by Canine Companions for Independence continue living with the disabled people they helped. If that isn't feasible — as it wasn't for Kristie when Cullen needed to retire — the dogs typically return to the people who raised them as puppies. Cullen didn't have either of those options, though: he was raised by an inmate in a men's prison.

"He's a prison puppy!" Kristie said. "Lots of service dogs get trained in prisons. They benefit from having that real intense, close, 24-7 relationship with the prisoner who's working with them."

Yes, if Cullen could talk, he'd be one of the most interesting cocktail-party guests imaginable. Still, he doesn't need words to convey one key detail about his past: he loves Kristie. When he sees her, his serious demeanor melts away, and his whole body starts to shimmy. During a recent visit, Cullen and Kristie's current service dog, Hobbes, smiled at each other with an elated air, then came to Kristie for pets. "Oh, there they go — your two men are fighting over you again!" Jeanne joked.

Kristie hooted with laughter as she scratched both dogs. "Ah — this is my blood-pressure medicine!" she said.

Kristie marvels at all the physical tasks her service dogs have done for her all these years, but she said the greatest benefits to her well-being have been social. They serve as cheerful, furry icebreakers and conversation starters. "Before I had a dog, if I'd go some-place with friends or family and I was in a wheelchair, people would look straight over my head," she said. "They'd say to the people with me, 'Well, is she hungry? Do you want a menu for her?'"

Kristie actually sympathizes with people's awkwardness around her; even her own mother taught her not to stare at someone in a wheelchair because it was rude. "But when you don't stare at somebody, what do you do? You look away," she said. "And if you can't make eye contact with somebody, how can you make friends? How can you have a conversation?

"One of the functions of these dogs is to be that bridge. Now it's no longer 'Oh, that poor person's in a wheelchair.' Now it's 'Look at that lucky lady with a dog! She gets to take that dog in here!' Then that opens up an opportunity to talk to people."

These days, as a semiretired nine-year-old, Cullen seems to sense that he's got it pretty good. And Kristie loves to see him thriving and continuing to do meaningful work.

"Dogs live up to what you expect of them," she said. "If you expect more, they'll keep astounding you with what they're able to do."

BRETAGNE, 15

The Last Known Surviving 9/11
Search Dog from Ground
Zero Still Lends a Helping Paw

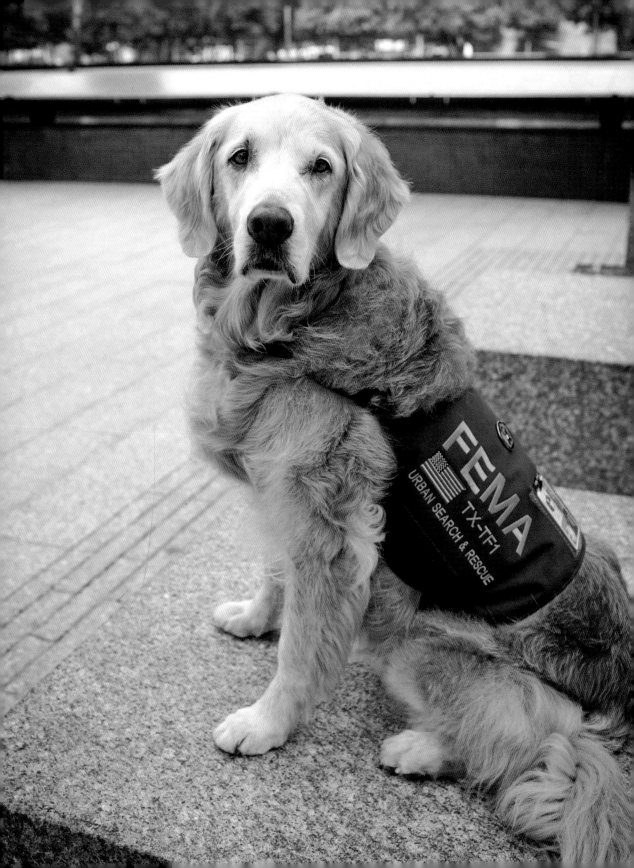

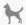

> **"**The best way to find yourself
> is to lose yourself in the service of others.**"**
> — Mahatma Gandhi

Some heroes boast muscle and brawn. Others possess steely nerves and impeccable timing. But this hero is a little different.

This one has feathery fur, a sunny smile, a calm nature, and — for a dog — an uncanny ability to zero in on the people who need her most. She's a golden retriever named Bretagne (pronounced "Brittany"), and she's the last known surviving search dog who worked at Ground Zero in New York City after the September 11, 2001, terrorist attacks.

In September 2014, at the age of fifteen, Bretagne returned to the site of the former World Trade Center complex with her longtime handler and owner, Denise Corliss of Cypress, Texas. Denise hadn't been sure about coming back to this place — ever. She was afraid seeing it in person might rip her apart. She kept her dog close as she gazed at the 9/11 Memorial's enormous waterfalls and reflecting pools, which are surrounded by bronze panels bearing the names of the nearly three thousand people killed on September 11.

The leaves of the memorial's oak trees shuddered in a silent breeze; the new One World Trade Center skyscraper, previously dubbed the "Freedom Tower," loomed behind them. Bretagne sniffed the air and remained on high alert. Her mom was crying.

"Seeing this kind of took my breath away a bit, similar to how the pile was the first time I saw it," Denise said that morning. "It's so calm and peaceful now, unlike the chaos of before. After 9/11, everybody — all of us — felt such sadness. We all wanted to help. I just felt so honored that we were able to respond."

Bretagne is an anomaly for this book because she was not adopted as an older dog. Her story is here, though, because Bretagne's retirement years demonstrate the potential all dogs have as they age. In fact, the second half of Bretagne's life has been almost as surprising as the first. That's because Denise got timely encouragement to rescue Bretagne from something that afflicts many older dogs: boredom.

"I'm so grateful I learned this before it was too late," Denise said. "Dogs are like people, and they aren't happy sitting in a corner not being active. They still want to be involved in the world. They want to be included!"

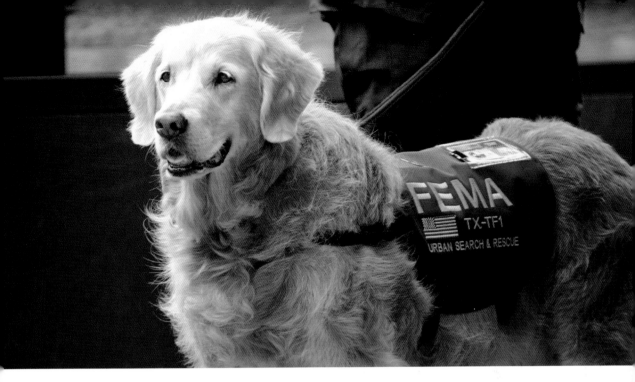

In 2014 alone, Bretagne strutted down a red carpet in Beverly Hills, raised money for charity, and spent quality time with NBC News legend Tom Brokaw for special 9/11 broadcasts in New York. She also helped first graders in Texas gain confidence reading out loud, and she got plenty of exhilarating yet low-impact exercise.

Just a couple of years earlier, none of Bretagne's 2014 experiences would have seemed possible. At age thirteen, Bretagne started to experience so much stiffness and joint pain that she could no longer climb the stairs in her home.

"I was *so* worried about her as she was getting older," recalled Denise. "And then my vet told me, 'Denise, you can't treat her like a china doll. You have to let her be physically and mentally stimulated. Don't protect her so much that she withers away.' That was a wake-up call for me."

Denise installed an above-ground pool in her backyard and let Bretagne swim for at least ten minutes a day. "It made a *huge* difference," Denise said. "She started doing the stairs again….Now I have to do something with her every single day, or she just barks at me. She wants to play or swim or run around a lake near our house — and you should see her go! She's trotting in front of me, and I'm having to jog to keep up with her!"

Denise also thought hard about ways to help Bretagne stay mentally active. That led to Bretagne serving as a reading-assistance dog at a nearby elementary school. "Helping kids with their reading in school is great for Bretagne," Denise said. "It helps her as much as it helps them."

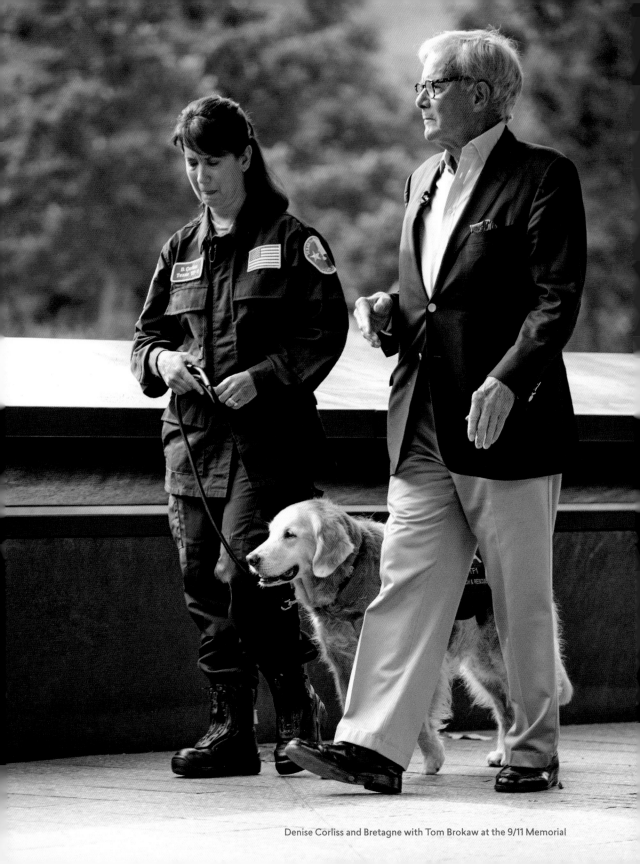

Denise Corliss and Bretagne with Tom Brokaw at the 9/11 Memorial

These days, whether she's assisting in the classroom or looking alert and regal during high-profile television appearances, Bretagne clearly doesn't care that she's closing in on one hundred in human years. She loves staying active, and her motto is apparent: Never retire.

"She still has this attitude of putting her paw up and saying, 'Put me in, coach!'" Denise said. "Nothing makes her happier than going to work."

Bretagne's work ethic got ignited at an early age. It began in the late 1990s, shortly after Denise, an electrical engineer, became fascinated by the work of disaster-search dogs. Denise learned that civilian volunteers — who receive no pay and work and travel at their own expense — can undergo rigorous training with their dogs and become qualified to assist federal emergency-response efforts. If they make the cut, the dog and handler can support emergency-response teams at disaster sites around the United States.

In the fall of 1999, Denise brought home Bretagne, a wriggly eight-week-old puppy who had much to learn and wanted to learn it. "I was so excited about doing this, but I didn't have the appreciation of how life-changing it would be," Denise recalled. "It took twenty to thirty hours a week, easily, to stay on top of training. This is what I did when I wasn't at work."

In 2000, Denise received news that thrilled her: she and Bretagne qualified as official members of Texas Task Force 1. This meant the pair had what it takes to scour a disaster site and find survivors buried in the rubble.

What they never could have anticipated was the site of their first deployment: the twisted pile of steel beams, concrete, and ash where the World Trade Center once stood. It was a harrowing assignment for the most seasoned rescue workers, and it could be a frustrating one for search dogs because there were no human survivors to be found — only human remains. "I really believed we could find somebody — anybody! — if we could just get to the right void space," Denise said. "But our reality was much different. We found all various kinds of remains, some recognizable, others not so much."

Bretagne persevered through nearly two weeks of twelve-hour shifts at Ground Zero. On her very first search, she had to balance precariously on a wet metal beam — and she slipped. But she recovered quickly, pulling herself back up onto the beam with her front paws and continuing to sniff intently as if nothing had happened.

Even though she had just turned two — an age when many canines relish romping, chewing, and making mischief — Bretagne was focused on the mission and always ready to offer comfort to grim-faced first responders. On one occasion, Bretagne left Denise's side and hurried toward a sullen firefighter sitting on the ground. Concerned, Denise implored Bretagne to come back, sit, and stay — to no avail. "I was surprised that she wasn't listening to me, but she really wasn't — it was like she was flipping me the paw," Denise said. "She went right to that firefighter and laid down next to him and put her head on his lap."

Cindy Otto, a veterinarian who provided medical care for 9/11 search dogs at Ground Zero, said the three hundred or so dogs who worked the pile of rubble brought much more to the job than their capable noses. "You'd see firefighters sitting there, unanimated, stone-faced, no emotion, and then they'd see a dog and break out into a smile," Dr. Otto recalled. "Those dogs brought the power of hope. They removed the gloom for just an instant — and that was huge because it was a pretty dismal place to be."

Dr. Otto spent years tracking the health of dozens of 9/11 working dogs after the terrorist attacks. Among her favorite findings: search-and-rescue dogs tend to live longer than other dogs. "They have a bond with their handlers, they have purpose, they have physical fitness — it's all really good for the dog and for the person who does this work," she said. "Even on terrible assignments when they're finding remains instead of survivors — can you imagine the closure they provide for families?"

Her work with the 9/11 dogs inspired Dr. Otto to launch the Penn Vet Working Dog Center at the University of Pennsylvania on September 11, 2012. Through the center, dogs like Bretagne continue to be monitored, and puppies get trained to sniff out everything from explosives to diseases to live humans buried in rubble.

As a tribute, the puppies in training at the Working Dog Center all get named after 9/11 dogs. Bretagne's namesake, dubbed "Bretagne 2," moved in with a New Jersey man named Wayne Mowry who has type 1 diabetes. Bretagne 2 paws at Wayne's leg to alert him when his blood-sugar level is out of normal range and he needs to eat.

"That makes me so proud!" Denise said. "I'm so humbled that they would find Bretagne worthy to have a puppy named after her who's carrying on the tradition of the working dog."

In the years that followed 9/11, Bretagne and Denise deployed together in response to numerous disasters, including Hurricane Katrina, Hurricane Rita, and Hurricane Ivan. Bretagne retired from formal search work at age nine, and Denise trained another search dog named Aid'N. Then Aid'N grew too old for search work, and Denise began training Taser, a golden retriever.

"I call our house a geriatric home for retired search-and-rescue dogs!" said Randy Corliss, Denise's husband of twenty-three years. "I've got those two sitting on the couch watching the young one go out the door to go to work — and you know, the older dogs are not happy about that."

But since Denise learned the value of keeping older dogs active and engaged, life is anything but dull for Aid'N and Bretagne. In fact, in September 2014, American Humane Association recognized Bretagne as one of eight finalists for its annual Hero Dog Awards. Bretagne flew with Denise to Los Angeles for the black-tie awards gala, complete with a swanky strut down an actual red carpet. The dog beamed throughout the night without showing any sign of her past mobility problems; her status as a Hero Dog finalist resulted

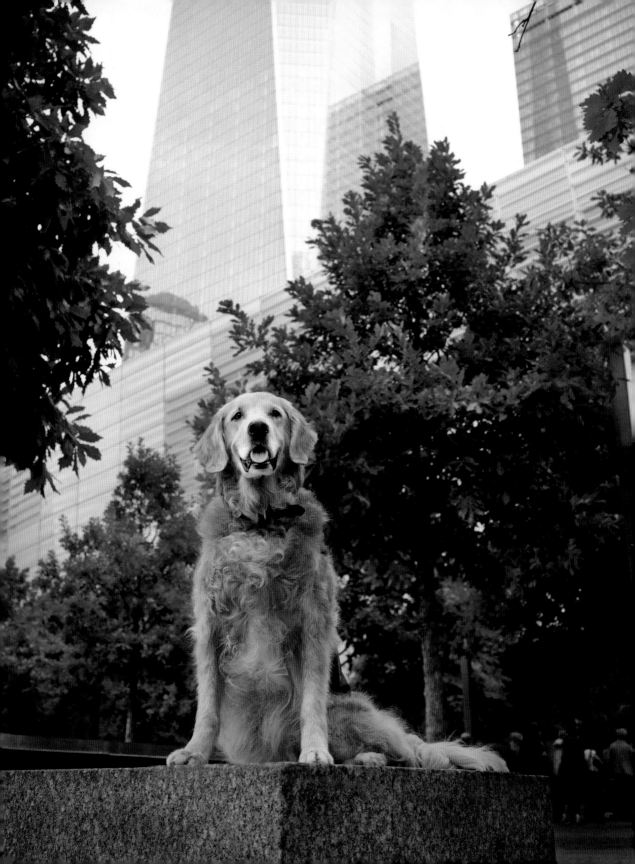

in a $1,500 donation for the Penn Vet Working Dog Center and a prime-time television appearance on the Hallmark Channel.

Earlier that same month, Bretagne and Denise traveled to New York and returned to Ground Zero for the first time since the 2001 attacks. Denise did become emotional during that visit, but she acknowledged how valuable it was for her to come back to the site thirteen years later. "It is so important not to forget what happened here," she said. "We *can't* forget."

Tom Brokaw spent time with Denise and Bretagne at the 9/11 Memorial, and then shared their story on the *TODAY* show and *NBC Nightly News* on September 11, 2014, in concert with a story I wrote for TODAY.com. Throughout their morning together in Lower Manhattan, Brokaw clearly was smitten with Bretagne.

"Bretagne is so laid back…but, 'When you need me to go to work, I'm ready!'" Brokaw told me after he concluded his interview with Denise. "It's amazing."

Brokaw said search dogs like Bretagne have fundamentally changed recovery efforts at disaster sites. "They have this inner scope in them when something's wrong or something's right," he said. "I think it's a great tribute to canines, I really do." The ardent dog lover also understood Denise's concerns about Bretagne's comfort and well-being as she aged.

"I've had older dogs, and they changed my life," Brokaw said. "When I lost a dog that I had, it was the most heartbreaking thing imaginable — but on the other hand, she had given me such a great, great life."

Bretagne's enduring love of work is obvious every time she dons her service vest and prances purposefully through Roberts Road Elementary School in Hockley, Texas. As a reading-assistance dog at the school, she tends to sense which students and teachers are having rough days in much the same way she did for that firefighter and other first responders at Ground Zero.

"I've seen Bretagne almost select a child," said Shelley Swedlaw, a search-dog handler and former special-education director who brings Bretagne to reading sessions while Denise is at work. "She's just really good about knowing who needs that kind, canine attention."

At disaster sites, Bretagne's presence always helped Denise feel like she had "a secret advantage": "I had my best friend sitting alongside me," she explained. This, in turn, helped Denise learn important lessons while responding to disasters. "Deployments put things back into perspective very quickly because they remind you how quickly things can change," she said. "Every time I go on one, things that seemed to be really important before I left become less so.

"What do you think people are thinking about just before? It's probably not work. They're thinking about family. They're thinking about love."

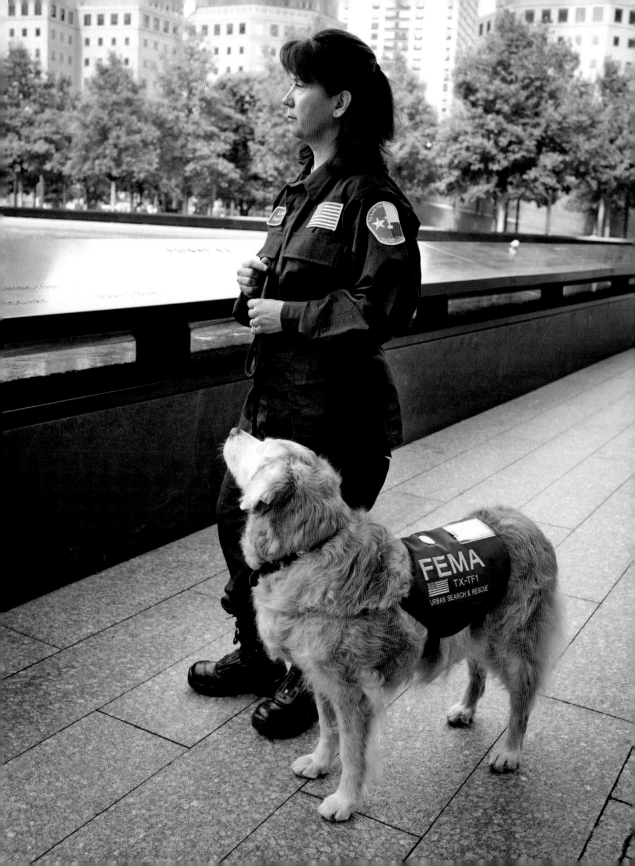

CODY, 9

After a Life in Law
Enforcement, a German
Shepherd Must Be Freed
from Doggy Jail

Retirement works out pretty well for most police K9s. Sure, they often have aches and pains after years of physically taxing work. But what they notice more than anything is that they get to relax at home with their trusted handlers who adore them, appreciate them, and want them to be comfortable.

Sometimes, though, the pathway to a typical K9 retirement goes awry. When it does, a highly trained working dog can become a misunderstood shelter dog with great speed.

Take Cody, for instance. Man, was that dog good at his job. If a violent criminal needed to be stopped, the German shepherd would ignore his own injuries to do what had to be done. One time, a fleeing felon tried to drown Cody in a deep puddle of water at a trailer park. Cody did not lose that fight, and he got his man. Another time, Cody fell nearly twenty-five feet from a walkway over the living room in a home with high vaulted ceilings. He landed, hard, on a porcelain tile floor and was knocked unconscious. About ten seconds later, the dog hopped to his feet, climbed back up the stairs, and caught a parolee hiding in a bedroom.

"Cody performed every time — I never, ever had a situation where he didn't perform as expected," recalled Detective Sergeant Steve Trickle of the Oxnard Police Department in California. "He would go in even at the risk of being killed."

Steve served as Cody's handler for five years and loved the intensely loyal, hardworking dog. He also learned a secret about him that the bad guys never would have guessed: when not in work mode, the one-hundred-pound German shepherd is a big, huggable softy with almost every person he meets — especially children. "He's very social, and he was always very, very gentle with my son," Steve said. "He's literally like a big bear and just wants somebody to scratch his belly."

Cody is so reliably good with kids that he was always a go-to dog when the Oxnard Police Department gave K9 demonstrations at schools. "We had some dogs who couldn't be out around the kids because they weren't social, but Cody could do it," Steve said. "He'd lie down, and they could scratch his belly. He couldn't be happier."

But of course, much like any human, any dog is bound to have an issue or two. Cody's behavioral weak spot was that he could become aggressive around other dogs. Not all dogs — Steve had a female Labrador retriever who loved Cody so much that she'd curl up in his kennel with him for naps. The dogs who unnerved Cody were small dogs pretending to be big dogs — the kind who might charge up to him, barking madly and acting like they wanted to start something.

This problem almost proved to be Cody's undoing.

Cody worked as a dual-purpose narcotics-detection and patrol dog from age two until age seven. The K9 was still eager to jump into the patrol car and get to work when an early retirement was thrust upon him. This happened when Steve got promoted to a position outside the K9 unit.

"Most German shepherds work until age nine or ten, and Cody wasn't physically ready to retire," Steve said. "He didn't understand it. He wasn't happy sitting at home."

Steve wanted to keep Cody as a pet and help him make the transition to a relaxed, content couch potato, but he faced some roadblocks at home. For one thing, Cody's high drive kept him on high alert whenever Steve left for work without him. That played right into the biggest obstacle of all: Steve's wife was scared of Cody. She coped well enough when Cody went to work with Steve for fifty-plus hours a week and came home exhausted. But having Cody around 24-7? Yikes.

"When she was younger, my wife got attacked — bitten in the face, actually — by a German shepherd," Steve said. "Even though Cody was sweet and gentle with her, she was just never comfortable with him."

Heartsick, Steve began trying to find the right home for Cody. It wasn't easy. Plenty of people wanted Cody for the wrong reasons; others lacked the proper experience to handle a dog who'd been trained to bite. "Finding the right person to give your dog to is like finding the right person to give your kid to," Steve said. "It took me almost a year to find a person who was suitable. I wasn't going to give him to someone who wasn't in law enforcement."

The person Steve found seemed perfect: a police officer in another part of California who aimed to keep Cody working in a lower-stress gig for another couple of years. Cody's new job would involve sniffing for narcotics only — no more violent run-ins with felons — and Steve knew how much Cody would relish being back in the game.

Everything was ideal until Cody experienced what Steve called "the curse of the older dog." The other officer's police department wound up choosing a younger dog for the narcotics-detection job. That meant Cody had to stay home alone while his new caregiver worked long, grueling hours.

Cody had a monster-sized kennel in the officer's backyard — as big as a nice-sized room in an average house — but if he stayed in it for too many hours, he'd start to bark

and cry and howl pitifully. To avoid making his neighbors crazy, the officer sometimes let Cody have access to the entire fenced backyard as well as the kennel.

At first, that seemed to work out all right — but social animals crave company, and an athlete like Cody could scale almost any wall with ease. One day in late 2013, overcome by boredom and loneliness, Cody escaped the yard and sniffed his way over to a neighbor's porch.

The neighbor called animal control, and Cody got taken to a nearby shelter. According to animal-control records, Cody's owner raised the height of his fence right after that jaunt, but Cody escaped again two weeks later and got into a fight with a dog. That resulted in another ride to the shelter. Records indicate that Cody enjoyed the old thrill of hopping into a vehicle with spotlights and strobes: "The dog jumped in the truck and turned and sat down." When his owner picked Cody up for the second time, he agreed to these terms: "Cody is to be kenneled any/every time Cody is left unattended."

🐕 Everything was fine for almost two months, until Cody did something he had never done before: he scaled the backyard fence at night while his owner was home.

It turned out to be a disastrous evening. A neighbor walked out to his front yard with his little dog on a leash. There was Cody. The little dog barked and barked. Cody grabbed the little dog in his mouth. The little dog's owner screamed. A neighbor heard the commotion and came running outside to help. Crazed and confused, Cody bit the neighbor on the calf.

When it was over, the small dog was dead. The man with the dog bite made his way to a nearby hospital, where he received an antibiotic injection and dressing for a small puncture. Cody got quarantined at the animal shelter. And Cody's owner was aghast.

"He was greatly remorseful and said he wanted to offer what he could to compensate for the damages and loss," records from that night state. "He said he felt horrible."

🐕 Linda Wieczorek, a senior field-services officer for the animal shelter in California where Cody wound up, pieced together the details of Cody's story and sensed the situation called for special care.

"I felt sorry for him because a lot of dogs in situations like his can get the short end of the stick," Linda said. "On the night with the little dog, he didn't know what to do. He normally had someone telling him what to do. Working dogs rely on their partners, and they never, ever, ever work alone — *ever*. Not having a partner there, Cody was reacting to his environment."

Linda spoke with Cody's owner and outlined the violations and stringent kenneling, muzzling, and insurance requirements he could be facing. She told him that if he was willing, she would do everything she could to find an appropriate rescue group to help Cody. He decided to surrender the dog.

Linda reached out to Mission K9 Rescue, a group with the goal of "lending a hand to paws that serve." Mission K9 Rescue tries to find ideal homes for military and contract working dogs, as well as law-enforcement dogs, when they retire from their vocations.

"These are amazing dogs who have done amazing things, and we owe it to them to give them amazing retirements," said Kristen Maurer, cofounder of Mission K9 Rescue. "They stepped up and helped us when we needed them, and it's our turn to step up and help them when they need us."

Mission K9 Rescue volunteers started a Facebook campaign to get the word out about Cody. Meanwhile, Linda arranged to have Cody neutered and to get his titanium teeth repaired. (It's common for police K9s to break many of their natural teeth when training to do bite work; Cody has several titanium implants and caps that require frequent care.)

A whole bunch of humans were making headway on his behalf, but Cody didn't understand that. All he knew was that he was stuck in a cage. Two weeks after his awful night with the little dog, these notes appeared in Cody's file: "Unfortunately, he is aggressing on himself due to kennel stress since he can't be taken out for walks or anything. Caretaker noticed he started biting on his tail and then started kennel fighting through the chain link at his neighbors."

To Steve, Cody's original handler, the whole situation was heartbreaking. "If you told me five years ago that he would be quarantined in a kennel, I wouldn't have believed it," Steve said. "How did this police dog go to dog jail? How did he end up behind bars?"

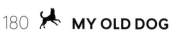 Linda did what she could to help Cody decompress, but it was tricky during regular shelter hours because he was a bite risk around other dogs.

"I'd take him out after work and throw the ball to him, and he loved that," she said. "I got very attached to him. I would have taken him in a heartbeat, but I have multiple dogs at home. Cody was a pretty awesome dog."

A month and a half after Cody landed in the slammer, Mission K9 Rescue helped arrange for his adoption by a sergeant with the Riverside County Sheriff's Department in Southern California. The man who adopted Cody understood patrol-trained K9s well, and Cody began readjusting to civilian life.

But this new chapter in Cody's life would be brief. Within a couple of months, the sergeant ran into the same issue Steve had encountered: the sergeant's fiancée was scared of Cody because she had small dogs.

The sergeant began asking around at work and learned that a colleague of his at the sheriff's department, Sergeant Sergio Rodriguez, was actively looking for a German shepherd to adopt. Every detail of Sergio's situation was perfect: he had experience with police K9s; he didn't have any other dogs; his yard was huge — a full acre — and surrounded by a tall concrete wall; and he had an eight-year-old daughter who loved big dogs.

Sergio met Cody in the summer of 2014 and instantly knew this was the German shepherd he wanted. Cody adored Sergio right back and, even better, finally seemed ready to relax. By this point, the large, lumbering dog was neutered, calmer, a tiny bit shakier on his feet — and grateful to downshift into a low-stress lifestyle.

"It's great!" Sergio said. "I mean, to me, it makes it twice as nice that I got the exact pet I was looking for, and I also got to save him — especially after the service that he's given.

"He's so happy now. He likes the life he has."

Cody appreciates the simple things in life at his new home in Riverside, California. He carries a large red rubber ball with him almost everywhere he goes; when the ball isn't in his mouth, he looks around with a ready-for-fun smile on his face.

His retirement has special purpose because he has a special person in his life: Sergio's

eight-year-old daughter, Maddy. "She gets along great with him, and he instantly became protective of her," Sergio said. "He really has taken to her."

As many close friends do, Maddy and Cody have established their own rituals. Maddy feeds Cody his dinner at 6:00 PM each day — a routine she demonstrated on a school night at home.

"Do you wanna eat? Do you wanna eat?" Maddy asked Cody. "Sit!"

Cody sat and smiled expectantly.

"Good boy!" Maddy said as she gave Cody his food.

"Good boy!" Sergio chimed in.

Maddy also tries playing with Cody in her bedroom — but that can be a risky proposition because of Cody's obsession with stuffed toys. "Yeah, I have too many stuffed animals," Maddy explained. "Mister over here wants to eat them!"

"Yes, he has a thing for stuffed animals," Sergio said with a laugh. "Any stuffed toys he will grab and then try to hide in different places in the house!"

"Remember when he took one of the Stitches in my room?" Maddy said, referring to the character from the Disney movie *Lilo and Stitch*. Cody followed this conversation with perked-up ears and a giant smile; it was as if he, too, remembered that particular Stitch heist as *hilarious*.

Maddy and Cody have other funny games. To demonstrate one of them, the little girl sprawled out on the carpeted living-room floor. "If I'm just lying like this, he'll come over, and he'll think I'm injured," Maddy said. On cue, Cody dropped his red ball and rushed over to sniff her with concern. Then Maddy popped up and gave him a hug.

"Remember when you really did get injured in the kitchen?" Sergio said.

"Oh yeah!" Maddy said. "I slipped on the tile. It's because he slobbers when he gets water. I slipped on the water and I fell and I scraped myself, and he came over to me and was like, 'Hmmm! Hmmm! Hmmm!' He wouldn't stop whimpering."

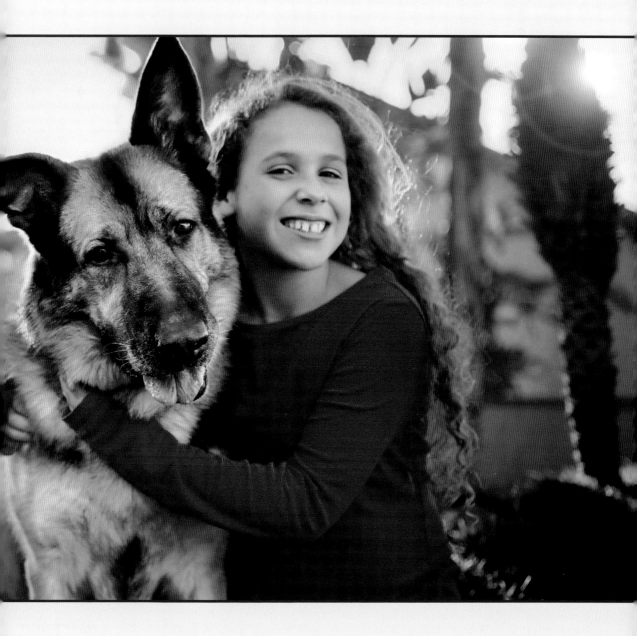

The close bond between Cody and Maddy makes Sergio happy, and Sergio is crazy about the dog as well. He spends lots of time playing with Cody and exercising him in the backyard, and he's careful not to become complacent about Cody's past, even as the dog shows signs of aging. Sergio inherited that room-sized kennel for Cody, and he set it up in a covered, shaded spot on his property. He keeps Cody secured inside it when he goes to work four days a week.

"I live on my [police] beat, so I come home for lunch," Sergio explained. "I'll play with him for about fifteen or twenty minutes at lunchtime so he gets a break from the kennel."

For Cody's first winter in Riverside, Sergio was planning to relocate the large kennel to his garage. "I want to keep him sheltered," Sergio said. "I'll put a heater on the one end of the kennel, so if he does want some heat, he can move over to that end, and if he wants it cooler, he can move back over to the other end.…Being old, his joints are going to start aching. I want him to be comfortable."

He paused to rub Cody's ears, and then he shook his head and laughed.

"I don't know," Sergio said. "I'd say he's fallen into retirement rather well!"

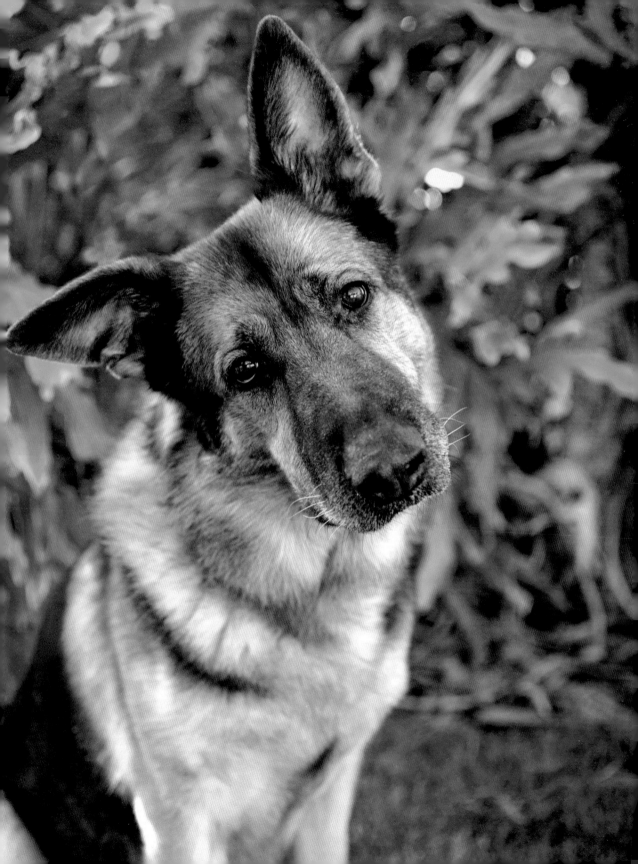

CHANEY, 9

An Ex-Military Dog Helps
Ease His Former Handler's
Burdens at Home

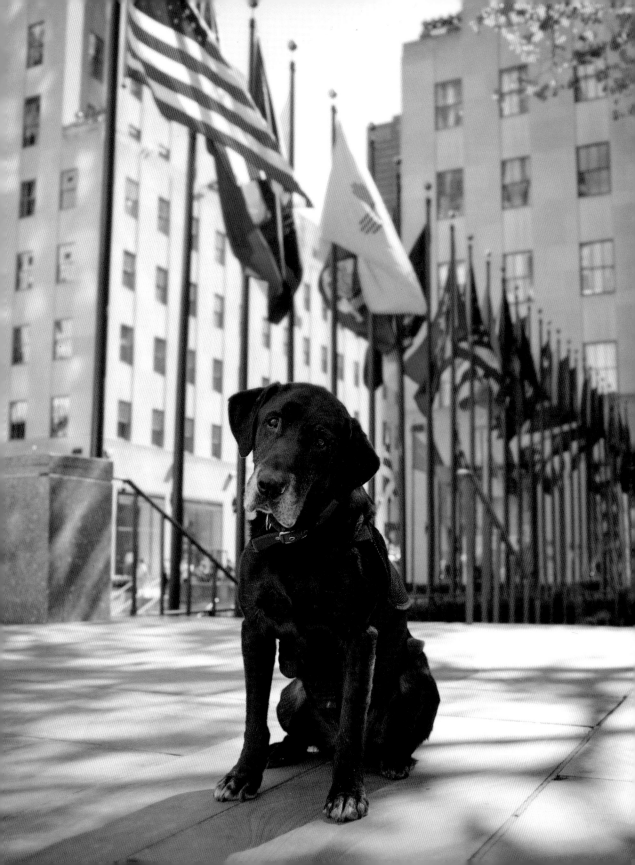

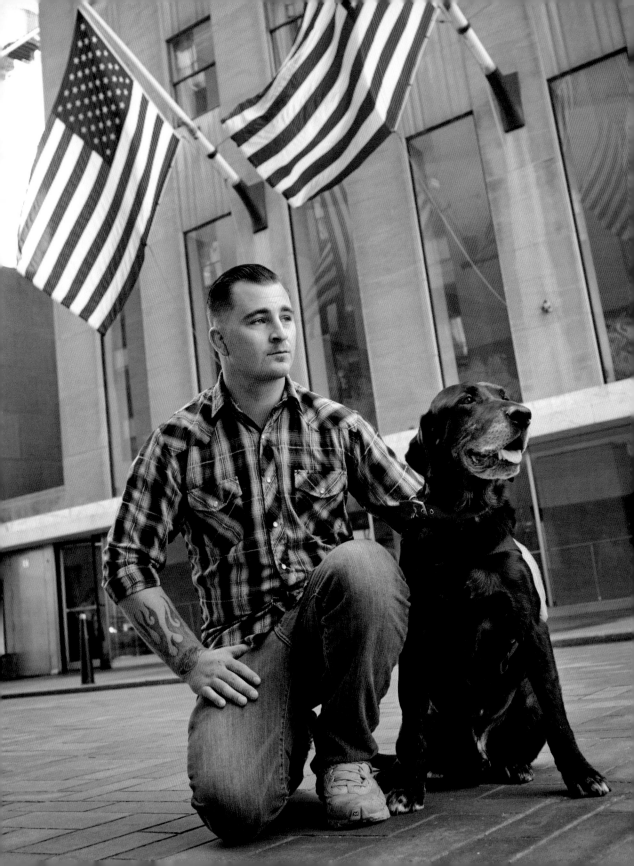

> **"**A true friend never gets in your way
> unless you happen to be going down.**"**
> — Arnold H. Glasow

A dog can bring out the best in a person — especially when what's best in him has gone missing for a while.

Corporal Matt Hatala didn't mean to lose his way. His four years of active-duty service in the U.S. Marine Corps filled him with pride, and he always loved helping people. But the months he spent searching for hidden explosives in Afghanistan's Helmand province did something to him.

Matt became numb. Numb to the idea of dying. Numb to the idea of living. What started as a coping mechanism became his default setting, and he didn't know how to wake up.

"When we first got over there, it literally looked like we were walking through a sea of lightbulbs: Is this my last step? Is this my last step?" Matt recalled. "Fast-forward to six and a half months later, and we were stomping around. We just didn't care. That's how bad it is. You just *don't care* anymore. You have to become that numb in order to survive."

One exceptionally focused member of Matt's patrol base never stopped caring. He also never stopped being in a good mood. His name is Chaney, and he's a ninety-pound black Labrador retriever with a slobbery kissing tongue and a nose like a divining rod. During multiple tours in Iraq and Afghanistan, the dog helped save hundreds of lives by sniffing out deadly improvised explosive devices. Matt served as Chaney's handler in Afghanistan in 2010 and 2011, and as a team, they enjoyed the closest of bonds — but not right away.

"I met Chaney in South Carolina, where I went to dog-training school, and he was the biggest dog that we had," Matt said. "At first, he wouldn't listen to me. He wouldn't do anything I was saying. It was really frustrating."

Transitions can be tricky when working dogs part ways with their former handlers, as Chaney had done after serving in Iraq. Before long, though, Chaney and Matt began to

understand and respect each other, and that mutual respect grew into a sense of complete trust. "I didn't really see Chaney as a dog anymore," Matt explained. "He's a Marine. He's like a brother to me. I talk to him like I talk to a person."

Chaney helped keep his human comrades sane during grueling and seemingly endless security patrols. Over the course of seven months, Chaney, Matt, fourteen other Marines, and several Afghan National Army members trekked 2,600 miles together — entirely on foot. "It was rough. I lost fifty-two pounds," Matt said. "It created complications for Chaney, too. I had to look out for the pads on his feet and also carry extra water and IV supplies for him."

Through it all, Chaney stayed lively and upbeat. He'd splash into the Helmand River for a refreshing swim, then shake himself off all over the Marines. When they'd make camp for the night, Chaney would wiggle up to them excitedly and lick their faces.

"He's definitely a lover — you get no personal space with Chaney," said Corporal Shea Boland, a Marine in Matt's patrol group in Afghanistan and one of his closest friends. "He always gave us lots of good laughs. Having him there helped calm everybody down, too. It was almost a little sense of normalcy, something that we were used to back home."

Matt said Chaney was a "big goober" and a "big softy" who had an uncanny ability to help the Marines forget where they were — and who also happened to possess an astonishing work ethic.

"When he'd smell something, he'd turn on," Matt said. "His nose is on the ground, his ass is in the air, and his tail is going a million miles a minute. He gets very birdy and starts zigzagging, and when he finds the most potent spot, he lies down on it.

"He was very methodical in his search — very, very good at what he did. I would walk behind him anywhere."

One night in 2011, Matt and Chaney went to sleep after ending their security watch at 2:00 AM. About three hours later, they were awakened with urgency: there had been an explosion, and they had to go check for secondary explosive devices right away.

It was still dark when they rolled out with three Marines from their squad and seven from a different squad. Matt helped cordon off an area near the bank of the Helmand River that needed to be searched. Then he and Chaney thoroughly swept the left side of the area, but not the right side; Matt thought other Marines had that side covered.

"There must have been a secondary that everybody missed," Matt said. "I never sent Chaney over there, so he never had a chance to find it."

That remaining explosive would cause devastating injuries for two Marines. A couple of days later, one of Matt's friends tripped it.

"I got to go down there and see my mistake exploded all over the beach," Matt said. "My buddy lost his leg and shattered his other one, and another Marine had a major traumatic brain injury.

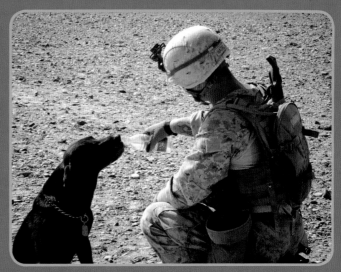

Matt Hatala gives Chaney some water to drink during a seven-mile patrol in Afghanistan in 2011

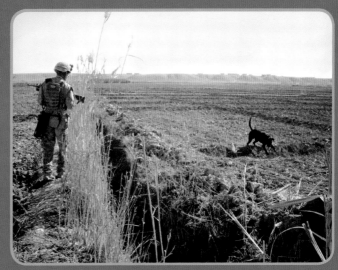

Shea Boland, a Marine in Matt's patrol base and one of Matt's closest friends, looks on as Chaney sniffs for explosives

Matt and Chaney work as a team on a routine patrol route in the desert

Photographs courtesy of Matt Hatala

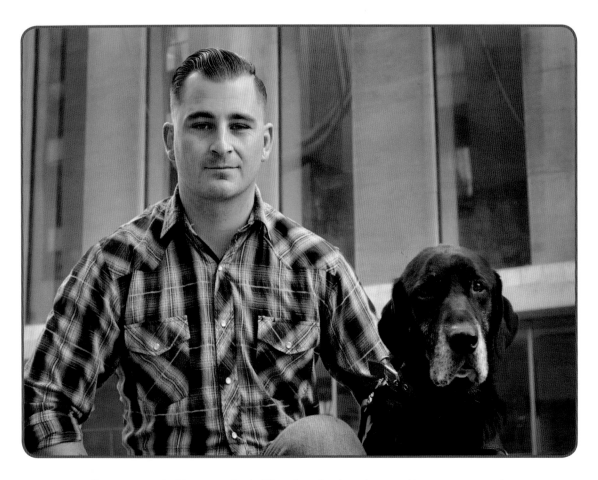

"I was so worried it was my fault. When I got back to the patrol base, someone singled me out in front of everyone and said, 'If it wasn't for you and your stupid f——ing dog, this would have never happened.'…

"I didn't feel like I deserved to live."

Matt came home from Afghanistan in August 2011. His return to civilian life was rocky from the start.

"We got back to Camp Pendleton, and within five minutes of being there, I had to put Chaney on a truck," Matt recalled, his voice breaking. "It didn't seem real. We'd gone through, you know, a lot together. It was like losing a friend."

Chaney got shipped back to American K-9 Interdiction, a private company that had a contract to train explosive-detection dogs for the U.S. Marine Corps's use in Afghanistan. Chaney would rest for a few weeks at American K-9's training facility in South Carolina, then begin adjusting to a new Marine for his next tour in Afghanistan.

In late 2011, Matt and his wife, Genna Schoneman, temporarily moved in with Matt's parents in Waverly, Iowa. Both twenty-two-year-olds were looking for work — but most positions seemed meaningless to Matt after his service in the Marine Corps. In fact, almost everything seemed meaningless.

"When I moved home, it was a huge culture shock, and things got really, really bad, really quick," Matt said. "I felt alienated. I couldn't relate to a lot of people. I was drinking every day and doing risky stuff just to do it — speeding, drunk driving, bar fights, anything I wasn't supposed to do. I would do it just for that adrenaline.

"My wife, my parents — everyone — was trying to get me to get help. But at that point, literally Jesus Christ himself could have come down and told me to get help, and I wouldn't have done it. Nobody could get me to change the path I was on."

Daily — hourly, even — Matt replayed that scene on the beach in Afghanistan and blamed himself for what had happened. Genna knew he was struggling but had no idea how to reach him. "It was really scary and really sad," Genna recalled. "You want to help someone, but you don't know how."

In January 2012, Matt's parents left town for a funeral. While they were away, Matt, Genna, and some friends rented a hotel room and spent the night partying. By the wee hours of the morning, everyone else had fallen asleep — but not Matt. He stayed awake, drinking by himself and devising a plan. Early that morning, he and Genna returned to his parents' house, a ranch-style home on four forested acres with a long driveway.

"I decided that was going to be the day I left the earth," Matt said. "I kicked my wife out of the house. I moved my truck across the driveway because I figured if cops were going to come up to the house, they'd have to come up on foot, and I'd take them out, too. I remember thinking that I was going to do this."

Matt loaded his Taurus .45 handgun and a semiautomatic rifle. Then he sent a text message to his mother: "It's over. I'm done with it."

As soon as Matt banished Genna from the house, she began mobilizing people. She called and texted Matt's closest Marine buddies, and she also contacted her parents, who lived nearby. They hurried over and called 911. Police officers and sheriff's detectives sped to the neighborhood and set up a loose perimeter around the property.

Alone inside the house, Matt couldn't stop crying. His parents didn't drink alcohol, but he found a bottle of white wine in a cabinet. He chugged all of it down at about 8:30 AM, then vomited uncontrollably. Once he stopped being sick, Matt tried to steady himself. He took the safety off his handgun. He put the gun in his mouth.

Just then, Matt's phone rang. It was Mark Johnson, one of Matt's best friends and a fellow Marine who lived in Tennessee. As soon as Mark saw a text message from Genna, he rushed to find a quiet spot to call Matt.

"At first, he asked me why I called — he thought it was weird that I had called him

right then," Mark said. "I remember talking to him about how he didn't need to make a life-altering decision in that state of mind. I told him that he didn't need to do anything that he couldn't take back."

Matt listened to his friend.

"I don't really remember exactly what he said," Matt explained later. "I just remember thinking: 'Dear God, at least someone cared.'"

Once he hung up with Mark and calmed himself down a bit, Matt decided to drive to the store to buy some cigarettes. He stepped outside carrying both his handgun and his semiautomatic rifle, then climbed into his white Chevy Silverado truck with his weapons. Police monitored Matt's every move.

He slowly pulled out of the driveway and began heading south on a road that curved up a hill. At the top of the hill, a police roadblock awaited him.

Police ordered Matt out of the truck and told him to get down on the ground. He didn't resist. They handcuffed him and took him, not to jail, but to the hospital. Matt ultimately traveled to St. Cloud, Minnesota, for weeks of treatment for alcohol abuse and posttraumatic stress disorder.

When he returned to Iowa, Matt tried to put his life back together. It wasn't easy. He felt like no one really understood him — and he didn't really understand them, either. He could relate to other Marines who had served with him, but he never got to see them. Everyone had returned to different parts of the United States and gone on with their lives. Everyone, that is, except Chaney: he was back in Afghanistan, trudging through miles and miles of desert and sniffing out explosives.

Matt missed Chaney desperately. Chaney always understood him and helped him feel better. Matt knew the dog would soon be too old for explosive-detection work, so he began trying to adopt Chaney — a process that proved to be labyrinthine and laborious. As Matt attempted to submit the right applications to the right places, the Marine Corps's working-dog contract switched from American K-9 Interdiction to another company, K2 Solutions in North Carolina.

"Just finding out where to send paperwork was a nightmare," Matt said. "Someone would tell you to call guy A, and then guy A would send you to guy B, and he'd tell you to talk to guy C, and then guy C would send you back to guy A."

As he waited, Matt got involved with Retrieving Freedom, a charity with a facility in his hometown in Iowa. The group trains service dogs for military veterans and children with autism, and Matt began volunteering there to help get dogs socialized and ready for their future jobs.

Retrieving Freedom's cofounder Scott Dewey said he could tell Matt was hurting. He sensed how much Matt would benefit from regular contact with dogs in training.

"I approached him and said, 'Hey, you have experience with dogs. Would you help us

get this dog ready for a guy who really needs it?'" Scott explained. "Then Matt would take that dog out to Walmart and other public places, and that would get people talking to him. Matt would explain, 'Oh, we're training this dog for a veteran who lost his leg.' Pretty soon, people would realize Matt's a veteran, too, and they'd say, 'Thank you for your service. What you're doing here is great' — and that would make his whole day. It was so, so important. It helps you start feeling that everybody's not against you."

Matt soon realized how much Scott and others at Retrieving Freedom cared about his well-being. "I started doing this to help them out, but all along, they were helping me," Matt said. "Working with the dogs made me feel good about myself. I had purpose again."

Finally, in the summer of 2013, Matt got the message he'd been hoping to receive: Chaney was available for adoption. All Matt had to do was travel to K2 Solutions in North Carolina and pick him up.

"I can still remember the day Matt walked in and told me it was approved," Scott said. "He said, 'I don't believe it. This is the best day of my entire life.'"

Getting Chaney back after nearly two years of separation was such a momentous occasion that it had to be done right. Matt arranged for a road trip and reunion with his best friends and fellow Marines: Shea Boland, Keegan Albright, and Mark Johnson. The plan was to meet up in Indianapolis, drive to North Carolina, pick up Chaney, and then head to Tennessee and stay at Mark's house together.

K2's kennels were out in the middle of nowhere, and cameras weren't allowed on site. Even though Matt's reunion with Chaney couldn't be documented, the veterans who were there that day said they'll never forget it.

"As soon as Chaney heard Matt's voice, he became his typical self, licking and snorting and all excited," said Keegan, of St. Louis, Missouri. "Whoever says dogs don't remember people, I don't know where they get that. Matt and Chaney were both ecstatic."

Genna remembered how elated Matt was in July 2013 when he returned to Iowa with Chaney in tow. "He got home with Chaney really late at night, and he was just *beaming*," she said. "He just seemed like a happier person — he had his best friend back. Chaney would follow Matt everywhere he went and make sure he was okay. He *has* to keep his eyes on Matt at all times."

Matt immediately began sleeping better at night once he had Chaney with him. He found himself talking to Chaney constantly, without reservation, and that helped him feel better, too. Then, all at once, Chaney's presence prompted a realization — and a rush of relief — in Matt's mind.

"It occurred to me that I would never, ever, ever, ever, ever consider hurting myself again, because what would that mean for Chaney?" Matt said. "Where would he go? How would that affect him? He's like my kid. I want to give him a good life."

As Matt grew stronger and more stable, he and Genna came to a mutual decision: they would file for divorce. Matt moved to Lansing, Michigan, in May 2014 and began training to become a firefighter. Matt's Marine buddy Shea had started in the program first, so Matt and Chaney moved in with Shea and Shea's dog, Reagan.

"I don't know a lot of people here in Michigan, so a lot of time it's just me and Chaney hanging out while I do homework," Matt said. "In the past, I was wanting to drink all the time, but now I can't. I've got to get up early in the morning and take Chaney to the river or get to class."

After he moved to Michigan, Matt got a surprise: Retrieving Freedom had encouraged Matt to nominate Chaney in the military dog category for American Humane Association's annual Hero Dog Awards — and Chaney won. The designation resulted in two adventure-packed trips for Matt and

Chaney in September 2014: one to New York City for an appearance on NBC's *TODAY* show, and another to Los Angeles for a stroll down the red carpet at an awards gala at the Beverly Hilton hotel. Genna came to the black-tie event as Matt's bursting-with-pride date.

During the awards show, Matt and Chaney walked across the stage together. Matt looked dashing in a navy-blue tuxedo; Chaney wore a dog vest that was red, white, and blue. Poised and polished, Matt addressed a room packed with celebrities as television cameras rolled.

"I'd like to take a second to speak directly to all the combat veterans here tonight and those watching at home," Matt said. "First off, I'd ask that you never forget who you are and the proud warrior culture that we come from. Secondly, don't ever stop checking on your brothers. When we get back from war, our dedication to one another does not stop there.

"And lastly, to my brothers out there that are living with posttraumatic stress, I want to remind you that posttraumatic stress does not mean that you're weak. Posttraumatic stress does not mean that you're broken. The one and only thing that posttraumatic stress means is that you have walked through the fires of combat and are still alive to talk about it.…We need to spend every day honoring the memory of those that can't say the same thing. Thank you all, and semper fidelis."

The 650 people in attendance leapt to their feet. Matt received one of the most thunderous standing ovations of the entire evening.

After that whirlwind weekend in Beverly Hills, Matt returned to Michigan and hit the books. His diligence paid off: when he completed his firefighter's certification in late 2014, he graduated as fire academy captain.

"I got voted as captain by my peers," Matt said with a proud smile.

The next phase of his education would be paramedic and emergency medical technician training, which Matt planned to tackle in Des Moines, Iowa, with Chaney as his roommate.

"It means the world to me that I have Chaney with me," Matt said. "It's like getting a buddy back. You lose a lot of friends when you get out of the military, but to be able to have one of them live in my house with me every single day is amazing. It's a blessing.…

"Chaney has helped me so much. I had been at my lowest point — I don't know if I could have gone much lower — and then just two or three years later, here I am winning the Hero Dog Awards and getting flown all over the place. It's incredible. The main thing I would tell any veteran is this: Never give up. Just never, ever give up."

PART 5

How You Can Help

Simple, Surefire Tips for Having a Happy, Healthy Senior Pet
Marty Becker, DVM

I have always had a tender, open heart when it comes to older dogs. My earliest memories from childhood involve learning to walk, using an old border collie like a four-legged crutch. All through junior high, high school, and college, I watched as our black Labrador retriever Luke went from a lump of black with puppy breath, to a strapping adult who could walk all day long beside the tractor, to a loving senior whose raw desire said he could still follow me around the family farm long after his hips said, "No more." (I still took him with me, but on a motorcycle or inside the cab of the pickup.)

As a veteran veterinarian and lifetime dog lover, I've learned some tactics, tips, and strategies that make the life of a senior dog easier, with less pain, fewer problems, and more energy and enjoyment. These are things I still use with our three senior dogs (ages fifteen, twelve, and eleven), recommend to dog owners in the exam room, write about in my syndicated column, and preach about on TV.

Whether you have a canine who's getting older or are considering helping a senior move from the cage at the shelter to the couch at your home, don't assume that an elderly pet can't enjoy months, or even many more years, of a pain-free, comfortable, and satisfying life.

Start with a veterinary visit. The worst thing you can do is assume that your pooch is exhibiting signs — such as lethargy, confusion, depressed appetite, or weight loss — just because he or she is old and that nothing can be done to help. Sure, sometimes the pet has reached the point when saying good-bye is the next compassionate step. But much of the time, the problems can be explained as extreme pain from arthritis or infected teeth, parasite infestation, metabolic problems (like low thyroid or diabetes), or even a lack of

fuel to the brain. Take your senior dog to the veterinarian for a comprehensive exam and consultation that includes a full diagnostic workup.

Take care of the basics. We're talking food and water. Many older pets struggle with hydration. In some cases, it hurts them too much to move to the water dish, or the water dish doesn't seem appealing enough. In addition to pain meds to ease movement, my strong recommendation is to invest in a drinking fountain that encourages dogs to drink more. You also can switch to moist food, which has a higher water content. Many older dogs suffer from diminished smell and taste, so food isn't as appealing to them. To amp up the palatability, you can top-dress the dry food with various types of commercially available products that work kind of like salad dressing, switch to moist or canned food, or, with either, heat the food in the microwave to release the odor and flavor.

Pain management is primary. Remember, while dying isn't optional, suffering is. The veterinary profession has powerful pain medications that can keep the hurt at bay. Older pets, like older people, are often dealing with pain from arthritis and worn joints. And while most humans can't stand a day of a bad toothache before going to the dentist for relief, many older pets have suffered from unremitting dental pain for years. To me this is unforgivable because the veterinary profession now has the tools to diagnose and treat dental disease and stop pain. If your dog is in pain, your veterinarian may recommend weight loss, special therapeutic diets that can help manage disease, probiotics to help the gut (about 80 percent of the immune system is in the gastrointestinal tract), supplements to help lubricate joints or hydrate the skin, or even potent free-radical scavengers that can improve brain function and increase activity.

Pay attention to your dog's cognition. I can't tell you how many times I've had a woman (most primary caregivers of pets are women) come into the practice choking back tears, fully expecting that I'm going to put a hand on her shoulder, look into her eyes, and say, "There's nothing we can do for____. We might consider this is the time to let her go." But in fact, after a thorough examination and diagnostics, the dog's internal organs are still going strong, and there's no evidence of metabolic problems, severe dental disease, arthritis, or cancer; instead, it just seems like the dog has run out of "go juice."

In many of these cases, the dog is suffering from what we call Canine Cognitive Dysfunction, which acts like early Alzheimer's disease in humans. Dogs with this disorder often display a lack of energy and playfulness, start having soiling accidents inside the home, seem confused, and experience disrupted sleep patterns. Your veterinarian may recommend medications or therapeutic diets that can add years to your dog's life — and life to your dog's years. In other cases, the brain just isn't getting enough fuel. There are some amazing new diets that use medium-chain triglycerides to energize the brain. I can tell you from experience that trying these diets, prescriptions, and supplements can often be like putting fresh batteries in your dog.

Focus on safety and comfort. Just as older people need accommodations to get into

bed, off the toilet, and around the house, so do senior pets. Let's start with a really, deeply cushioned bed (my favorites have orthopedic foam and are heated). Since many pet owners like sharing a couch or bed with a pet, there are wide varieties of ramps and stairs that make it easy for the pet to get up to that level and get some loving. Older pets are often less sure on their feet, so it may be necessary to put carpet runners in the house that give the dog pathways over tile and wood floors, or try putting traction booties on their paws.

Most of us remember being at Grandma's house, where she wore a sweater and cranked the thermostat to just under boil. You can do the same for an older dog who has trouble staying warm (especially a problem with shorter-haired breeds) by keeping them in a sweater or coat, using a heated bed, or putting a space heater in the room with them. For walks, there are a multitude of support slings that fit around the dog's torso and allow you to assist them with their walking (much like walkers for humans), as well as carts that act like wheelchairs, taking the weight off of a dog's hind legs.

When is it time to say good-bye? One of the hardest things a veterinarian must do is help guide families near the end of their beloved pets' lives. Should they let a pet die naturally, or speed the process to prevent unnecessary pain or suffering? We are fortunate that our dogs are benefiting from better nutrition and veterinary care and are living longer. At some point, though, just as with people, nothing more can be done. That doesn't always mean euthanasia must be the next step. More and more, people are turning to end-of-life programs that help ease a pet's journey out of life in a way that maintains comfort while giving his family extra time with him. Known as "pawspice," a term coined by veterinary oncologist Alice Villalobos, this approach allows pet owners and veterinarians to work together to increase survival time, ensure quality of life, relieve pain, and recognize when it's time to say good-bye. This palliative medical model includes pain management, infection control, nutritional support, and complementary therapies such as acupuncture or massage. Pets who receive this type of care often survive longer, giving people and animals more good time together before death.

So when *is* it time to say good-bye? There is no one answer that fits every family circumstance (and you may not have any more money to spend chasing an elusive cure), but I got my good-bye guide from veterinary oncologist Greg Ogilvie: as long as the "good days" outnumber the "bad days," then it's okay to keep going. You decide as an individual or a family what are this dog's good days (can still go outside, go on walks, eat with gusto, play) and bad days (can't move, doesn't eat, soils inside the home, has gastrointestinal upset). I watched my eighty-nine-year-old mother suffer away from her home in the company of total strangers in a nursing home for almost a year as doctors shuffled her around, promoting diagnostics and treatments that had little effect on her ultimate passion. I truly think being able to end the suffering of a dog who is in unremitting pain, who will never be cured or effectively treated, or whose quality of life is extremely poor is the final grace we can give.

MARTY BECKER, DVM, "America's Veterinarian," has spent his life working toward better health for pets and the people who love them. He was the resident veterinary contributor on *Good Morning America* for seventeen years, and he has written twenty-two books that have sold more than seven million copies. He serves on the board of directors of American Humane Association and on the advisory board of the Grey Muzzle Organization, which is dedicated to helping homeless senior dogs.

Old Dogs *Can* Learn New Tricks:
Tips on Training and Behavior Management
Mikkel Becker

I adore senior dogs, and I've seen firsthand that they love to learn just as much as their younger counterparts. Training is helpful for older dogs because it keeps them mentally alert, helps them adjust to the changes that come with aging, and enhances their bonds with their families.

It's important, when first adopting a dog of any age, to get started on training. This helps the dog understand what his or her new family expects; then, rather than being punished for doing something unwanted, the dog can be asked to do something desirable and get rewarded for it. For many rescued seniors, these training sessions represent the first time in their lives that they feel understood and equally understand what is being asked of them.

As a trainer, I highly recommend using reward-based training methods that rely on giving dogs things they want contingent upon their performance of desired behaviors. A reward-based approach increases a dog's contentment with, and confidence in, his or her new human family, and it also allows for any issues to be resolved in a nonconfrontational manner that gets to the root of the problem. In contrast, punishment-based methods can increase anxiety and the potential for aggression. Rewards can include treats, praise, petting, play time, and the opportunity to do something the dog wants (like going outside). It's similar to children learning to say "please" for things they want; dogs also can learn polite behaviors, like "sit," before getting what they want.

Here are some specific training and behavior-management tips for the older dogs in your life:

Mental stimulation is key. Walks are not just for physical activity, but for mental wellness, too. Dogs of all ages have an inborn desire to work and explore, but many do

not get the mental activity they need. As such, it's important to provide dogs with various activities to keep them engaged.

On walks with your dog, it's important to do more than cover physical distance. Remember to let your dog sniff and explore with his or her nose. Dogs feel calm and engaged when they can investigate different smells. It's actually relaxing for them! This means that even if senior pets can't move very far, they still benefit from being taken outside to smell and explore. If their mobility is extremely limited, you can take them out in a wagon or stroller so they can experience sights, sounds, and smells while riding along.

Scenting games also can be thrilling activities for older dogs. Try hiding treats under cups, or scattering kibble on the carpet or in the grass of your yard for your dog to search out and eat.

Training is mentally engaging for dogs as well. In particular, clicker training — using a small mechanical noisemaker along with positive reinforcement, such as a treat — challenges a dog to "think out" a problem and figure out what will make the person click.

Meet mobility challenges. It's important to help your dog adapt to age-related changes, which might require the use of mobility aids such as stairs, ramps, slings, or coverings for their paw pads to prevent slipping.

Food lures are useful for getting dogs to move up and down ramps or stairs willingly when they are first learning to get in the car or on a bed in this manner. Leave a trail of treats leading up to the top, or have treats in your hand (or a soft treat, like peanut butter, on a spoon). Hold the tasty reward in front of the dog's nose to entice him or her to follow. Small licks or bites of a treat can be given on the way up the stairs or ramp to help keep the dog comfortable when first learning to navigate the equipment.

When fitting a sling or dog boots, keep the experience positive. Pair the first sight of the equipment with attention, praise, and rewards. As you bring the gear near, continue to reward the dog for staying calm. When the dog walks for the first time with the equipment on, give yet more rewards so the process stays positive. With the sling or lifting harness, lift the dog very lightly at first, then release and give a reward. This will help the dog gradually grow accustomed to the sensation of being lifted.

Be alert to changes in hearing and vision. If such changes are gradual, it's helpful to start transitioning your dog's reliance away from visual or verbal communication. Vibration collars (just the sensation without any shock) can be very helpful for some dogs. Or if your dog is losing his or her hearing, begin teaching more visual cues; alternatively, if your dog's vision is faltering, increase your use of clear verbal cues.

Watch for physical and cognitive changes. Dogs change as they age, but not all changes are unavoidable parts of the aging process. If you see your dog slowing down, for instance, a medical issue like arthritis might be to blame. Arthritis can make standing up and walking more painful. Treating the condition by reducing inflammation can give dogs the boost they need to act like their younger selves.

Dogs also can experience cognitive decline that is very similar to Alzheimer's disease

in humans. Stay alert for any abnormal behavior, such as periods of distress or sleepless-ness at night, bouts of spacing out and staring off into the distance, problems with house soiling, regression in previous training, disorientation, or a sudden onset of anxiety. Talk to your veterinarian about such changes because many of them can be medically treated and improved, sometimes by giving the dog a specialized diet and supplements.

On occasion, older dogs need to be retrained to remember where to go potty. If that happens, be sure to keep those training sessions reward-based and positive. Also have the dog checked out completely by a veterinarian. House-training problems can be triggered by changes in the body, such as urinary-tract infections, that make holding in the bladder difficult.

MIKKEL BECKER, the resident trainer for Vetstreet.com, is certified as a dog trainer by the Association of Professional Dog Trainers and as a dog behavior consultant by the International Association of Animal Behavior Consultants. She also serves on the advisory board of the Grey Muzzle Organization.

SENIORS ROCK!
And Here's How to Help Them

If you've read this far, you probably like dogs — a lot. And you probably have a soft spot for older dogs who still have so much love, loyalty, and laughter to give. You can help them out in all sorts of ways. Here are a few ideas:

1. *Adopt a senior dog.* As the stories in *My Old Dog* show, you aren't likely to regret adopting a calm, sweet, house-trained, grateful older dog. People who adopt older dogs consistently describe the experience as life-changing and life-affirming.

2. *Try fostering an older dog.* If you're not in a position to adopt right now, you could provide a foster home for a senior dog who belongs to a shelter or rescue group. Fostering is something you can do on a short-term basis — for days or weeks — or, in some cases, on a longer-term basis by providing a "final refuge" foster home until the end of the dog's life. Either way, you'll help a senior dog escape a loud, disorienting shelter, and you probably won't have to worry about veterinary bills because most shelters and rescue groups will cover them.

3. *Volunteer for a shelter or rescue group.* Many animal-welfare organizations operate on razor-thin budgets and need help with all sorts of caregiving tasks, from feeding to dog walking to bathing to doing cleanup work. And if you have specialized skills — particularly in areas like photography and pet grooming — don't hesitate to offer them. A nice, new hairstyle and a professional photo shoot can make or break an animal's chances of getting adopted.

4. *Provide administrative help.* Almost every animal-rescue volunteer interviewed for *My Old Dog* mentioned this. Their small groups tend to be

overwhelmed, and they need help staying organized. "Lots of people say they'd like to help walk dogs, but what we really need is administrative help: filing, paperwork, document design, that sort of thing," said Deborah Workman, founder and director of the Sanctuary for Senior Dogs in Cleveland. "I know that's not as much fun as interacting with the dogs, but it's where we have a *huge* need for volunteers."

5. *Donate to a specific rescue group.* The groups highlighted in *My Old Dog* are doing great work. They are all charitable organizations, and your donations will be tax deductible. You can find contact information for these and many other groups in the resource guide at the back of this book.

6. *Donate to a nationwide program.* If you want to know your donation will help older dogs all over the United States, consider the Grey Muzzle Organization. This group carefully checks and funds effective programs that help homeless older dogs across the country. Grey Muzzle also donates orthopedic dog beds to shelters to get kenneled seniors off the concrete floors. Another group, the White Muzzle Fund, is building an endowment with the goal of funding reputable senior-dog rescue organizations for years to come.

7. *Help a shelter launch a senior-pet program.* Most shelters have programs in place for seniors these days — but some don't, and you might be able to help start something wonderful. For instance, Sammie's Fund, an endowment to help older animals awaiting adoption at the Seattle Humane Society, was started in 2011 in memory of the late Wendy Moss, who had adored and cared for an older Labrador retriever named Sammie and many other senior dogs. Sammie's Fund has been used to give older dogs and cats veterinary care and to underwrite their sheltering costs so they have all the time they need to be adopted.

8. *Start a senior-rescue group of your own.* If no one else is focusing on senior shelter dogs where you live, consider taking the plunge and starting a rescue group of your own! You can get helpful, practical guidance about how to run a successful foster-based rescue organization from Muttville Senior Dog Rescue in San Francisco. (See the resource guide at the back of the book for information on Muttville.)

9. *Value every day with your dog at every age.* The only flaw dogs have is that they don't live as long as we wish they could. If you have a pet who isn't old now, he or she likely will be before you know it — and you'll never, ever regret any time you spend making your dog happy. "Don't say, 'We'll wait until tomorrow morning to take that walk or go on that drive' — do it now," advised Hany Hosny, of Roanoke, Virginia, who lost his beloved senior dog Stella in March 2014. "At the end of her life, I was sad, but I was okay with it — I was *very* okay with it — because I knew that I had always chosen the better of two options for her. I took her on the hike. I brought her with me on the car ride. And she was happy."

Want to help the humans who help older dogs? Then this resource guide is for you. Here you'll find contact information for groups that promote animal welfare and do rescue work in the United States, Canada, and other English-speaking countries. You'll also find organizations that provide comfortable retirements to military and law-enforcement dogs; pair veterans with service dogs, therapy dogs, or companion dogs; and help military service members with their pets during deployments.

The list of organizations below is extensive but incomplete. There are hundreds of rescue groups working tirelessly to assist older animals in need. Many animal shelters also offer special programs for older pets, so remember to check with shelters in your area.

For a regularly updated list of senior-dog rescue groups, see this book's website, MyOldDogBook.com.

ORGANIZATIONS AND PROGRAMS IN THE UNITED STATES

National Organizations and Programs

ANIMAL-WELFARE ASSOCIATIONS

American Humane Association
1400 16th St. NW, #360
Washington, DC 20036
Website: www.americanhumane.org
Phone: 800-227-4645
Email: info@americanhumane.org

American Society for the Prevention of Cruelty to Animals (ASPCA)
424 E. 92nd St.
New York, NY 10128
Website: www.aspca.org
Phone: 888-666-2279
Email: publicinformation@aspca.org

Humane Society of the United States

2100 L St. NW
Washington, DC 20037
Website: www.humanesociety.org
Phone: 202-452-1100 or 866-720-2676
Contact form (Animal Rescue Team):
www.humanesociety.org/forms/contact
_us/disaster_services_contact.html

GRANTS FOR SENIOR-DOG PROGRAMS

Grey Muzzle Organization

14460 Falls of Neuse Rd., #149-269
Raleigh, NC 27614
Website: www.greymuzzle.org
Phone: 919-529-0309
Email: info@greymuzzle.org

White Muzzle Fund

PO Box 6321
FDR Station
New York, NY 10150
Website: www.whitemuzzlefund.org
Phone: 212-726-1397
Email: info@whitemuzzlefund.org

NETWORKING EFFORTS

HeARTs Speak

A global network of artists offering pro-bono
creative services to help animal-welfare
organizations.
PO Box 2645
Poughkeepsie, NY 12603
Website: www.heartsspeak.org
Email: info@heartsspeak.org

Senior Dogs Project

Extensive clearinghouse of online
information to help older dogs.
Website: www.srdogs.com

Susie's Senior Dogs

Facilitates senior-dog adoptions across the
United States.
Website: www.susiesseniordogs.com
Facebook page: www.facebook.com
/susiesseniordogs
Email: susie.doggie@gmail.com

Victoria Stilwell Positively Dog Training

Find training tips and connect with a positive-
reinforcement dog trainer near you.
Website: www.positively.com

TRANSPORTATION FOR PETS IN NEED

Operation Roger: Truckers Pet Transport

PO Box 522
Joshua, TX 76058
Website: www.operationroger.com
Phone: 682-622-1172
Email: operationroger01@operationroger.com

Pilots N Paws

4651 Howe Rd.
Landrum, SC 29356
Website: www.pilotsnpaws.org
Email: info@pilotsnpaws.org

Wings of Rescue

5959 Topanga Canyon Blvd., #285
Woodland Hills, CA 91367
Website: www.wingsofrescue.org
Contact form: www.wingsofrescue.org
/contact-page

Organizations and Programs by State

ALASKA

Homer Animal Friends

PO Box 2300
Homer, AK 99603
Website: www.homeranimals.com
Phone: 907-235-SPAY (907-235-7729)
Contact form: www.homeranimals.com
/contact-us

Loving Companions Animal Rescue's
Senior Pets for Senior People
Program
1360 Old Richardson Hwy.
North Pole, AK 99705
Website: www.lovingcompanions
 animalrescue.org
Phone: 907-488-0516 or 907-347-4829

Second Chance League
PO Box 83474
Fairbanks, AK 99708
Website: members.petfinder.com
 /~AK17
Phone: 907-451-0078
Email: info@secondchanceleague.org

CALIFORNIA
Angel City Pit Bulls
PO Box 19944
Los Angeles, CA 90019
Website: www.angelcitypits.org
Contact form: www.angelcitypits.org
 /webform/contact

BAD RAP
PO Box 27005
Oakland, CA 94602
Website: www.badrap.org
Email: contact@badrap.org

Best Friends Animal Society–Los Angeles
15321 Brand Blvd.
Mission Hills, CA 91345
Website: la.bestfriends.org
Phone: 818-643-3989
Email: bestfriendsla@bestfriends.org

Camp Cocker Rescue
14320 Ventura Blvd., #236
Sherman Oaks, CA 91423
Website: www.campcocker.com
Phone: 800-431-5911
Email: CampCockerInformation@gmail.com

German Shepherd Rescue of Northern California
PO Box 1930
Cupertino, CA 95015
Website: www.gsrnc.org
Phone: 800-728-3473
Contact form: www.gsrnc.org/contact.asp

Labradors and Friends Dog Rescue
2307 Fenton Pkwy., #107-160
San Diego, CA 92108
Website: www.labradorsandfriends.org
Phone: 619-990-7455
Email: labradorsandfriends@yahoo.com

Lily's Legacy Senior Dog Sanctuary
PO Box 751002
Petaluma, CA 94975
Website: www.lilyslegacy.org
Phone: 415-488-4984
Email: lilyslegacysds@gmail.com

Lionel's Legacy
232 Murray Dr.
El Cajon, CA 92020
Website: www.lionelslegacy.org
Phone: 619-212-5623
Email: seniors@lionelslegacy.org

Muttville Senior Dog Rescue
PO Box 410207
San Francisco, CA 94141
Website: www.muttville.org
Phone: 415-272-4172
Email (general): info@muttville.org
Email (Seniors for Seniors Program):
 seniorsforseniors@muttville.org
Muttville's visual presentation on how to run a
 successful foster-based rescue organization:
 www.muttville.org/pdfs
 /RunningAFosterBasedRescue
 Organization-2014.pdf

No-Kill Los Angeles (NKLA)

1845 Pontius Ave.
Los Angeles, CA 90025
Website: www.nkla.org
Phone: 424-208-8840
Email: info@nkla.org

Peace of Mind Dog Rescue

PO Box 51554
Pacific Grove, CA 93950
Website: www.peaceofminddogrescue.org
Phone: 831-718-9122
Email: info@peaceofminddogrescue.org

Retrievers & Friends of Southern California

PO Box 1822
Temecula, CA 92593
Website: www.retrieversandfriends.com
Phone: 951-696-2428
Email: info@retrieversandfriends.com

San Diego Spaniel Rescue

PO Box 179043
San Diego, CA 92177
Website: www.sdsr.org
Phone: 619-922-0545
Email: sandiegospanielrescue@yahoo.com

Springers for Seniors

19518 Nashville St.
Northridge, CA 91326
Website: www.springerrescue.org
/springers_for_seniors.html
Email: info@springerrescue.org

Tails of the City Animal Rescue

2539 7th Ave.
Los Angeles, CA 90018
Website: www.tailsofthecityrescue.com
Phone: 323-388-6541
Email: tailsofthecityanimalrescue@gmail.com

COLORADO

Golden Retriever Rescue of the Rockies

15350 W. 72nd Ave.
Arvada, CO 80007
Website: www.goldenrescue.com
Phone: 303-279-2400
Email: info@goldenrescue.com

Old Dog House

3457 Highland Meadows Dr.
Florissant, CO 80816
Website: www.olddoghousecolorado.org
Contact form: www.olddoghousecolorado.org
/contact.html

Safe Harbor Lab Rescue

601 16th St., #C-322
Golden, CO 80401
Website (with contact form): www.safeharbor
labrescue.org
Phone: 303-464-7777

CONNECTICUT

Blind Dog Rescue Alliance

PO Box 53
Seymour, CT 06483
Website: www.blinddogrescue.org
Phone: 877-BLIND-01 (877-254-6301)
Email: info@blinddogrescue.org

Out to Pasture Farm & Rescue

PO Box 310174
Newington, CT 06131
Website: www.outtopasture.org
Email: carrie@outtopasture.org

DELAWARE

Senior Dog Haven & Hospice

PO Box 1441
Wilmington, DE 19899
Website: www.seniordoghaven.org
Email: info@seniordoghaven.org

FLORIDA

Dalmatian Rescue of Tampa Bay

PO Box 341951
Tampa, FL 33694
Website: www.dalrescuetampabay.org
Phone (voice mail): 727-417-6017
Email: susan@dalrescuetampabay.org

Fairy Tail Endings

PO Box 17483
Sarasota, FL 34231
Website: www.fairytailendings.org
Email: fairytailendingsSRQ@gmail.com

Golden Retriever Rescue of Southwest Florida

PO Box 110987
Naples, FL 34108
Website: www.grrswf.org
Phone: 239-369-0415
Email: info@grrswf.org

Greyhound Pets of America Senior Sanctuary of Florida

2205 Hunterfield Rd.
Maitland, FL 32751
Website: www.gpaseniorsanctuary.org
Phone: 352-728-2839
Email: info@gpaseniorsanctuary.org

Mastiff Rescue of Florida's "Oldies But Goodies" Program

PO Box 354
Webster, FL 33597
Website: www.mastiffrescuefl.org
Contact form: www.mastiffrescuefl.org
/contact-us.html

The Old Dog House

1650 Margaret St., Ste. 302, PMB 137
Jacksonville, FL 32204
Website: theolddoghouse.org
Phone: 904-419-7387
Email: info@theolddoghouse.org

Pawlicious Poochie Pet Rescue

PO Box 7895
St. Petersburg, FL 33734
Website: www.pawliciouspoochie.com
Phone: 727-430-2491
Email: pawliciouspoochiepetrescue@gmail.com

Paws 4 You Rescue's Seniors Program

PO Box 561163
Miami, FL 33256
Website (Seniors Program): www.paws4you.org
/seniors
Email: seniors@paws4you.org

Pet Alliance of Greater Orlando

2727 Conroy Rd.
Orlando, FL 32839
Website: www.petallianceorlando.org
Phone: 407-351-7722
Contact form: www.petallianceorlando.org
/about-us/contact-us-2

Suncoast Basset Rescue

5200 NW 43rd St., #102318
Gainesville, FL 32606
Website: www.suncoastbassetrescue.org
Phone: 352-371-8082
Contact form: www.suncoastbassetrescue.org
/ContactUs.aspx

GEORGIA

Retired Retrievers

Savannah, GA
Website: www.retiredretrievers.org
Email: suzanne@retiredretrievers.org

HAWAII

K9 Kokua

PO Box 2471
Waianae, HI 96792
Website: www.k9kokua.org
Phone: 808-853-7267
Email: info@k9kokua.org

Rainbow Friends Animal Sanctuary

PO Box 1259

17-382 13 Mile Rd.

Kurtistown, HI 96760

Website: www.rainbowfriends.org

Phone: 808-982-5110

Email: mail@rainbowfriends.org

ILLINOIS

Pets for Seniors

PO Box 64

Edwards, IL 61528

Website: www.petsforseniors.org

Phone: 309-446-9721

Email: pfsshelter@gmail.com

Quad City Animal Welfare Center

724 W. 2nd Ave.

Milan, IL 61264

Website: www.qcawc.org

Phone: 309-787-6830

Contact form: www.qcawc.org
/contact.html

Young at Heart Pet Rescue

PO Box 1293

Palatine, IL 60078

Website: www.adoptaseniorpet.com

Phone: 847-529-2025

Contact form: www.adoptaseniorpet.com
/contact

LOUISIANA

Animal Rescue New Orleans

271 Plauche St.

New Orleans, LA 70123

Website: www.animalrescueneworleans.org

Phone (voice mail): 504-571-1900

Email: arnovolunteer@yahoo.com

MARYLAND

Beagle Rescue of Southern Maryland's "Friends of Winston" Program

PO Box 983

Waldorf, MD 20604

Website: www.beaglemaryland.org/web_pages
/main_fow.htm

Phone: 301-934-3616

Email: info@beaglemaryland.org

House with a Heart Senior Pet Sanctuary

6409 Stream Valley Way

Gaithersburg, MD 20882

Website: www.housewithaheart.com

Phone: 240-631-1743

Email: housewithaheart@comcast.net

MASSACHUSETTS

Yankee Golden Retriever Rescue

PO Box 808

Hudson, MA 01749

Website: www.ygrr.org

Phone: 978-568-9700

MISSOURI

Senior Dogs 4 Seniors

1109 Babler Forest Ct.

Chesterfield, MO 63005

Website: www.seniordogs4seniors.com

Phone: 636-458-1892

Email: info@seniordogs4seniors.com

St. Louis Senior Dog Project

7488 Rivermont Trail

House Springs, MO 63051

Website: www.stlsdp.org

Phone: 636-671-7223

Contact form: www.stlsdp.org
/#!contact-us/c1nh7

Montana

Rolling Dog Ranch Animal Sanctuary

400 Rolling Dog Ranch Ln.
Ovando, MT 59854
Website: www.rollingdogranch.com
Phone: 406-793-6000
Email: info@rollingdogranch.org

New Jersey

Penny Angel's Beagle Rescue

PO Box 2161
Ventnor, NJ 08406
Website: www.pennyangelsbeagle
 rescue.com
Phone: 609-965-9476
Email: beagler534@comcast.net

New Mexico

Senior Doberman Project

144 Road 2776
Aztec, NM 87410
Website: www.doberman911.org/seniors
Email: seniors@doberman911.org

New York

Animal Haven

251 Centre St.
New York, NY 10013
Website (with contact form): www.animal
 havenshelter.org
Phone: 212-274-8511

Best Friends Animal Society–New York

Foster program in New York City.
Website: ny.bestfriends.org
Phone: 347-76-ADOPT (347-762-3678)
Email: contactnyc@bestfriends.org

Forever Home Greyhound Adoptions

213 West Fulton Rd.
Middleburg, NY 12122
Website: www.foreverhomegreyhounds.com
Contact form: www.foreverhomegreyhounds
 .com/about/contact_us.shtml

Last Hope Animal Rescue and Rehabilitation

PO Box 7025
Wantagh, NY 11793
Website: www.lasthopeanimalrescue.org
Phone: 631-425-1884
Email: info@lasthopeanimalrescue.org

Louie's Legacy Animal Rescue

Operates in Staten Island.
Website: www.louieslegacy.org
Phone: 646-397-LLAR (646-397-5527)
Email: newyork@louieslegacy.org

Posh Pets Rescue

Operates in New York City.
Website: www.poshpetsrescue.org
Phone: 917-319-4304
Email: mslondonspets@aol.com

Rescue Me–Purebred K9 Rescue

PO Box 758
Oneida, NY 13421
Website: www.rescuemek9.org
Phone: 315-271-6161
Contact form: www.rescuemek9.org
 /ContactUs.html

North Carolina

Alaskan Malamute Assistance League (AMAL)

PO Box 54
Concord, NC 28026
Website: www.malamuterescue.org
Phone (voice mail): 419-512-2423
Email: contact@malamuterescue.org
AMAL-affiliated rescue contacts throughout
 North America: www.malamuterescue.org
 /rescue/listorg.html

German Shepherd Rescue & Adoption

PO Box 471
Fuquay-Varina, NC 27526
Website: www.gsdrescue.org
Email: gsdrescue75@hotmail.com

OHIO

Almost Home Dog Rescue of Ohio

7671 Southview Dr.
Columbus, OH 43235
Website (with contact form): www.almost
 homeohio.org

Louie's Legacy Animal Rescue

Operates in Cincinnati.
Website: www.louieslegacy.org
Phone: 513-65-LOUIE (513-655-6843)
Email: info@louieslegacy.org

Sanctuary for Senior Dogs

PO Box 609054
Cleveland, OH 44109
Website: www.sanctuaryforseniordogs.org
Phone: 216-485-9233
Contact form: www.sanctuaryforseniordogs.org
 /id16.htm

OREGON

Golden Bond Rescue of Oregon

PO Box 25391
Portland, OR 97298
Website: www.goldenbondrescue.com
Phone (voice mail): 503-892-2897
Email: GoldenBondRescue@yahoo.com

Senior Dog Rescue of Oregon

PO Box 1051
Philomath, OR 97370
Website: www.sdroregon.com
Phone: 541-224-2488
Email: SDROregon@gmail.com

PENNSYLVANIA

Delaware Valley Golden Retriever Rescue

60 Vera Cruz Rd.
Reinholds, PA 17569
Website: www.dvgrr.org
Phone: 717-484-4799
Email: info@dvgrr.org

Southwest Pennsylvania Retriever Rescue
Organization

142 Stark Dr.
Plum, PA 15239
Website: www.sparro.org
Phone: 412-795-0163
Email: jobarlabs@comcast.net

SOUTH CAROLINA

Carolina Basset Hound Rescue

PO Box 80082
Charleston, SC 29416
Website: www.cbhr.com
Phone: 888-909-2387
Email: rescue@cbhr.com

TENNESSEE

Old Friends Senior Dog Sanctuary

PO Box 93
Mount Juliet, TN 37121
Website: www.ofsds.org
Email: ofsdstn@gmail.com

Willy's Happy Endings

2073 Wilma Rudolph Blvd.
Clarksville, TN 37040
Website: www.willyshappyendings.org
Phone: 931-217-4495
Email: WillysRescue@gmail.com

Texas

Abandoned Animal Rescue

419 E. Hufsmith Rd.
Tomball, TX 77375
Website: www.aartomball.org
Phone: 281-290-0121
Email: info@aartomball.org

Central Texas Dachshund Rescue

7544 FM 1960 Rd. E., #71
Humble, TX 77346
Website: www.ctdr.org
Email: info@ctdr.org

Citizens for Animal Protection

17555 Katy Freeway
Houston, TX 77094
Website: www.cap4pets.org
Phone: 281-497-0591
Contact form: www.cap4pets.org
/contact-us

Golden Retriever Rescue of North Texas

PO Box 670031
Dallas, TX 75367
Website: www.goldenretrievers.org
Phone: 214-750-4477
Email: info@goldenretrievers.org

Mission K9 Rescue

14027 Memorial Dr., #185
Houston, TX 77079
Website: missionk9rescue.org
Contact form: missionk9rescue.org
/contact-mission-k9-rescue

Utah

Best Friends Animal Sanctuary

5001 Angel Canyon Rd.
Kanab, UT 84741
Website: www.bestfriends.org/The-Sanctuary
Phone: 435-644-2001
Email: info@bestfriends.org

Best Friends Animal Society–Utah

2005 S. 1100 East
Salt Lake City, UT 84106
Website: utah.bestfriends.org
Phone: 801-574-2454
Email: utahpets@bestfriends.org

Virginia

Richmond Animal League's Seniors for Seniors Program

11401 International Dr.
Richmond, VA 23236
Website: www.ral.org
Phone: 804-379-0046
Email: adopt@ral.org

Washington

Greyhound Pets

PO Box 891
Woodinville, WA 98072
Website: www.greyhoundpetsinc.org
Contact form: www.greyhoundpetsinc.org
/contact.html

Old Dog Haven

621 SR9 NE, #A4
Lake Stevens, WA 98258
Website: www.olddoghaven.org
Phone: 360-653-0311
Email: office@olddoghaven.org

Saving Pets One at a Time (SPOT)

PO Box 211
Burlington, WA 98233
Website: www.savingpetsoneatatime.org
Phone: 360-336-5388
Email: spot@savingpetsoneatatime.org

WISCONSIN

Greyhound Pets of America–Wisconsin

PO Box 2115
Madison, WI 53701
Website: www.gpawisconsin.org
Phone (voice mail): 414-299-9473
Email: webmaster@gpawisconsin.org

Organizations Supporting Military Service Members and Veterans

PAIRING VETERANS WITH DOGS

America's VetDogs

371 E. Jericho Turnpike
Smithtown, NY 11787
Website: www.vetdogs.org
Phone: 866-838-3647
Email: info@vetdogs.org

Canine Companions for Independence

PO Box 446
Santa Rosa, CA 95402
Website (with contact form): www.cci.org
Phone: 800-572-2275

Freedom Service Dogs of America

2000 W. Union Ave.
Englewood, CO 80110
Website: www.freedomservicedogs.org
Phone: 303-922-6231
Email: info@freedomservicedogs.org

Help for Heroes

PO Box 21804
Keizer, OR 97303
Website: www.joydogs.org/HelpingHeroes.php
Phone: 503-551-4572
Email: info@joydogs.org

Hero Dogs

PO Box 64
Brookeville, MD 20833
Website: www.hero-dogs.org

Phone: 888-570-8653
Email: hero@hero-dogs.org

Honor Therapy and Assistance Dogs

PO Box 77108
Charlotte, NC 28271
Website: www.honortherapydogs.org
Phone: 704-759-0108
Email: ann@honortherapydogs.org

K9s for Warriors

260 S. Roscoe Blvd.
Ponte Vedra Beach, FL 32082
Website: www.k9sforwarriors.org
Phone: 904-686-1956
Email: info@k9sforwarriors.org

Patriot PAWS Service Dogs

254 Ranch Trail
Rockwall, TX 75032
Website: www.patriotpaws.org
Phone: 972-772-3282
Email: office@patriotpaws.org

Paws Assisting Veterans (PAVE)

PO Box 871
Cornelius, OR 97113
Website: www.paveusa.org
Email: info@paveusa.org

Paws of War

34 E. Main St., #303
Smithtown, NY 11787
Website: guardiansofrescue.org
 /banners-view/paws-of-war-32413
Phone: 888-287-3864
Email: info@guardiansofrescue.org

Pets for Patriots

218 E. Park Ave., #543
Long Beach, NY 11561
Website: www.petsforpatriots.org
Phone: 877-473-8223
Contact form: www.petsforpatriots.org
 /contact-us

Retrieving Freedom

1148 230th St.

Waverly, IA 50677

Website: www.retrievingfreedom.org

Phone: 319-290-0350

Contact form: www.retrievingfreedom.org
/contact

Sam Simon Foundation

30765 Pacific Coast Hwy., #113

Malibu, CA 90265

Website: www.samsimonfoundation.com
/veterans.asp

Phone: 310-457-5898

Email: info@samsimonfoundation.org

Service Dogs for America

PO Box 513

Jud, ND 58454

Website: www.servicedogsforamerica.org

Phone: 701-685-2242

Contact form: www.servicedogsfor
america.org/contact

Veterans Moving Forward

PO Box 404

Catharpin, VA 20143

Website: www.vetsfwd.org

Phone: 866-375-1209

Email: admin@vetsfwd.org

Warrior Canine Connection

23222 Georgia Ave.

Brookeville, MD 20833

Website: www.warriorcanineconnection.org

Phone: 301-260-1111

Email: info@warriorcanineconnection.org

HELPING MILITARY DOGS

K-9 Battle Buddies

American Humane Association program that
reunites retired military dogs with their human
handlers.

1400 16th St. NW, #360

Washington, DC 20036

Website: www.americanhumane.org

Phone: 800-227-4645

Email: info@americanhumane.org

Mission K9 Rescue

Brings retired military and contract working
dogs back to the United States; also finds homes
for retired law-enforcement dogs.

14027 Memorial Dr., #185

Houston, TX 77079

Website: missionk9rescue.org

Contact form: missionk9rescue.org
/contact-mission-k9-rescue

Save-A-Vet

Supports military and law-enforcement dogs
in their later years.

387 Northgate Rd.

Lindenhurst, IL 60046

Website: www.save-a-vet.org

Phone: 815-349-9647

Email: info@saveavet.org

United States War Dogs Association

Sends care packages to military dogs
on deployment and helps cover
medical expenses for retired
military dogs.

1313 Mount Holly Rd.

Burlington, NJ 08016

Website: www.uswardogs.org

Phone: 609-747-9340

Email: ronaiello@uswardogs.org

HELPING MILITARY SERVICE MEMBERS WITH THEIR PETS

Dogs on Deployment

Arranges for long-term boarding of dogs,
cats, and other pets while military service
members are deployed or have other
service commitments.

PO Box 710286

Santee, CA 92072

Website: www.dogsondeployment.org

Phone: 619-800-3631

Guardian Angels for Soldier's Pet

Offers a Military and Veteran Pet Foster Home Program and a Military Pet Assistance Fund.
9725 FM 1783
Gatesville, TX 76528

Website: www.guardianangelsforsoldierspet.org
Phone (voice mail): 646-653-1045
Contact form: www.guardianangelsfor
soldierspet.org/contact-us

ORGANIZATIONS AND PROGRAMS IN OTHER COUNTRIES

AUSTRALIA

Australian Working Dog Rescue

PO Box 4188
Pitt Town, NSW 2756
Website: www.workingdogrescue.com.au
Contact form: www.workingdogrescue.com.au
/contact-us-2

Save-a-Dog Scheme (SADS)

Central Park PO Box 2325
East Malvern, VIC 3145
Website: www.saveadog.org.au
Phone: (03) 9824 7928 or 0418 389 810
Email: admin@saveadog.org.au

Seniors and Silky Rescue

PO Box 3026
Marrickville Metro, NSW 2204
Website: www.seniorsandsilkies.org.au
Contact form: www.seniorsandsilkies.org.au
/contact.html

CANADA

Loyal Rescue

171 Rink St.
Peterborough, ON K9J 2J6
Website: www.loyalrescue.com
Phone: 705-772-4916
Contact form: www.loyalrescue.com
/loyal_rescue_contact.php

Senior Animals in Need Today Society (SAINTS)

33860 Dlugosh Ave.
Mission, BC V2V 6B2

Website: www.saintsrescue.ca
Email: info@saintsrescue.ca

NEW ZEALAND

Retired Working Dog Adoption

North Island of New Zealand
Website: www.retiredworkingdogs.co.nz
Email: retired.workingdogs@gmail.com

UNITED KINGDOM

Oldies Club

49A Kinross Close
Cinnamon Brow
Warrington
Cheshire WA2 0UT
England
Website: www.oldies.org.uk
Email: oldies@oldies.org.uk

ACKNOWLEDGMENTS

 Laura T. Coffey

For starters, thank you to all the bighearted, emotionally generous people who help voiceless creatures by giving them friendship, nice baths, yummy treats, and soft beds. I would like to buy you a beer.

Thank you to my husband, Michael Wann, for being the love of my life and the person with whom I share pooches and smooches. Thank you for making me laugh every single day since I met you at that fish cannery in Alaska. I love you so, so much.

Thank you to my son, Tyler, for being the best boy in the whole world and for making me laugh even harder. I love you more than two (variant spelling of too)! ;-)

Thank you to my mother-in-law, Beth "Gaga" Wann, for making this book possible by feeding me healthy snacks to keep my blood-sugar levels up, letting me hide out in your basement for marathon writing sessions, and encouraging me every step of the way.

Thank you to Dawn Browne and Matt Crisler for your friendship, support, and comedic relief. Dawn, thank you for being my best friend and external hard drive since we were eleven. And thank you both for letting me go on "writing hermitudes" at the cabin and for dreaming up the best Bigfoot-themed drink names in history. (My favorite remains the "Skunk Ape.")

To my dad, Mel Coffey; my brother and sister-in-law, Eric and Amanda Coffey; and my nephew, Dylan Coffey: thank you for being my unfailingly loyal support system.

Thank you to Grandpa and Grandma Pat — Mike and Pat Wann — for cheering me on from the Great North!

Thank you to photographer Lori Fusaro for loving animals so sincerely and rescuing Sunny for all the right reasons. Thank you to Sunny for being such a good girl.

Thank you to alert reader Emily Schroeder Orvik for nudging me on Facebook to check out Lori's senior-dog photography project for a possible TODAY.com story. Wow. *That* sure turned out to be a good story tip!

Thank you to our agent, Cheryl Pientka of Jill Grinberg Literary Management, for being the visionary who made this project happen. Thank you, Cheryl, for saving a senior dog named Sasha in the wake of Hurricane Sandy, then finding a way to convey the transforming power of that adoption experience through the pages of this book. I will never forget your compassion, kindness, support, and use of exclamation points in email messages precisely when I needed them. Thank you!!!

Thank you to our editor, Jason Gardner of New World Library, for believing in this book as soon as he heard about it. I don't know how to find the words to thank you properly for all you've done, Jason — and I'm sure you wish I wouldn't find the words, since you told me to keep these acknowledgments short! But please let me say this: your calm, wise guidance at every imaginable turn helped me so many times to breathe deeply and keep going. Thank you!

Thank you to everyone at New World Library — including Kristen Cashman, Tracy Cunningham, Mark Colucci, Monique Muhlenkamp, and Munro Magruder — for transforming our words and photos into the most beautiful book I've ever seen. Tracy, your design skills! Mark, your rock-star copyediting skills! I bow at your feet! (And I also would like to buy you a beer!)

A tremendously huge thank-you to my family at TODAY.com, the website of NBC's *TODAY* show, for supporting this book with so much enthusiasm and for teaching me how to find and write the sorts of stories that appear on these pages. Special shout-outs to Sarika Dani, Jen Brown, Rick Schindler, Ian Sager, Meena Duerson, Mish Whalen, Vidya Rao, Kyle Michael Miller, Steve Veres, Rebecca Dube, Amy Eley, Carissa Ray, Eun Kyung Kim, Danielle Brennan, and Lauren Sullivan for your friendship, kindness, and snort-worthy comedy from across the continent!

Thank you to all the far-flung folks all over the country who rallied around the cause of this book and offered such wonderful ideas and support. There are too many to mention here — and please forgive omissions — but they include: NBC News correspondent and animal advocate Jill Rappaport; Jennifer Kachnic and Julie Dudley of the Grey Muzzle Organization; Elissa Jones, Barbara Williamson, Amy Wolf, and Mary-Jo Dionne at Best Friends Animal Society; Dr. Robin Ganzert and Mark Stubis of American Humane Association; Michael Weiss of the White Muzzle Fund; Sherri Franklin, Patty Stanton, Marie Rochelle Macaspac, and Andrea Brooks at Muttville Senior Dog Rescue; veterinarian and author Marty Becker; Old Dog Haven cofounders Judith and Lee Piper; longtime animal rescuer and author David Rosenfelt; and Camp Cocker Rescue founder Cathy Stanley.

Thank you to Neko Case for having such a kind heart. Thank you to Bruce and Jeannie Nordstrom for being so genuine and down-to-earth. Thank you to George Clooney for being so gracious.

For sage words of advice, brainstorming help, and, in some cases, couch-surfing support while traveling, special thanks to: Darrell Fusaro, Bob Sullivan, Maria Goodavage, Athima Chansanchai, Helen A. S. Popkin, Bill Dedman, Allen and Linda Anderson, Tyler and Che Maio Shell, Mario and Eve Juarez, Laurie Harker, Suzanne Choney, Katy Khakpour, Ginny and Garrett Schlief, John Griffin, Wilson Rothman, Jennifer Laird, and Bonnie and Mike Chickering.

Jennifer Sizemore! Thank you for pretty much everything! So many good things in my life can be traced back to you. Thank you for being my friend.

Thank you to my late friend Lisa Clausen, a beautiful human being who taught me to love dogs.

Thank you to my fun-loving senior dogs, Frida and Manny, and my giant senior cat, Diego, for keeping your eyes locked on me as I worked on this book. You always had such unwavering confidence that I might throw toys or drop snacks.

Last, thank you to my mother, Esther Coffey. I lost you in June 2013, just one month before I met Lori and unwittingly embarked on a journey toward my first book. I wish you could see this book, Mom! You would be so excited and so happy! I can't wait to tell you all about it someday. In the meantime, I can still hear your big laugh and sense the words you would have told me if you could have. For that, I am so, so grateful.

Lori Fusaro

First I have to thank my very wonderful, supportive, understanding, and loving husband, Darrell, who manned the Fusaro compound and all the animals while I was traveling to photograph the dogs in this book. Without you I wouldn't have clean clothes, decent meals, or a made bed. I love you.

I want to thank my dad, Jack Tomlinson, for teaching me how important animals really are in our lives, for finally agreeing to let me get a horse after years of begging and then adopting not one but three at a "last stop before the glue factory" auction, for adopting old guy Scout after he lost his home to divorce, and for being just about he best dad I could have ever hoped for.

My mom, Sharon Faber, also deserves a big thank-you. You stayed up all night to feed my ailing hamster Snowball; you tolerated my cat Tiffany even when she peed and pooped in your shoes; you taught me to fight for the underdog and follow my heart. You and I are so much alike, and I am so happy to call you Mom.

Thank you, baby brother, Chris Tomlinson, for enduring the torture I put you through as a kid and for always being there when I need you. Glad you had the human kids so mom and dad have a few nonfurry grandchildren.

Thank you to every person who has opened their heart and let an old dog inside. It's

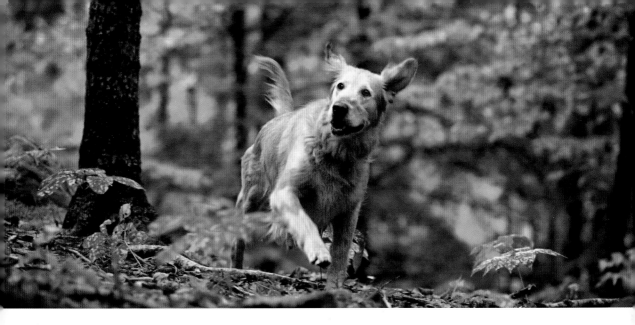

not an easy road, and I'm grateful to know there are so many who know that love doesn't keep track of years and that every moment, even if they are few, is important.

I want to thank Kerry O'Connor for showing me that the joy of adopting an old dog absolutely outweighs the fear of losing them too soon. Without you, that seed would never have been planted in my head. Gemma made a lasting impact on me, and your love for her made me understand so much.

Thank you, Guillermo Moreno from the Carson Animal Shelter, for making sure my Sunny girl was safe while she waited for me to come and get her.

I would also like to thank Jeff Trujillo and Mark McGuire for spending days and days with me filming and editing my "Silver Hearts" Kickstarter video. You helped me get my thoughts and ideas into something coherent, and it ended up being the catalyst for the book.

Thank you to all the "Silver Hearts" supporters for letting me photograph your furry family members and for supporting the book before it was even a book.

Thank you, Rita Earl, for capturing some of my most treasured photographs of Sunny, Gabby, Enzo, and Francis; for being there for my panicked emails and phone calls when I thought Sunny was a goner; and for helping me navigate the world of senior dogs. I am so lucky to call you a friend.

Thank you, Cheryl Pientka of Jill Grinberg Literary Management, for making that phone call asking me if I would possibly be interested in being represented by you; for letting me sleep on your couch; for always being there to answer any question, no matter how silly; and for having the smarts to know that a book that included the dogs' stories was the way to go.

Thank you, Laura Coffey, my partner in crime, my road-trip buddy, and just about the

best writer I know. You took a chance writing that very first piece about Sunny and her silver-faced friends, and wow, look where we ended up. You invested your heart and soul in this book, and your words make everyone love these old dogs. I'm so glad we took this leap of faith together.

Thank you to editor Jason Gardner of New World Library for your passion about old dogs and for believing in this book from the get-go. And of course a big thanks to everyone else at New World Library — including Tracy Cunningham, Monique Muhlenkamp, Kristen Cashman, Munro Magruder, and Mark Colucci. We are a great team, and I thank you so much for making this labor of love become a reality.

Thank you, Dana Collins, Michael Hand, and Elissa Jones from Best Friends Animal Society, for supporting this book, for cheering me on, and for being just about the best bosses I could ever ask for.

Thank you to Lori Wildrick and Melanie Morrill from Petco for your blog posts and support of Sunny. You helped so many see what I saw in her eyes. I will forever cherish the words you wrote about her.

Thank you, Sue Manning and Richard Vogel from the Associated Press. You helped my girl and her story go viral, and I am so grateful that people all over the world got to see her beautiful face and read about her life.

I also want to thank my friend Lisa Prince Fishler, founder of HeARTs Speak, a true humanitarian and one of the most talented women I know. Thank you for supporting my shelter work, for hours and hours of phone conversations about nothing and everything, and for just being you.

Thank you to some special friends who kept me sane through this crazy journey of creating a book: Edward Biagiotti, Jesse R. Booker, Regina Doeppel, Kea Duggan, Kati Ennis, Hany Hosny, Pam Nelson, and Amy Wolf. Your love and support mean the world to me.

And last but certainly not least, I want to thank all the folks in this book. Your willingness to open your hearts to dogs who many overlooked and the bond you share with your furry companions are beyond beautiful — without you this book would have no soul. Each and every person (and dog) I met on this journey has changed me to the very core.

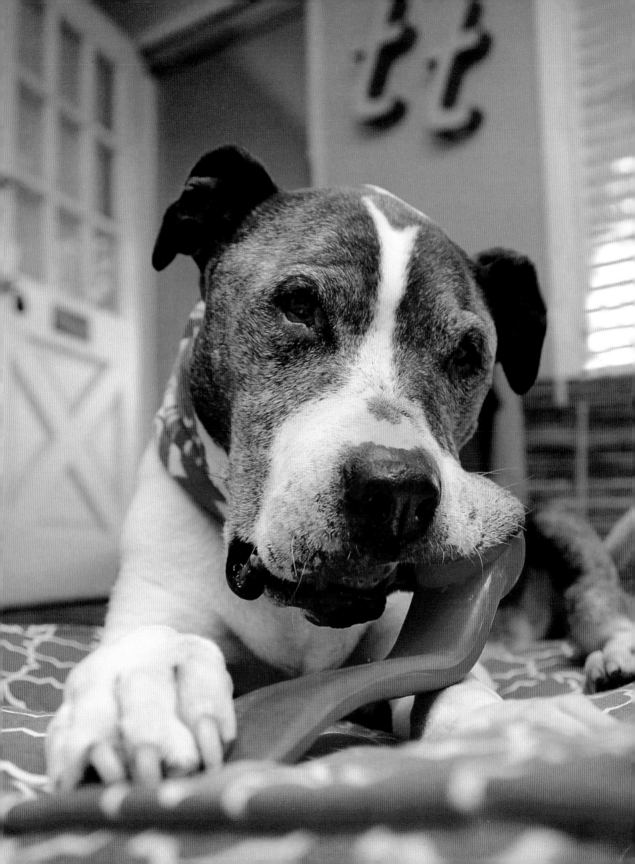

ABOUT THE AUTHOR

LAURA T. COFFEY is a longtime writer, editor, and producer for TODAY.com, the website of NBC's *TODAY* show. A journalist with more than two decades of experience, Laura has written and edited hundreds of high-profile human-interest stories. She has won numerous awards, including first-place feature-writing awards from the Society for Features Journalism and the Dog Writers Association of America. Laura lives in Seattle with her husband, Michael, her son, Tyler, and their dogs and cat. You can connect with Laura at www.lauratcoffey.com.

ABOUT THE PHOTOGRAPHER

LORI FUSARO is staff photographer at Best Friends Animal Society in Los Angeles and owner of Fusaro Photography, whose clients include BAD RAP, Guide Dogs for the Blind, k9 connection, Angel City Pit Bulls, and other animal-rescue organizations. She also serves on the advisory council for HeARTs Speak. An advocate for homeless animals, Lori has donated her time to photograph dogs and cats at shelters to increase their chances of being adopted. Lori lives in Los Angeles with her husband, Darrell, and their dogs and cats. Her website is www.fusarophotography.com.

Photo by Rita Earl

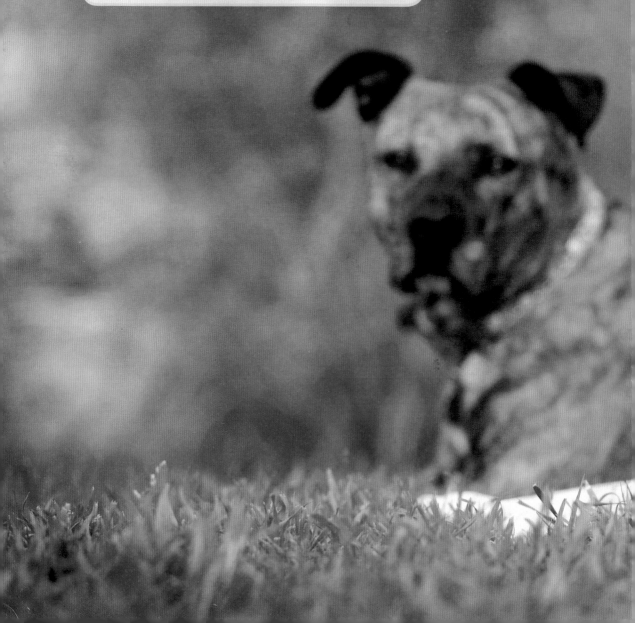

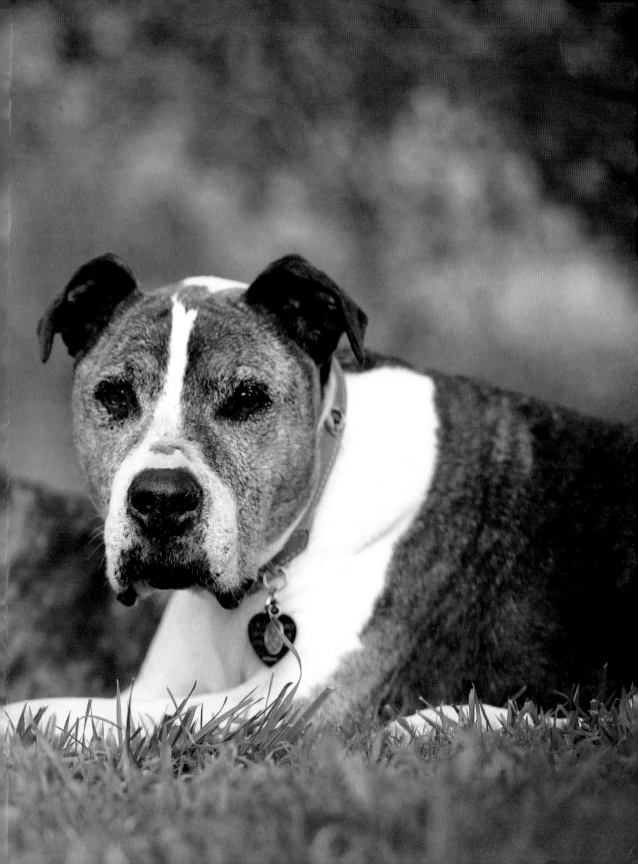

NEW WORLD LIBRARY is dedicated to publishing books and other media that inspire and challenge us to improve the quality of our lives and the world.

We are a socially and environmentally aware company, and we strive to embody the ideals presented in our publications. We recognize that we have an ethical responsibility to our customers, our staff members, and our planet.

We serve our customers by creating the finest publications possible on personal growth, creativity, spirituality, wellness, and other areas of emerging importance. We serve New World Library employees with generous benefits, significant profit sharing, and constant encouragement to pursue their most expansive dreams.

As a member of the Green Press Initiative, we print an increasing number of books with soy-based ink on 100 percent postconsumer-waste recycled paper. Also, we power our offices with solar energy and contribute to non-profit organizations working to make the world a better place for us all.

Our products are available in bookstores everywhere.

LET'S CONNECT

www.newworldlibrary.com

At NewWorldLibrary.com you can download our catalog,
subscribe to our e-newsletter, read our blog,
and link to authors' websites, videos, and podcasts.

Find us on Facebook, follow us on Twitter, and watch us on YouTube.

Send your questions and comments our way!
You make it possible for us to do what we love to do.

Phone: 415-884-2100 or 800-972-6657
Catalog requests: Ext. 10 | Orders: Ext. 52 | Fax: 415-884-2199
escort@newworldlibrary.com

NEW WORLD LIBRARY
publishing books that change lives 14 Pamaron Way, Novato, CA 94949